5/21

talk ART

'For me, art is that thing which happens after language. It's a kind of romantic view of it, but it's one I hold dear — that if you can't say it, if you can't write it, then it needs a work; it needs another kind of experience . . . What I try to do is use art to say things which cannot be said otherwise.'

LAWRENCE
ABU HAMDAN

Russell Tovey + Robert Diament

talk ART

CHRONICLE BOOKS
SAN FRANCISCO

CONTENTS

DISCOVERING CONTEMPORARY ART

HOW TO GET INVOLVED IN CONTEMPORARY ART

FOREWORD

Everything I know about art comes from two places. One is looking; always looking. The other is listening; listening to artists. Reading this book is like listening in on brilliant, curious, strange, charismatic people telling you things that you didn't know you needed to know until you heard them. Every page here left me a little changed — which is a lot. Time is slowed, allowing you to look for waters from a deeper well.

Russell and Robert have a kind of magical elixir about them, something elevated, urgent, passionate, joyous, heart-breakingly earnest, silly and unashamed to ask anything. Somehow they free their subject with a combination of questions and observations that range from smart to the unexpected to the stupid. In art this last category often yields penetrating insights. When they spoke to me I ended up spilling moon-rivers of my deepest self — the self you usually keep dancing at a distance. Sometimes in the answers they elicit you hear terrible spirits, ghosts, inner self-murders that make artists beat on against whatever current they're called on to fight against. Hearing these is fearsome and at the same time like listening to love stories. Stories about how artists come to find their own voice, muster courage to keep going, deal with rejection and surrender to what they're helpless not to do — which is to make art, even if it's ugly, embarrassing, illogical, obscure, or alarming.

When it comes to contemporary art, I often have no idea what critics, curators and artists are talking about. Many speak a kind of unintelligible gobbledygook that only 155 other equally abstruse people speak. That language is meant to keep people out, to intimidate and impress. Russell and Robert roll a different way, covering subjects as wide-ranging as contemporary painting, political art, aesthetics of race and gender, art history and how to look at art for dummies (that was me, a former long-distance truck-driver with no school and no degrees, who didn't start writing until I was 40). They are able to say something is crap and be able to say why, exorcise demons that tell you that you don't know what you're doing (hi, everyone!), explain why a lot of art is over-priced, how to think about the 'market' and 'money', how to navigate galleries and much more. All this is made accessible, fun, gossipy and fast-paced.

The artists and art-world subjects in this book form a beautiful, diverse core-sample of the extraordinary multiplicity of artistic practices on the one hand, and an overall grasp of art today on the other. Prepare to enter a portal to the mysteries of art, canonical wisdom, an understanding of how pleasure is an important form of knowledge, and the serpents that live inside all art.

Jerry Saltz

Welcome to *talk* ART

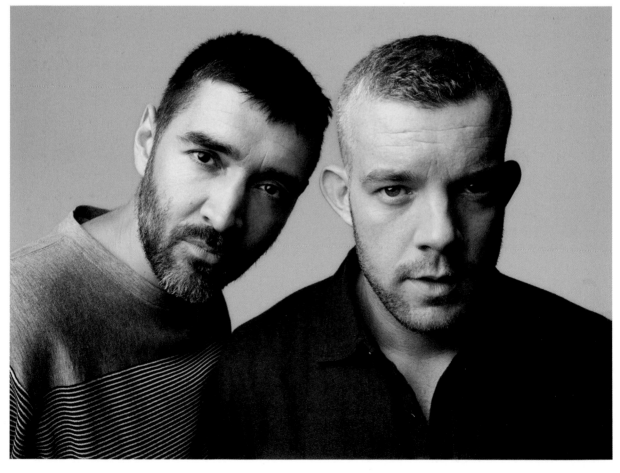

©Rankin

talk ART

Good afternoon, good morning, good evening, wherever you are in the world. We're Russell Tovey and Robert Diament … and this is *talk* ART, the Book!

Art has enriched our lives. It can enrich yours too and hopefully, probably, already has. This book is proof. It's a celebration of our experiences with art thus far, spotlighting the artists and artworks that have been part of our friendship and beyond. We first met in what now seems like a galaxy far, far away in August 2008. Russell was an up-and-coming actor, having recently starred in *The History Boys* film, and Robert had just released his debut album as singer-songwriter in electro-pop band Temposhark. The artist Tracey Emin invited us both to a dinner in Edinburgh to inaugurate *20 Years*, a major retrospective of her work held at the Scottish National Gallery of Modern Art. Within minutes of conversation we formed a bond, immediately connecting over a shared enthusiasm for Tracey's titles, scratchy drawing style and ability to disclose intimate stories.

This chance meeting led to over a decade of friendship, emails, text messages, phone calls and video chats, sharing urgent daily discoveries of new artists and artworks. We recognized each other's passion, as if kindred spirits. We began adventuring across London, and eventually the world, to visit every gallery and museum we could find, as well as tracking down public sculptures on empty beaches, on busy streets, in city parks, or the secret gardens of collectors' homes. Art has been a joyous constant, a source of inspiration closely by our sides, and without a doubt the glue in our friendship.

We had very similar stories: in our early twenties, having become increasingly obsessed with the idea of living with contemporary art, we saved up every penny we could and started our own small art collections. We dreamed of one day being bona fide, fully fledged art collectors – guardians and protectors of the artworks we adored. The previous decade had opened our minds to the possibilities and expansiveness of art, thanks in large part to the works of the Young British Artists. Our family and friends were frequently bemused by our hyperbolic love of an unmade bed, a shark in formaldehyde or a ceramic blue heritage plaque. It began with posters and mugs, then limited-edition signed and numbered prints, and before long unique drawings and watercolours. Nothing beat the thrill of taking home a print from the framers' that was actually signed in pencil by the artist. Artists were gods to us, so to have something

made, or simply touched by the artist's hand, felt incredibly exciting and life-affirming. These works were bursting with meaning and passion and struggle and genius. They shared stories of lives lived and new ways of looking at the world. We were able to live with and witness history. Once hung on our apartment walls, the artworks became windows to other worlds, transforming the dull everyday into something magical and full of promise.

Neither of us had big budgets, but what we lacked in funds we made up for in passion and an unrelenting desire for knowledge. We held the story of American collectors Herbert and Dorothy Vogel close to our hearts. They worked as civil servants in New York City for more than half a century and in that time carefully amassed a collection of over 4,780 works, many displayed on the walls of their small Manhattan apartment. The works they couldn't hang, they stored in cupboards and even under the bed. Their collection is now regarded as one of the most important post-1960s art collections in the United States.

We rapidly understood that learning about and engaging with art is a seemingly endless pursuit, with infinite possibilities. There is always a new artist to discover and a new story to be told. The history of art, as it has been presented to us, often misses out or excludes so many voices and cultures: women, people of colour and queer people, for starters. Discovering and learning about different artists and their journeys has been a big part of art's enduring appeal for us. Getting to meet and befriend artists and visit their studios, we have the privilege of sharing their journey and helping to support and facilitate their dreams. This so inspired Robert that he even changed his career, swapping the music world for the art world and becoming a gallerist in 2010. Russell, too, has more recently begun to curate gallery exhibitions, and even Margate Festival, in parallel with his increased

dedication to art collecting and supporting emerging artists. We always have something new to learn, and by seeing art, reading about art, watching documentaries and chatting with artists, we have been able to learn more about ourselves and each other, and to understand further what it is to be human.

Our insatiable art appetite finally led, in Autumn 2018, to the *Talk Art* podcast. With the encouragement of our mothers, who had heard a previous joint interview on the *Thought Starters* podcast and felt for the first time that they were gaining an insight into why we love art so much, we reached out to our favourite artists, collectors, gallerists and curators, and even our talented friends from other creative industries such as acting, music and journalism. Through each hour-long conversation, we learn about the guest's life experiences making art, working with artists, collecting, living with or viewing art. It's become like a time capsule, a treasured archive of creative thinking. In our first year of broadcasting, we had over one million downloads, with listeners in sixty countries around the world, and it very quickly became a second career for both of us.

We aim to help make art more accessible, more approachable, and to share a snapshot of the art world as it is today. We wanted to make a show that was inclusive, a place to share ideas that would bring people together. We often found that if we mentioned to people at dinner parties or in varied social situations that we either worked in art or collected art, the immediate response would be, 'I'm so sorry, I know nothing about art, you'll probably find me very dull' or 'I'm embarrassed to even talk to you about art', perhaps because they felt as if they knew less than us, or needed to have retained every last drop of art history. The art world is often viewed as aloof or rarefied, and therefore inaccessible. We believe that art is

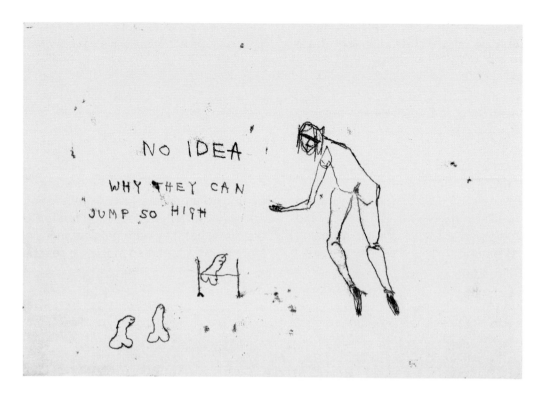

Tracey Emin, *No idea why they can jump so high*, 1998, monoprint, 29.7 × 42cm (11¾ × 16½in). This was the first work that Russell bought with his paycheck from *The History Boys* movie.

for everyone and that it can positively influence your experience of the world. Free access to art is vital. It has been a lifeline to both of us, comforting us in challenging times and, more broadly, entertaining and uplifting us almost like a best friend. Art and the art world have at times been intimidating, elitist, frustrating, overtly academic, impenetrable, frightening even. Yet, on the flip side, they have been joyous, exhilarating, incredibly EXCITING, encouraging, poetic, and the best kind of challenging. This is why we started the podcast and wrote this book: because we want to offer a non-pretentious, open conversation, a starting point from which the listener or reader can partake.

This book acts as a guide to what art means to us today. It's a launch pad for you to begin or develop your own relationship with art, and it will hopefully provide encouragement to further your art education or inspire the creativity within you. We are also really excited to share the awesome unique artworks created exclusively for the book – you will find these at the very start of each chapter.

One thing is certain: we need art! We need artists, and we need to express ourselves. So, let's go forth and share our story and the story of the artists we admire, and in doing so we hope you will get involved and start your journey to find the art you love!

WHAT DOES ♡ CONTEMPORARY ART MEAN TO <u>US</u>?

Contemporary art is the art of now. It's a giant umbrella bringing together artworks created from the second half of the 20th century right up to this very day! At its best, contemporary art is a document of humanity, resilience and progress, of new ways of seeing and thinking about the world. And this is why we love contemporary art so much – its relevance to our everyday life, its unparalleled storytelling. It helps us to understand others while making sense of ourselves in real time.

What differentiates contemporary art from the art that has gone before is that it's being made, and has been made, during a time of radical technological advancement, in a world more globally connected and faster paced than ever before. However, while the last 50 years appear to have brought humans closer together in innumerable ways, it's also been a time of great adversity, with international political challenges, instability and division. Alongside these moments of drastic social change, contemporary art has thrived, highlighting, responding to and providing an escape from numerous issues and injustices. Crucially, the art world is becoming more inclusive and more culturally diverse than ever before.

Through curating, collecting and interviewing artists, we've learned that, more often than not, art cannot be made in a vacuum. Most artists need support, guidance, and at the very least, an encouraging friend to listen and be constructively critical. Art is a collaboration of sorts, a dialogue. Through recording *Talk Art*, we've had the privilege of nurturing, facilitating and witnessing great art being made – the art of today which becomes tomorrow's history; the art that will grace museums around the world and will share with future generations a snapshot of what it was like to live, to breathe, to love at this moment in time. Living history. They say never meet your heroes, but we found one of the most exhilarating parts of being alive at the same time as the artists you love is that you *can* meet them. Ask them questions. Find out what drives them. Be part of the experience.

Somewhere, at this very moment, an artist is thinking, researching, reading, planning, drawing, dancing, singing, painting, spraying, pouring, cutting, tearing, sewing, weaving, writing, chopping, bending, moulding, firing, photographing, filming, editing, digitally altering and much, much more. In terms of materials, contemporary art is expansive,

innovative and experimental, with seemingly limitless possibilities, choices and methods of presentation. All on the precipice of creating something. Something new. Something we've never seen before. At least, that's the aim. It is, in fact, a lifelong pursuit, a lifelong commitment. The truth is great artists often refer to and learn from the past, or even steal from that past, in order to reposition, repurpose and renegotiate the meaning of art today.

This is one of our favourite shots by Rob's old friend Tom Lardner – taken in November 2018. At this point we had already released two *Talk Art* episodes but didn't have official artwork, so Tom designed it for us.

We love artists most of all because they create imaginative new worlds and new languages. They stand outside mainstream society, looking in, keenly observing, analysing, criticizing, and sometimes even celebrating humanity's eccentricities, quirks and flaws. These worlds may not look like the world we know; they may, in fact, consist solely of abstract colour or shapes. Or they may appear to look just like our world – meticulous, figurative facsimiles. But art is all its own. Its potential lives and breathes. And even though at times it may seem futile, contemporary art has the power to change people's hearts and minds. Art can transform and make possible the seemingly impossible; it can meaningfully contribute to and influence how we treat one another.

Robert aged five, Easter 1986, at the Natural History Museum in
London, where his mum Judith worked for fifteen years.

ROBERT

Cover artwork,
Temposhark (Robert's band),
The Invisible Line, 2008.

In childhood, I always found historical art stuffy and dry. Growing up, I was repelled by the dusty oil paintings and framed prints lining the walls of my schools and local church. Anodyne landscape paintings, or watercolours, or black-and-white reproductions in textbooks. Little did I know of the actual majesty and profound beauty of Old Masters. To me they just seemed dull. Art felt ancient and far removed, not remotely related to the living, breathing me. There were a few moments where I connected to art, specifically postcards my mum framed of Andy Warhol's 'Endangered Species' wildlife and a hand-painted canvas of a famous L.S. Lowry painting, meticulously copied by a 90-year-old woman from Reading. Otherwise art felt wholly inaccessible, as if I needed to have all the knowledge before being able to appreciate the work. I longed for something new, something fresh, something that was alive.

As soon as I possibly could, I opted out of art classes, aged 12, to focus on music and theatre, which felt more vibrant, vital and relevant. But to my surprise, eventually a more personal relationship with art developed – one of intense, passionate discovery. And maybe that's what it boiled down to: I needed to make the discoveries myself, rather than be told in a hushed classroom about how significant Michelangelo's *David* was. The only David for me was David Hockney, whose books I stumbled across in my secondary school library one afternoon, while 'sick' off games. Perhaps even more revolutionary to my development was a Frida Kahlo biography by Hayden Herrara. Kahlo's life story spoke to me, and before I knew it, I was hooked. The dramas,

the intrigue, the warts-and-all honesty led me to obsess over her artwork. I couldn't get enough. I wanted to know every title, which year the works were made, and how they related to her biography and the social circumstances and political challenges she faced. I admired both Hockney and Kahlo for their bravery in using their own voices, for their innovation, and for what seemed to me to be a rigorous interrogation into the human psyche. They left no stone unturned in the search for their truth, making paintings, drawings, etchings and photographs about their intimate worlds and desires. They taught me that love existed in different forms and that all love, regardless of sexuality or gender, was valid. Art gave me permission.

Yes, I had music and songwriting too. But at last, for the extrovert that I was, I had discovered something private and sacred to soothe the intense emotions I was experiencing in my teens. What resonated most was these artists' urgent

need to create. The sense that one can survive and overcome trauma through self-expression, and that creativity would ultimately set you free. They made work about their desires, losses, joys and pain that, combined, made total sense to a 14-year-old who was coming to terms with being gay, with being an outsider, and whose brother had recently died in a nightclub. I didn't know yet how to recognize, feel or own my anger and grief, so I lived vicariously through the stories presented within their artworks. Art gave me the power to be myself, to face each day with the knowledge that there were others like me in the world, and that being different was in fact a strength, not a weakness.

By the mid-1990s I began hearing a lot in the British media about a radical new gang, the Young British Artists. Finally, it felt like something new was afoot and not limited to books. This was the art of our time! Tracey Emin brought stories to gallery walls of real life, of her childhood and adolescence in Margate. One phrase has always stuck in my mind from her early work: 'I Need Art Like I Need God'. This became my mantra. I soon realized art could be, if not exactly a religion, then a family of like-minded souls, and ultimately a place of solace and growth. Contemporary art was something to believe in, something to nurture and champion. Art was the most precious part of our culture, and it needed to be protected.

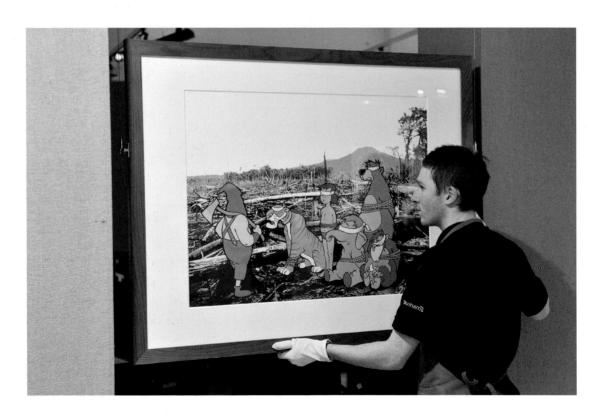

Banksy, *Save or Delete Jungle Book*, 2001, digital print of the design for the Greenpeace campaign. Robert worked with Greenpeace to promote 'Save or Delete', the 2002 campaign and 2003 exhibition at the Oxo Tower in London. Including Banksy's now-iconic artwork of characters from *The Jungle Book*, the campaign and exhibition highlighted global deforestation.

talk ART

My journey to living with art was, in a way, accidental. As a teenager I plastered my bedroom walls with posters I discovered at 1980s high street art shop Athena alongside photographs of my favourite musicians, such as Madonna, Prince and Kate Bush. I began to obsessively collect memorabilia and ephemera, culminating in a gift from my mother to mark my 18th birthday – a limited-edition framed photograph of Tori Amos sitting in a blue chair, taken by Cindy Palmano, signed and numbered in gold pen by Tori herself. While studying music at Westminster University, I continued to collect posters of bands and artists such as Goldfrapp, Peaches and Fischerspooner, whose visual identity and album artwork all came from a very artistic place. With my band Temposhark, I started performing live within London's queer club scene, witnessing the evolution of electroclash, and collaborating with and befriending creative figures such as Princess Julia, S'Express's Mark Moore, Bishi and Matthew Glamorre, whose legendary nightclub Kashpoint very much upheld the legacy of night-time impresario/performance artist Leigh Bowery.

Then, working part-time at a music and arts public relations agency, I helped promote Greenpeace's 2002 art exhibition and campaign 'Save or Delete', highlighting deforestation – the leading image of which was a painting of blindfolded characters from Disney's The Jungle Book by a then-underground graffiti artist named Banksy. This chance experience led to my introduction to buying and living with affordable prints. In no time I had adorned the walls of my student flat with striking, colourful screenprints by street artists including Banksy, FAILE, Invader, Paul Insect, D*Face and Eine. These purchases, although bought with the sole intention of filling my blank walls, inadvertently marked the start of my art career, because their value very quickly rose from the tens and hundreds of pounds that I originally paid, to thousands just a few years later.

I became a regular at East London gallery exhibitions, in particular connecting to the roster of Maureen Paley in Bethnal Green, passionately discovering artists there such as Rebecca Warren, Gillian Wearing and Wolfgang Tillmans. I became so compelled to live with their art that I decided to part with my entire graffiti print collection and use the funds to buy prints and unique works on paper by artists I truly loved. One of them was a Tracey Emin edition titled Tracey × Tracey, directly referencing Frida Kahlo's iconic painting The Two Fridas, and so it all came full circle. The pride I felt showing the works I had collected to visitors to my flat transformed my whole outlook. I gained so much joy from teaching others about the artists' work I loved that it was all I wanted to do. In my mid-20s I began touring with Temposhark in the United States and Europe, but while I was living out what I had once thought was my dream career, I found myself increasingly miserable on stage. I didn't enjoy performing live and frequently felt awkward and despondent. What saved me during that time of self-doubt was going to museums. I asked my management to book in museum visits in every city we travelled to, and so I came to see that this was where I was most happy. Not on stage singing but in museums and galleries, with art.

It was around this time I met Russell, and together we pushed each other even further to explore and learn. Finally I'd met someone who shared my intense enthusiasm, and from that moment we never looked back. The more we taught ourselves by visiting exhibitions and by spending hours looking at artworks, the more we wanted to participate, to be part of the art world, and to have art in our lives every day. We began to research and investigate the story behind each artwork we admired. It was a never-ending pursuit of discovery. This education was fun! It was exhilarating!

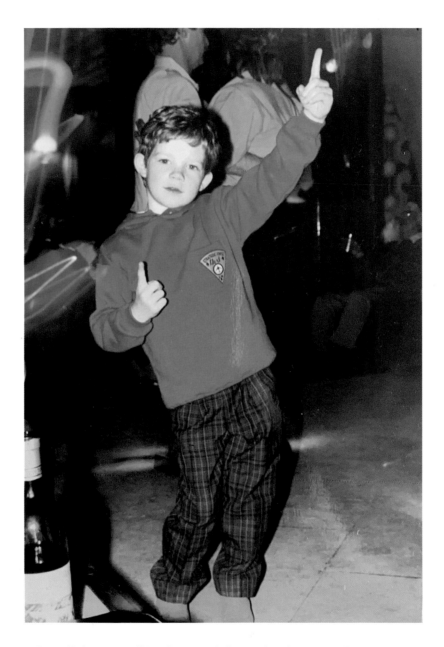

Russell showing off his dancing skills at a family party in Essex, 1988.

RUSSELL

Art has always played a vital and positive role in my life. Way before acting arrived, I felt a strong pull to the visual world. Animation was my in. To make a list would be cruel, but my top three would be *The Ren & Stimpy Show*, *Beavis and Butt-Head* and *Who Framed Roger Rabbit*. These three creations are the basic make-up of my whole adult personality. The use of colour and gesture and the style of these animations had a trigger effect for me, allowing a formative understanding of balance, composition and personal taste. The writing carried me through, but the images satisfied me beyond mere entertainment. I wanted to own them. Production animation cels, individual sheets, drawn on by artists, framed and photographed, then laid out in a sequence to create a flick-book movement that we eventually see as the end film itself: these became my fascination. Within the 'old school' style of making animation, way before Pixar computer-animated work took over, each singular sheet of hand-painted acetate held a piece of my childhood.

Animation gave way to advertising art – the likes of Mel Ramos with his kitsch Chiquita banana girls, and Joe Camel of Camel cigarettes fame. But then came pop art, and specifically Roy Lichtenstein. Oh Roy, I remember the first time I saw your image *Whaam!* of the fighter jet, rockets blazing ahead, blowing up some enemy plane, as I sat on the floor in the 'Arts' section of WHSmith aged around eight. It changed me molecularly. I drew it over and over again, trying to understand and copy the the halftone, comic-book technique Lichtenstein was so famous for, his solid, black outlining and use of flat light, the speech bubbles I found so nostalgic and satisfying. Inspired by his comic/cartoon/fine-art crossover, I felt anything was possible. Then Warhol swung by, of course; James Rosenquist came and went; but David Hockney and Keith Haring stayed for life.

It wasn't until around about the age of 20 that I realized owning and collecting art was an option. I collected everything as a kid, literally everything, from rocks and minerals to stamps and phone cards – remember phone cards, with images printed all across the front of them? I had books of them, from all over the world! Old British coins, dating back to medieval times, King Charles I shillings and George III cartwheel pennies. Star Wars figures and children's TV show annuals. But art, actual art, came much later on. I think Freud looked into the fascination for why some humans collect and some don't, even going so far as to suggest that obsessive behaviour is related to starting potty training early as a toddler! There doesn't seem to be a clear-cut reason: I am a hoarder and need 'stuff' around me, while my brother, two years older, doesn't need 'stuff' to feature in his life. Different strokes for different folks.

I was 16 when contemporary art caught me and teased me into its magical web. It was 1997, I was at a performing arts college in Barking, Essex, and I discovered Damien Hirst. Artworks collected by Charles Saatchi were being exhibited at the Royal Academy of Arts in London. I went along by myself and was transfixed. Ron Mueck's *Dead Dad* in the middle of the floor, Marc Quinn's humming refrigerated *Blood Head*, Gavin Turk's bronze sleeping bag crumpled at the entrance, Tracey Emin's

Everyone I Have Ever Slept With 1963–1995 appliqué tent (forever lost in the Momart storage fire some years later), Jake and Dinos Chapman, Marcus Harvey, Sarah Lucas, Damien Hirst's *Away from the Flock Divided*. I was officially obsessed.

I still didn't know that I could own and live with anything by any of these artists. I wanted to, but I had zero idea how. Cut to age 20, I was at a friend of a friend's house, and hanging on the wall was an edition of *Dog Brains* by Tracey Emin. My heart raced. I couldn't believe it, it was so perfect, so me. It didn't make sense that it was just there, hanging on a wall. I asked my friend where it was from and he couldn't help me: it wasn't his, it wasn't his friend's, it was his friend's flatmate's. That was far too complex a chain to follow, but I thought about the artwork often: how did it end up on that guy's wall in that random flat? And how envious I felt that, whoever they were, they could see it every day, it was theirs. Then, as if through astral manifestation, I met Tracey Emin, on her street in East London, sweeping up after the Queen's Golden Jubilee celebration. Now was my chance. I asked her how I could get it and she pointed me in the direction of Carl Freedman, founder of the world-respected fine-art print publishers Counter Editions. Eureka! I had cracked the code, and for my 21st birthday I instructed my parents that this work of art was to be my coming-of-age gift, please.

Gavin Turk, *NOMAD*, 2003, painted bronze, 42 × 169 × 105cm (16½ × 66½ × 41in). This artwork captured Russell's imagination as a teenager and sparked his ongoing interest in contemporary art.

The rest is history, or *The History Boys*. That was the play that took me to the South Bank Show awards. I was sat near Tracey and this time, plied with plenty of champagne, I was able to charm and make her laugh, spurring on a beautiful and special lifelong friendship. My paycheck from *The History Boys* movie went on an acquisition of an original Emin monoprint. I have lived with, cherished and collected her work since then. Her line is so unique, and her work is so very important to me, almost spiritual. She was the first artist I had ever come across who was both my hero and my friend. But it wasn't just me who felt like this. Little old Robert Diament, with the floppy hair and pop star lifestyle who sat next to me at an Emin retrospective party in Edinburgh in 2008, felt the same. And now here we are.

Talk Art isn't just a podcast: it's a testament to true friendship, and a product of finding someone else in the world who is just as much of a weirdo about something as you are. Enjoy this book: it's here to make you happy. Just like art has done for us. Art is for everyone, remember that, and don't be afraid to be weird.

Katherine Bernhardt,
Chapter 1, 2020,
acrylic on paper,
61 × 45.7cm (24 × 18in).

Performance Art

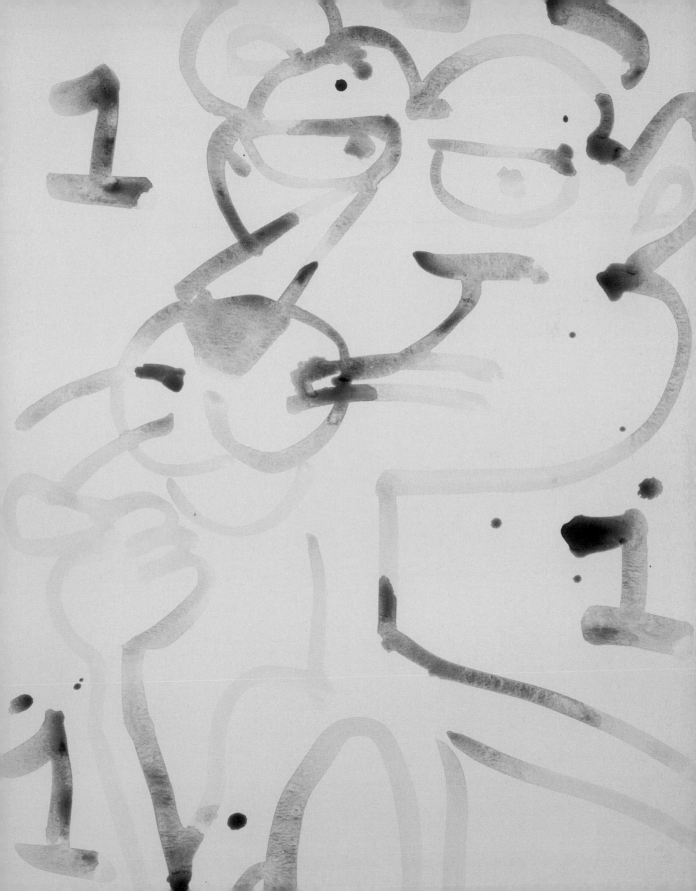

PERFORMANCE (ART) CAN CELEBRATE PHYSICALITY

AND LIFT THE HUMAN SPIRIT IN A UNIQUE WAY.

You had to be there, in that very moment. We all know that woeful feeling of missing out. Countless times we've had pangs of envy at friends in other cities, or even just the other side of the same city, who got the chance to see an art performance, a concert, a talk or a theatre show that we stupidly weren't quick enough to get a ticket for. In fact, in recent years, the audience for cultural events has seemed to be increasing exponentially, with tickets selling out faster than ever before. Museums and galleries have made live events a priority to engage as wide a public as possible. Performance art has been a vital part of this, with not only its aura of inclusivity and interactivity, but also an air of mystery that heightens audience curiosity. At its very core it is a coming together head-to-head with the present moment, frequently engendering an active collaboration. One major plus point is that you usually won't need a ticket to witness and participate. However, performance art often lacks financial support and can be difficult to collect – so much so that A Performance Affair launched in 2018, a small art fair with thirty exhibitors in Brussels, dedicated solely to promoting and educating collectors about performance art. In recent years, private art collectors and philanthropists have increasingly been encouraged to collect and archive performance artworks, including scripts as well as associated physical objects and documentation, thanks to clearer protocols from artists.

Some of our most memorable highlights are performances that we weren't prepared for, or even expecting. Performances that sneak up on you unawares, such as Martin Creed's *Work No. 850* at Tate Britain, a very simple idea whereby a person ran as fast as they could through the gallery every 30 seconds. Every run was directly followed by an identical pause, a silent break, that the artist viewed as a 'musical rest' or 'frame' that allowed the viewer to 'see the running.' The regular repetition of the action is vital, with each runner instructed to 'sprint as if their lives depended on it.' The work engaged Londoners from contrasting backgrounds and for four months celebrated the human body and the beauty of a very simple, direct movement.

It speaks volumes of the impact such work can have on an audience that major institutions around the world now have curatorial departments and faculties dedicated to nurturing and encouraging performance artists and facilitating the creation of new live art. In the United States, art historian and curator RoseLee Goldberg founded Performa in 2004, focusing on education, archiving historical and recent performance, commissioning new works, and most visibly presenting a three-week international Performance Biennial. In the UK, festivals such as Art Night have commissioned performances from artists as varied as Isabel Lewis, Jeremy Deller, Philomène Pirecki, Tamara Henderson, Marinella Senatore, Alberta Whittle and Zadie Xa.

talk ART

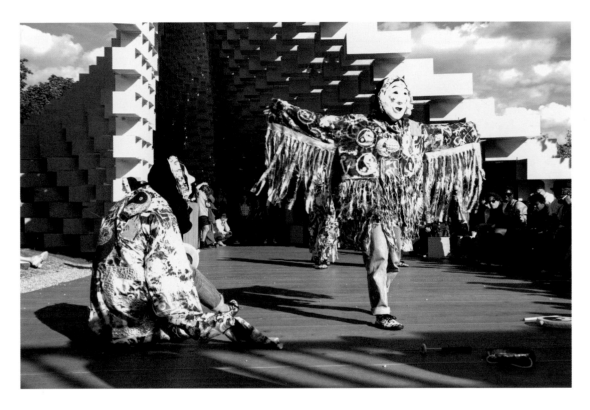

Zadie Xa, *Linguistic Legacies and Lunar Exploration*, 13 August 2016, Saturdays Live, Serpentine Gallery, London. Referencing traditional Korean mask drama and incorporating music, dance and ritualistic narratives, this was a memorable performance to witness.

Korean-Canadian artist Zadie Xa's live works bring together dancers as well as painted and sculptural elements. One memorable performance, *Linguistic Legacies and Lunar Exploration* (see page 27), was staged outdoors in the grounds of the Serpentine Gallery, London. Inspired by *talchum*, a Korean Mask Dance, the work revealed central themes of ritual, magic and the bonds of friendship through abstracted storytelling. In addition, Zadie creates layered textile works which she not only hangs in gallery exhibitions but also brings to life both by wearing them herself and by draping them on her performers. Through these capes and textile works the artist analyses the construction of contemporary identity, in particular in relation to her personal experiences of growing up in Canada within the Asian diaspora. The highly detailed, hand-sewn fabric works are wearable garments with eye-catching imagery, with references to hip-hop music, fashion design, the internet and art history. She explains, 'I basically started thinking about painting as something that could be dispersed through three-dimensional space, and the Serpentine was the first possibility for me to do that. So the grounds of the Serpentine then became a canvas from which I would be able to work, and a composition that kind of moved throughout real space.' With her textile work, she wanted to explore clothing and body painting, 'but in a way that was different than, let's say, traditional images of paint on the flesh, because I'm not into flesh the way some artists or painters are really interested in that idea of flesh or paint ... I'm just really interested in the way people move throughout space and present themselves to their friends or the outside world depending on what they wear.' Zadie's capes link to ideas of supernatural power and shapeshifting, 'so when a super-hero for example or magician wears a cape, this cape is a symbol of power; something that they're able to grow into as soon as that thing goes on top of their body ... Being able to transform.'

The Hayward Gallery's *Art of Change* exhibition in 2012 spotlighted Chinese performance artists such as Yingmei Duan and Xu Zhen, and the gallery has continued since with numerous one-off performances by British artists including Tai Shani and Florence Peake. Tate, too, has featured artists Anthea Hamilton, Sylvia Palacios Whitman, Cally Spooner, Tino Sehgal, Joan Jonas, Mark Leckey and Pablo Bronstein, to name but a few. In 2014, the Serpentine handed its gallery keys over to Marina Abramović to take over the entire space for her performance *512 Hours*, which demonstrated complete trust and respect for the medium that has helped shape and positively impact the British public's perception. Performed for eight hours a day, six days a week, this piece attracted almost 130,000 visitors. Abramović's performance consisted of her own body, the bodies of her performers, the audience and a small number of carefully selected props. Before entering the Serpentine, guests were asked to put their belongings into lockers, so that upon entering the gallery space they became, as the gallery put it, 'the performing body, participating in the delivery of an unprecedented moment in the history of performance art.

talk ART

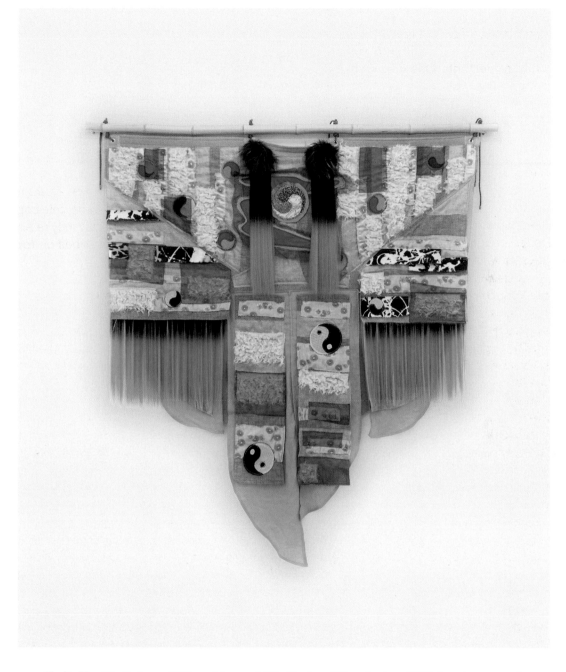

Zadie Xa, *Bio Enhanced/Hiero Advanced: The Genius of Gene Jupiter*, 2018, hand-sewn and machine-stitched assorted fabrics and synthetic hair on bamboo, 166 × 170cm (65⅜ × 70in). Informed by her years of painting, Zadie Xa's capes are bold textile works connected to her performances, and form part of ambitious multi-media installations.

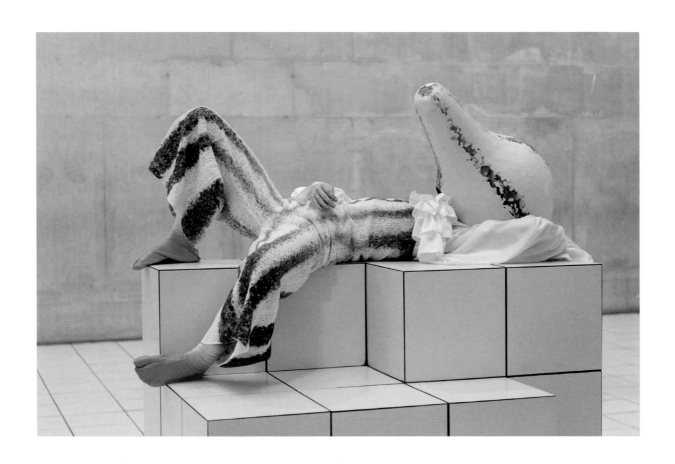

Anthea Hamilton, *The Squash*, 2018, installation view: The Duveen Galleries, Tate Britain, London. This is one of our all-time favourite art performances. With extraordinary costumes and choreography, it offered a contemporary perspective on participatory art and improvisational theatre.

We like the intrigue,
the open invitation, the
<u>possibility</u> that at any
moment something life-
changing could happen.

Performance is not a kooky artsy aside. It deserves respect and, when given a meaningful larger platform – such as Anne Imhof's *Faust* in the German pavilion at the 2017 Venice Biennale and her subsequent *Sex* in 2019 in Tate Modern's Tanks – it can celebrate physicality and lift the human spirit in a particular and unique way. Eddie Peake's works include a nude five-a-side football match staged while he was studying at the Royal Academy of Arts and *The Forever Loop* installation for the Barbican. The latter was an ambitious live, choreographed piece that combined sculptural objects (such as purple Perspex bears) with videos of past performances and childhood home movies. All were housed within a theatrical maze-like set with a 90-m (295-ft) fluorescent pink wall painting, a scaffold walkway and a bold, chequerboard dancefloor that was used to dramatic effect by dancers on roller skates.

These artists metaphorically reach out their arms to embrace the viewer and are increasingly able to get inside our hearts and minds. As there is a sense of immediate action and elevated excitement, performance art can overcome apathetic barriers and the lazy cliché that such work is simply to be written off as 'weird'. Perhaps it's fear of something new, or the fear of having to be present and involved that can be so off-putting. We, however, like the intrigue, the open invitation, the possibility that at any moment something life-changing could happen! Experiencing a performance live in front of you might not only be mind-altering, shaping you for the better, but somehow witnessing that performance might also provoke you to face unspoken parts of your psyche so that, between the time you enter and leave the room, your world view is transformed.

Equally fascinating are relics of performances. The holy, charged status of props, costumes and further documentation: Polaroids, photographs, grainy videos, old newspaper articles, *Artforum* critic reviews or artists' hand-written instructions. The rumours, myths and chitter-chatter that live on long after a work was initiated. There's a freedom to the genre, and the ability to use it to protest and make social commentary. There is potential for it to be affordable to carry out, but still to have great impact. An artist can start small, with what's immediately available to them, whether that be their body, the viewers' bodies, or everyday, easily accessible materials. Performance art can be convincing and can capture people's imaginations via the simplest of means.

A dramatic proponent of the art form is Kembra Pfahler, best known for her radical performances which run alongside both her film-making and her music-making as lead singer in glam shock-rock band The Voluptuous Horror of Karen Black. Kembra coined the term 'availabism', which has evolved over the past 40 years into a bona fide performance art movement. In 1983, she slept in an East Village storefront window at the ABC No Rio arts venue as part of *The Extremist Show*. This durational (i.e. taking place over a longer period of time) performance perfectly embodied her philosophy, encompassing intertwined themes of intimacy, privacy, vulnerability, stillness and listening. Over the decades, Kembra's chosen materials have consistently included her nude body adorned with colourful body paint; even her teeth are covered in paint. 'Did you ever see classical Chinese opera?' she asks. 'Colours have an actual significance in Chinese opera, like reds can indicate love, or blues can indicate sorrow or the sky. So colour therapy for me … I don't like primary colours on my body, I think it looks too comical, so I like cooler tones. And having this colour on my body is the only time I really love to be surrounded by colour. In my home, I don't have anything on the walls or any colour around me at all. I think I do what I feel like doing; that's it, really. So it's really just about feeling. I think that it's the same way that you probably choose paintings, or how you would get dressed in the daytime. It's something you listen to … it's an instinct.'

Kembra's on-stage persona is extreme, at times manic, shattering female tropes and archetypes. As well as body paint, she wears giant 'fright wigs', and wields props such as wooden crucifixes, a giant mirrorball penis sculpture, eggs that are cracked on her vulva mid-performance, and bowling balls attached to her feet. Her transgressive performances, inspired in part by Viennese actionism, push boundaries of what is deemed acceptable, most notably the sewing closed of her vagina for *Sewing Circle* in 1992, provoking ongoing fascination, outrage and even revulsion in a way similar to that of Valie Export's 1960s feminist legacy.

DEFINITION → AVAILABISM

The guiding principle of this movement is to use whatever is at hand at any given moment to devise and inform a performance artwork. It challenges the idea that big budgets are needed to create something of worth or impact, favouring instead low-tech, handmade, though sometimes still elaborate, costumes, props and sets. The concept is an exercise in artistic freedom, signifying an unshackling from societal pressure and expectation, and promoting the revelation of ineffable, intimate aspects of a performer's self.

DEFINITION → ACTIONISM

The term actionism is closely associated with a group of artists based in Vienna in the 1960s who worked independently to push performance art to a more extreme, knowingly provocative and at times even violent place. Key artists included Hermann Nitsch, Otto Muehl and Günter Brus, whose work centred around self-inflicted torture, blood, ritual and the body. The radical artistic energy within Vienna at the time went on to inspire Valie Export, who approached actionism with a new feminist perspective. Her work has made a lasting impact on the international stage.

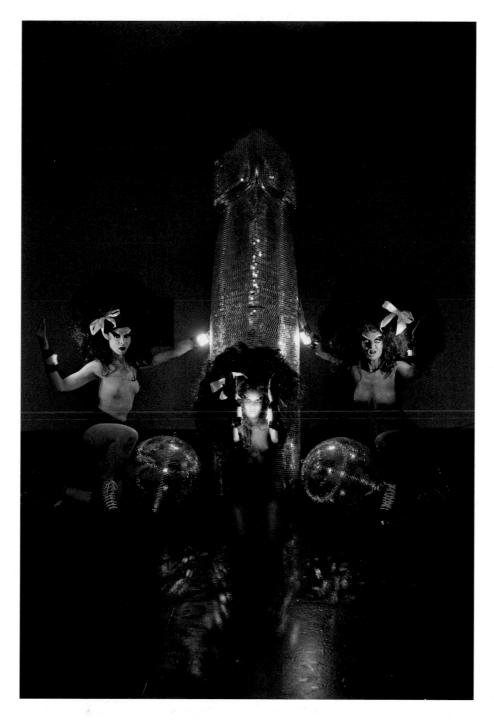

Kembra Pfahler, *Kembra Pfahler and The Girls of Karen Black (TVHOKB)*, 31 May 2019, performance view: *Rebel Without a Cock*, Emalin, London. We are so inspired by Kembra's fearlessness and bold approach to art making, and are surprised and enthralled by her every move.

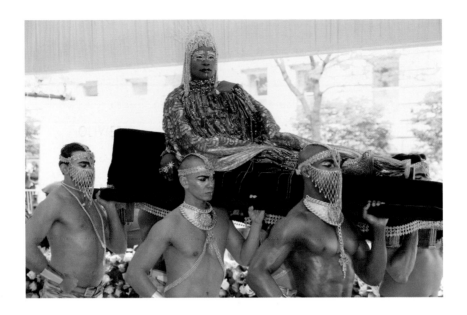

Billy Porter arriving at the Costume Institute Benefit celebrating the opening of *Camp: Notes on Fashion*, The Metropolitan Museum of Art, New York, 2019. Billy is a pioneer who has brought passion, creativity and performance art to a mainstream international audience.

Tai Shani's performances have also captured our imagination and garnered international acclaim, including joint winning the prestigious Turner Prize in 2019. The starting points for Tai's expansive installations and performances are often experimental texts. Themes of history, feminist science fiction, the retelling of lost tales and dark fantasy run throughout, with the ever-present potential of a utopia. There is a theatricality to her epic stagings: protagonists deliver monologues via video screens, while sets are saturated with rich colours and structured to be inhabited and activated by performers

Overleaf:
Tai Shani, *DC: Semiramis*, 2018, installation view: Glasgow International. Tai's captivating performances combine detailed sets, costumes, props, music and film to bring urgent feminist narratives to the fore.

coming together in a tableau vivant. Playing out over several hours – her Turner Prize work's duration was seven hours from start to finish – the ideas behind the work are similarly long-range and are conveyed by a wide array of media, from a radio play to elaborate handmade costumes, props, sculptures, and printed posters and texts. The work *Dark Continent* has grown over five years, with Tai adapting the 1405 *The Book of the City of Ladies* by the proto-feminist Christine de Pizan and updating it for the 21st century – forming a new space outside of gender norms and the patriarchy, an inclusive world for *all* women. Tai specifically employs the spelling 'womxn' to describe this 'womxn's city' that welcomes non-binary and trans people. Tai's sculptural practice, too, has elements of performativity: videos displayed on screens – breathing life and humanity into the arena – link back to her performance work.

In an interview with Naomi Rea for Artnet, Tai candidly highlighted the pitfalls of underfunding for performance art. She explains that this sometimes results in performances occurring only during VIP days, thus limiting the audience to an art world elite: 'Ultimately what happens is that the fallout of that is on the artists, and not on a critique about how we finance these things.'

Nonetheless, throughout the 2000s, it feels as if we've been hearing about performance art more and more. It's as if performance artists have multiplied, or artists have become more interdisciplinary than ever before. In the mainstream media, pop stars such as Lady Gaga collaborate with performance art icons such as Marina Abramović. Gaga has also participated in work by Robert Wilson, which was exhibited at both the Louvre museum and Wilson's own renowned 'performance laboratory' at the Watermill Center in Long Island, the United States. During Gaga's promotional world tour for her album *ARTPOP*, even the mundane process of leaving her hotel became a staging, a runway event of sorts, embodying art. Another leading cultural figure, Rose McGowan, took an artistic approach to her debut album *Planet 9*, participating in live and filmed performances alongside the Venice Biennale and Edinburgh Fringe Festival. Actor and singer Billy Porter brought elements of performance art to the red carpet, and in doing so became a household name. Contemporary dance has also crossed over with visual arts, including performances by the Michael Clark Company and more recently choreographer Holly Blakey, whose groundbreaking practice combines dance and movement with art and fashion and a gender-fluid, diverse group of dancers.

Performance art can capture the

imagination via the simplest of means.

So how the hell has performance art gone so mainstream, and is it really performance art? If not, what *is* performance art? Does it have to be contained within an art world context, or can walking through a hotel lobby and down the main staircase be classified as art? Sure, many of the above were headline attention-grabbers, but all authentically project their protagonists' strength and true selves through performance. If such endeavours don't fall into the critically approved notion of art, then perhaps art has given artists in other fields license to experiment and be braver, stripping themselves back to their very essence. In this digital age, maybe we are yearning more than ever for human interaction, for touch. To truly FEEL something. Performance art brings us closer to a shared real-world experience.

Check out these artists too:
Laurie Anderson • Janine Antoni • Franko B • Monster Chetwynd • Ana Mendieta • Senga Nengudi • Yoko Ono • Adrian Piper • Carolee Schneemann • Tori Wrånes

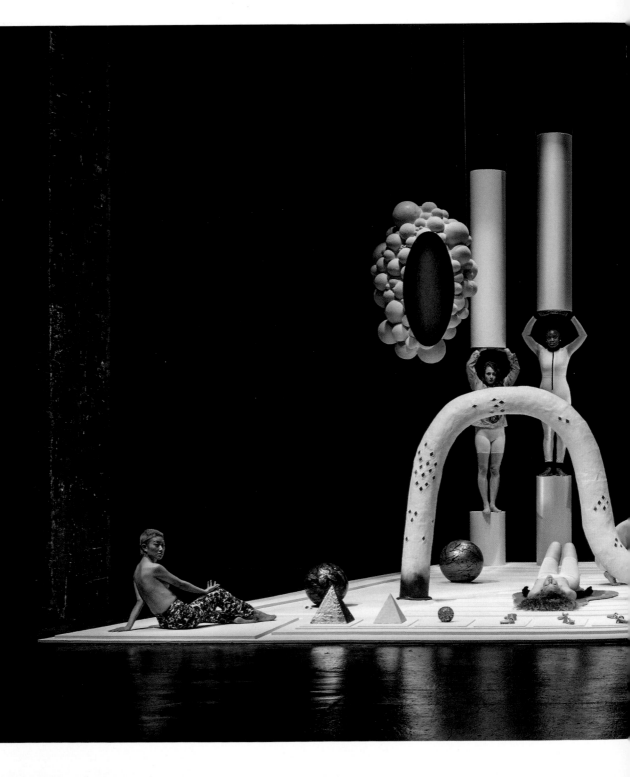

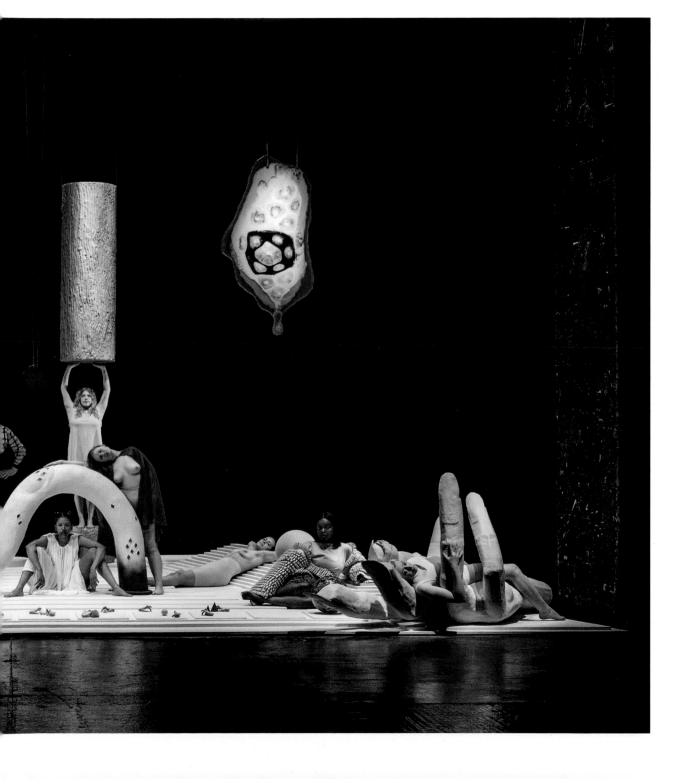

Public

Art

Yinka Ilori, *The Sun Will Continue to Shine on Us*, 2020, illustration, 50 × 50cm (19¾ × 19¾in).

Barbara Hepworth, *Winged Figure*, 1961–2, aluminium with stainless steel rods, height 5.8m (19ft 3in). First installed in April 1963, this has become one of Hepworth's best-loved works and without doubt one of London's most elegant public sculptures.

If you go to any town or city around the world and look about, you'll be sure to see public art, whether it be a large bronze sculpture on a high plinth, an artist-designed seating area or bus stop, or fly-posted imagery on disused shop awnings. Even the Christian cross, with Jesus looking down at us forlornly, could be considered by many as public art. It is all around us.

Take London: wander down Oxford Street and, on passing the John Lewis department store, you would probably notice a curious, winged, sculptural figure protruding from the side of the shop above street level. Both ominous and balletic, the steel structure has for years intrigued and perplexed passers-by. The piece is by one of Britain's greatest post-war artists, the sculptor Barbara Hepworth. Straightforwardly titled *Winged Figure*, the work is, according to the Hepworth Wakefield gallery, seen by an estimated 200 million-plus people every year. That is the potential power that public art has: to be seen by many. Most public art, it seems, is either there for art's sake as something beautiful, making an area more desirable, or for political statements, in memoriam celebrations or demonstrations of national or local respect for a remarkable figure – something which, in recent times, has become a subject of intense public debate.

Why was it important for Barbara Hepworth to create this work specifically, and to have it hang over the main shopping district of a capital city over 50 years ago? Who commissioned it? Why are we surrounded by so many public artworks that they can often go unnoticed? So much public art is taken for granted, seen only peripherally, and mysterious as to its maker and its whys and wherefores. What are the reasons for these works to be there, and ultimately why should we care?

Public art is as old as human history. The ancient Romans adorned their temples with the sculpted semi-clothed athletic bodies of demigods. The pharaohs of Egypt enslaved thousands in order to construct mindblowing architectural feats, dragged and hewn from sandstone, awe-inspiring in scale and achievement, becoming 'wonders of the world'. Michelangelo's marble statue of David (of Goliath fame) stood proudly naked near the city centre of Florence, so perfect, so aspirational. All were created to peacock the limitless heights of human ability. But why do we need man-made works of art around us? Why should we want to have these sculpted artworks, uninvited and thrust into our eye-sight daily? Because public art invigorates public spaces and, crucially, it mirrors us – who we are, what sort of a society we live in, and what values we think are worth commemorating. In offering a reflection of ourselves, public art can harness an ability to understand what we are, what we were, and where we think we are going. Public artworks are objects that offer us a past, present and future. And the great thing about public art is that it's completely free. Free for all and a gift of culture, without hierarchy, not hidden behind gallery walls, out in the open for anyone and everyone to enjoy.

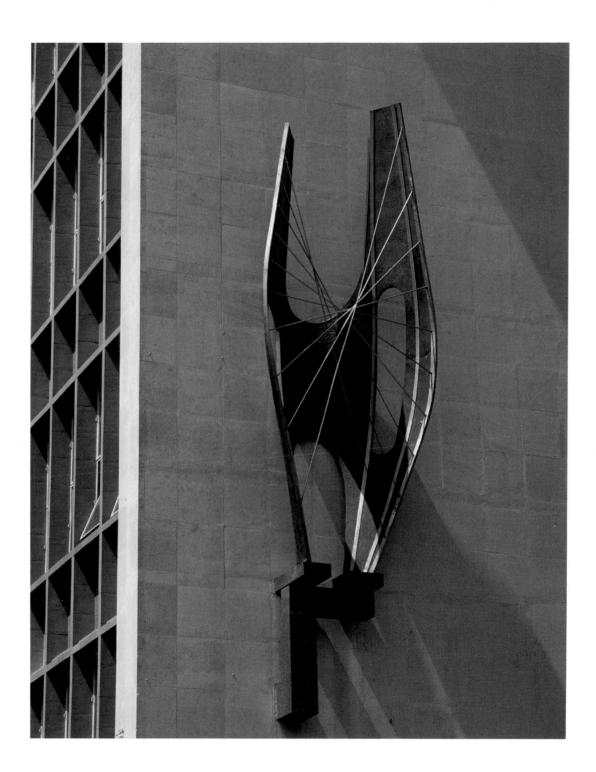

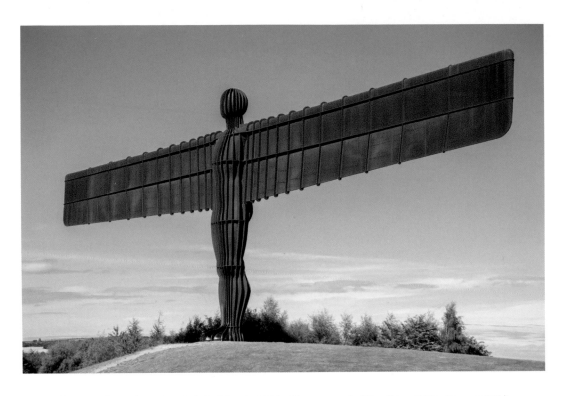

Antony Gormley, *Angel of the North*, 1998, Corten steel, 20 × 54m (65ft 6in × 177ft).
This giant steel structure, derived from a cast of the artist's own body,
is Britain's largest public sculpture.

If you asked people in the UK today to name one contemporary public sculpture that has shaped a community as well as a whole region, you'd probably be met with the same response: *Angel of the North* by Antony Gormley. Interestingly enough, it's another angel (if indeed that's what Barbara Hepworth's figure is). Maybe there's a real need for these virtuous astral beings – neither male nor female – to literally 'hang around' us, harking back to the Creation, heavens, purity and godliness maybe? A giant of steel, completed in 1998 with the help of National Lottery funding, *Angel of the North* today represents one of the greatest achievements in contemporary sculpture. It has redefined an area of the North of England and cemented the artist as a national treasure.

Antony Gormley has gone on to create multiple public artworks up and down the country, communing with millions and making superb art pilgrimages. At Crosby Beach, north of Liverpool, a hundred iron figures positioned all along the beach changed the town almost overnight into a cultural destination. Looking out to sea in Margate, a lonesome figure entitled *Another Time* is positioned underneath the Turner Contemporary gallery, also on the seafront. A few years ago, the sculpture was nearly decapitated by a reversing ferry, but it has still become a hotspot for locals and visitors alike. Public art can transform a town, bringing interest and excitement with it.

Gormley has also positioned artworks all over London, whether in permanent or fleeting

positions. One such work of permanence – considered an official public artwork when it is, in fact, privately owned – is visible during both low and high tide on the River Thames by Limehouse. It is owned by the actor and art collector Sir Ian McKellen, though he says, 'I'm just sort of its guardian.' Gormley gives very detailed instructions on how to display his work: 'he was very precise with what he wanted, the height that he wanted, looking out to sea, which is looking east from here'. He is also understandably particular about maintenance: 'He came to clean it one day in a little rowing boat, and stood up in the rocking boat, photographed by my neighbour throughout, who was hoping he might fall in! With a [wire] brush, he washed away all the birds' grime … I was told I wasn't allowed to touch it; that's not the deal. If something is in a public space like this, the fact that I own it … doesn't mean that I have any control over what happens to it.'

But public artwork doesn't always get bought privately or get commissioned by a borough council. Just look at the surprise offerings brought to us by one of the world's most famous street artists, Banksy. His works – essentially the product of an illegal act;

defacing public property with graffiti – go on to encourage the public to think in a way that is totally of the moment, instantly capturing the political zeitgeist, within a few spray-stencilled characters. These free artworks, when protected by a covering as so many of them now are, have been preserved to continue their simple, direct messaging. Banksy is notably well known for his anonymity. 'He is pathologically absent from public life,' we gleaned from his friend, artist David Shrigley, but that doesn't hinder his work from attracting attention and inspiring change by spotlighting numerous social and political issues. Maybe his cryptic mystery shines an even brighter spotlight onto his work.

Graffiti artist Nathan Bowen has also been invading empty walls and building site hoardings internationally for many years, with his 'Demons' series. Forming part of an art movement Nathan calls the 'Afterlives', these characters are dressed as builders, soldiers, beefeaters and businessmen. They all carry messages of hope and proudly sport the Union Jack, bringing to life dull and lifeless spaces, and filling them with inspiring art and positive messaging. Turn to page 213 for an image of one of Nathan's pieces.

WHY DO WE <u>NEED</u> WORKS OF ART AROUND US?

In today's Instagram culture, where an image can be reposted multiple times in the space of a second, Brian Donnelly, aka KAWS, has become a global phenomenon. Hashtag his name and there are over 1.3 million images to view. His Instagram page has a 3-million-strong army of followers. KAWS's first public 'offering' consisted of large graffiti graphic works high up on buildings, inside tunnels and alongside bridges. These were created first for his own entertainment as a kid. 'There's a piece on a building, when you come out of the Holland Tunnel [connecting Jersey City to New York City], that I did in maybe '91/92 and it's just a roller, a house-paint roller ... Sitting in my chair in class, I could see the building, so it was just completely, you know, for myself.' KAWS now boasts public artwork permanence all across the globe, entertaining the world on a daily basis in countries as far flung as Australia, China, Qatar and right across the United States, making him a superstar for the tech-savvy, millennial generation.

One of KAWS's shining moments was at the Yorkshire Sculpture Park, his first major UK solo show, in 2016. The historic landscape became home to six huge sculptures of key characters from KAWS's idiosyncratic, instantly recognizable oeuvre. His open-air figures include the now iconic *SMALL LIE*, made entirely out of natural afromosia wood. Towering above us, it depicts one of his characters with a Pinnochio-inspired long nose, with its head bowed. It's a story all

of us can relate to and will have experienced growing up. Therein lies the key to the way KAWS is able to connect to his audience. His sculptures have a purity and directness, but carried out with a dynamism resulting in contemporary heroic figures that know no geographic boundary – his works are relatable to people who speak different languages and are based in vastly different locations. His work can communicate through his unique visual language, one that is full of historical symbols. We admire his work for its lack of cynicism, and the hope and joy it offers. We also appreciate his sense of mischievous fun – especially when you consider the vast technical obstacles KAWS and his team have to overcome to present, for example, his giant 'HOLIDAY' series of works in an ambitious outdoor venue such as Hong Kong's Victoria Harbour, or his enormous 11-storey sculpture in Taipei. KAWS told us about the extraordinary planning required for the former: 'in Hong Kong, we had to get permits just for the different sections of water that the piece passed through, because it's all different territories and different people controlled it so, you know, the government is involved ... You're seeing this inflatable piece, but under it was a 40-ton steel structure with all the mechanics because it's constantly being inflated, and so to move, like, a 30-metre steel through Hong Kong, it's a lot! The logistics are crazy.'

KAWS, *HOLIDAY (HONG KONG)*,
2019, balloon, 37m (121ft).
This ambitious installation captured
the imaginations of art fans around
the world thanks to its message of
relaxation and playful use of scale.

talk ART

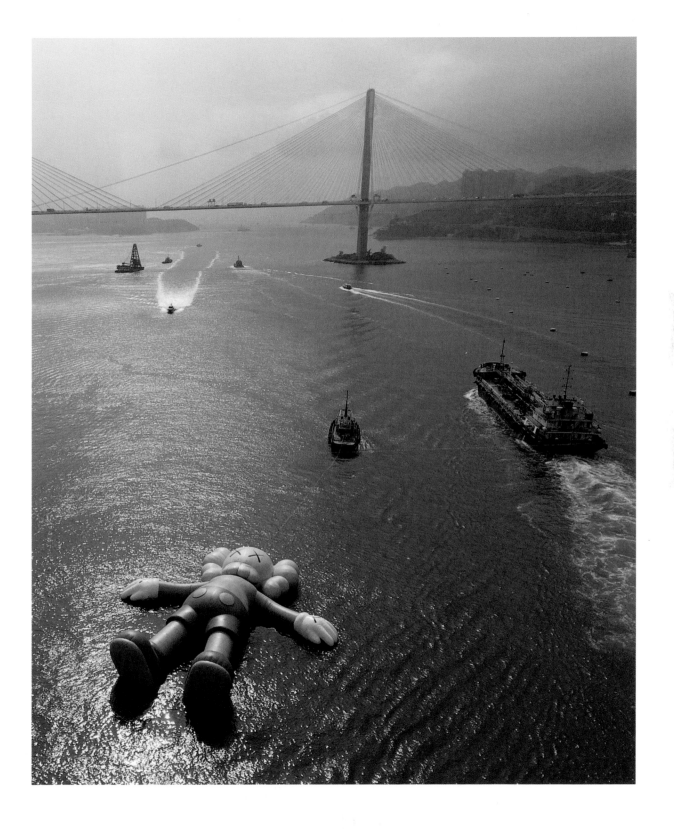

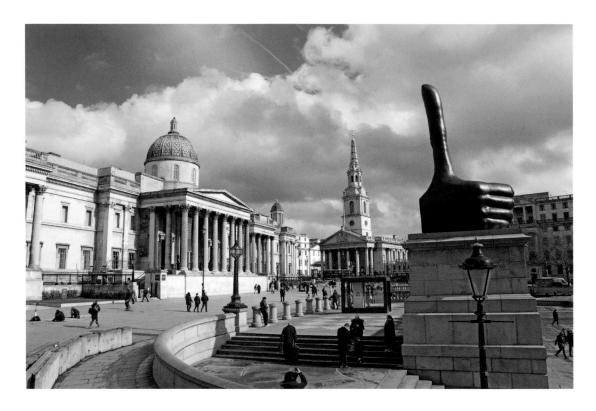

David Shrigley, *Really Good*, 2016, bronze, height 7m (23ft), The Fourth Plinth, Trafalgar Square, London.
The British artist David Shrigley aimed to bring positive energy to the city of London
with this giant thumbs up.

One artist who may be said to define the public art period in post-war Britain – an artist whose work has travelled internationally – is Henry Moore. Moore's works – vast, smooth, semi-abstract, monumental, shiny bronzes – stand stoically, in prominent urban centres from Canada, the Netherlands and Portugal to South Africa and Denmark, and all across the UK. The world's largest collection of Moore's work is open to the public, with permanent displays in both the house and grounds of the estate that was Moore's home in Perry Green, Hertfordshire. In addition, the Henry Moore Institute is an international research centre located in the vibrant city of Leeds, where Moore began his training as a sculptor. In an iconic building, the institute hosts a year-round changing programme of historical, modern and contemporary exhibitions. It promotes and nurtures the creation of new works, as part of its mission to bring people together to think about why sculpture matters.

Moore defined a moment in time when public art was given deserved social value. He was praised for sparking a sculptural renaissance, giving permission to later generations and setting the standard for the likes of KAWS to claim their own territory with large-scale public artworks. These works make people want to live near them, work around them, and travel to visit them.

talk ART

One of the most coveted and exciting spots for a contemporary artist to make a splash today is the 'Fourth Plinth' in Trafalgar Square. The original intention was for the plinth to hold an equestrian statue of King William IV, but because of a lack of funds it remained empty. In 1999 a commissions programme was started, later helmed by the Mayor of London and the London Culture Team, to give space to artists to interpret the plinth as they saw fit. David Shrigley chose his 2016 opportunity to create a piece that would reflect the mood of the moment: a giant, dark bronze hand, with the thumb extending beyond natural proportions. David's work plays with that very British love of sarcasm and comic absurdism. *Really Good* came at a time when the public mood was low in post-Brexit London, and David riffed on this with a satirical twist of positivity. Antony Gormley was also given the honour of filling the plinth in 2009, but he chose to use his platform to offer space for performers of all kinds to adapt the plinth as they saw fit. *One & Other* became a live public artwork, every hour, 24 hours a day, for one hundred days. Over the course of the artwork's existence, therefore, 2,400 people participated, whether demonstrating, acting, dancing, singing or simply using their time to reflect. Gormley's idea cemented the 'Fourth Plinth' into the public psyche, making it a household expression.

In New York, a disused freight rail line has become one of its biggest tourist attractions. Saved from demolition in 2009, it now makes a beautiful walkway above street level, filled with plants, trees and temporary contemporary artworks. Thousands of people use the High Line daily and experience its hybrid public space of nature, art and design. In London, The Line is the city's first dedicated art walk. It was opened in 2015 and follows the Greenwich Meridian between the Queen Elizabeth Olympic

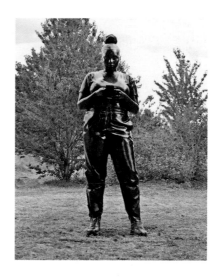

Thomas J Price, *Reaching Out*, 2020, bronze, 2.7m (9ft), The Line, London. This very modern portrait of a woman emphasizes complex ideas of loneliness while being connected. We particularly love its installation in close proximity to nature and trees.

Park and The O2. The walk was designed to encourage locals and visitors to engage with contemporary art while also exploring a lesser-known part of the city. Like the High Line in New York, The Line London is free for all to discover and has a revolving curated cross-section of artist commissions.

British sculptor Thomas J. Price is just one of many artists – including Larry Achiampong, Anish Kapoor and Alex Chinneck – who has created pieces for the Line. Thomas's work plays with scale and material and almost exclusively deals with the Black figure and Black representation. *Reaching Out* is one of very few public sculptures depicting a Black woman, and at 2.7m- (9ft-) tall, her presence is striking. This, combined with the ordinary act of checking a mobile phone, allows us to connect to her universality.

Denzil Forrester, *Brixton Blue*, 2018, installation view: Brixton Underground Station, London, 2019. Commissioned by Art on the Underground, this mural references Denzil Forrester's iconic painting *Three Wicked Men*, which commemorates the story of Winston Rose, a friend of the artist who died while under police restraint in 1981.

One amazing and simple way for art to reflect on a location's rich heritage and history is through the creation of murals. The British artist Denzil Forrester – best known for his vivid, colourful depictions of the London reggae club scene of the 1980s – was given the commission for an artwork to be seen at the entrance to London's Brixton tube station. 'London Underground contacted me,' Denzil recalls. 'I was avoiding them for quite a while, because I always paint what I like to paint; I don't paint for commission.' However, he was convinced by friend and art royalty, Matthew Higgs (director

of White Columns, a non-profit artist space in New York City, which had shown a career-changing exhibition of Denzil's a year before). Denzil's mural, titled 'Brixton Blue', captures the kinetic energy of the local nightlife, with a sense of music, lights and angled posturing figures filling the scene, but at its core lies a stronger message. The work was originally conceived by Denzil in 1981, at a time when racial tensions were rife in London and after the death of one of his childhood friends, Winston Rose, as a result of police brutality. Denzil felt a shift in his work, frantically searching for an understanding.

talk ART

From this exploration he uncovered three characters – the 'Three Wicked Men' of Britain: a policeman, a politician and a businessman – who went on to appear frequently in his work, although, as in the Brixton mural, not all three 'Wicked Men' are always present.

Brixton has a long history as one of the centres of Britain's multicultural society. The majority of the so-called 'Windrush generation' were housed there (named after the passenger ship *Empire Windrush*, which sailed from Jamaica and docked in Essex in 1948, launching a post-war immigration boom). The location of Denzil's mural is a rolling commission, meaning that the artwork changes every six months (although Denzil's mural was given a full year). Established by 'Art on the Underground' to celebrate Blackness, and created especially for artists of colour, the artwork space is there to represent the diverse narratives of London. Previous artists to have been given the opportunity to make a work for Brixton tube station were Njideka Akunyili Crosby in 2018 and Aliza Nisenbaum in 2019.

Making a temporary work has its pros and cons, the main con, of course, being that once the work has been placed it then has to be taken down again. Martin Creed, the eccentric 2001 Turner Prize-winning Scottish artist, has made several moving public sculptures, but one that has been completely embedded into art history is a work he created for New York, titled *Work No. 2630, UNDERSTANDING*. Using mammoth proportions, just like Antony Gormley with his *Angel of the North*, Martin made a sculpture out of steel and neon, over 15-m (50-ft) long, and with letters over 3-m (10-ft) high, spelling out the word 'UNDERSTANDING'. The sculpture spun through 360 degrees, at varying speeds, continuously for nearly six months. 'It's got to be literal and not too subtle,' says Martin. Located at Brooklyn Heights and visible all along the Hudson River, *UNDERSTANDING* was witnessed both day and night. 'That's why I got into neon – because I wanted stuff to be seen at night.' He came to this outdoors piece through discovery. 'I did a lot of these new works with words, and I first got into that because of doing a public work that was outdoors.' Rising to the challenge of his new outdoor arena, he thought to himself, 'What if it's as big as possible, with words? Really big.' In addition, in politically tumultuous times, he thought: 'If I'm doing something in New York like that, it's got – in the world now – to be some sort of peace monument or something, you know?'

ARTIST SPOTLIGHT

Yinka Ilori

Happy Street, 2019, 56 patterned enamel panels, Thessaly Road, London.

talk ART

Yinka Ilori and Pricegore, *The Colour Palace*, 2019, Dulwich Picture Gallery, London.
Below: As long as we have each other we'll be okay, 2020, archival digital print, 30 × 110cm (11¾ × 43in).

Creating public art can change the whole mood of an area. In 2019, artist Yinka Ilori transformed and completely revived a dark and dingy underpass in Battersea, South London. Collaborating with the local community and council, Yinka designed a permanent installation into and across the Thessaly bridge and underpass called *Happy Street*. Using 56 patterned enamel panels which he then decorated with 16 different colours, Ilori made a space that people look forward to walking through and local children and residents feel proud and happy to live near, while also increasing a sense of safety in their area. That same year, Yinka collaborated with the architecture practice Pricegore on an installation for the second Dulwich Pavilion at the Dulwich Picture Gallery in London. Full of colour, pattern and light, it celebrated London as a multicultural centre.

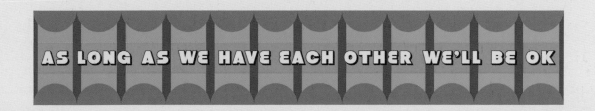

In 2020, the purpose of monuments has become more debated and contested than ever before. The taking down of numerous public statues during the Black Lives Matter protests was aimed at addressing an urgent need to redress the imbalance of the historical figures that are memorialized in streets around the world. There have been contrasting opinions regarding the best way forward. Should monuments be taken down and destroyed to correct the wrongs of history? Should they be put in museums and given historical context? Or should we keep them up as a reminder of past wrongs, and add to them with new, more relevant monuments to create a fresh dialogue? The contentious topic of public monuments has been presciently addressed in the past few years by a number of contemporary artists, most notably Kehinde Wiley, Gillian Wearing and Kara Walker.

Kehinde Wiley presented his first monumental public sculpture in October 2019, an eight-ton bronze equestrian statue titled *Rumors of War*, in New York's tourist shopping hub Times Square. Directly responding to

a monument in Richmond, Virginia, of the Confederate General James Ewell Brown Stuart poised atop a horse complete with a tense stare (one of many Confederate monuments in Richmond's Monument Avenue, and across the United States), Wiley's statue places a new figure atop the horse. The historical general is replaced by a young Black man wearing urban streetwear and Nike trainers. Wiley has stated: 'The inspiration for *Rumors of War i*s war – is an engagement with violence. Art and violence have for an eternity held a strong narrative grip with each other. *Rumors of War* attempts to use the language of equestrian portraiture to both embrace and subsume the fetishization of state violence. New York and Times Square in particular sit at the crossroads of human movement on a global scale. To have the *Rumors of War* sculpture presented in such a context lays bare the scope and scale of the project in its conceit to expose the beautiful and terrible potentiality of art to sculpt the language of domination.' Proof that context can be very powerful when it comes to art, Wiley's monument will live in perpetuity in the grounds of the Virginia Museum of Fine Arts, a short walk away from the Confederate statues that inspired it. This new sculpture, we hope, rides into a future of progress and equality.

The purpose of
monuments has
become more debated
and contested than
ever before

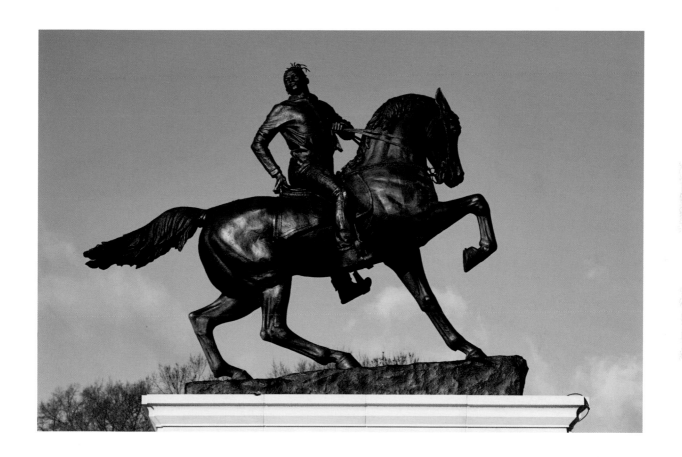

Kehinde Wiley, *Rumors of War*, 2019, bronze with limestone base, 835.3 × 776.9 × 481.6cm (27ft 5in × 25ft 6in × 15ft 19½in). This monumental bronze sculpture is now permanently installed on Arthur Ashe Boulevard, at the entrance to the Virginia Museum of Fine Arts in Richmond, Virginia. The work responds in a contemporary way to Confederate sculptures located across the United States.

In April 2018, the Mayor of London and partners 14-18 NOW, Firstsite and Iniva unveiled a new permanent monument by Turner Prize-winning artist Gillian Wearing. This public commission was a bronze statue of suffragist leader Dame Millicent Fawcett, holding a banner with the words 'Courage Calls to Courage Everywhere'. An historic moment, it represents both the first-ever monument of a woman to be placed in London's Parliament Square, and the first to be created for the site by a woman. Beneath the statue of Fawcett, the names and portraits of 59 women and men who campaigned for women's suffrage are inscribed on the plinth. The Mayor of London, Sadiq Khan, commented: 'Finally, Parliament Square is no longer a male-only zone for statues. This statue of Millicent Fawcett, the great suffragist leader, will stand near Mahatma Gandhi and Nelson Mandela – two other heroic leaders who campaigned for change and equality. There couldn't be a better place to mark the achievements of Millicent Fawcett, [than] in the heart of UK democracy in Parliament Square.' Again, we can only hope that this is the first of many new statues to come to fairly represent our current society, and to uphold values of equality, understanding and human rights. The sculpture's creation is another proof of the theory that art accurately reflects the society and mood, or zeitgeist if you will. The installation was concurrent with multiple student demonstrations, in both the United States and UK, demanding governments remove monuments celebrating colonial histories.

The following year, Tate Modern's Turbine Hall became home to a temporary new commission, Kara Walker's large-scale public sculpture *Fons Americanus*, which took the form of a four-tiered fountain. This work crucially confronts a history often misremembered and questions how we, in contemporary society, remember

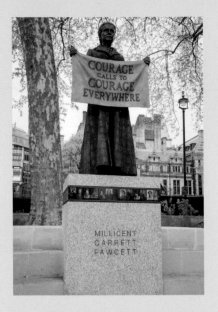

Gillian Wearing, *Millicent Fawcett*, 2018, bronze on marble plinth. Wearing's sculpture of the women's suffrage campaigner is the first statue of a woman to be erected in Parliament Square, and the first created by a woman.

history via public monuments. Walker's work is a response to the Victoria Memorial that was unveiled in front of Buckingham Palace in 1911 to honour the achievements of Queen Victoria, who was also Empress of India. As Tate stated: 'Rather than a celebration of the British Empire, Walker's fountain inverts the usual function of a memorial and questions narratives of power. Walker explores the interconnected histories of Africa, the United States and Europe. She uses water as a key theme, referring to the transatlantic slave trade and the ambitions, fates and tragedies of people from these three continents ... The monument asks uncomfortable questions by exploring a history of violence against Black people of Africa and its diaspora that is often unacknowledged.'

talk ART

The defining feature of permanent public art – and all art, really, but it maps out public art above all – is the notion that the work, once it has been cemented, clamped and drilled into its allocated position, will stay there for the rest of eternity, outliving us all and being puzzled over and ignored in equal measure until the end of time. From Nelson's Column in Trafalgar Square, commemorating the great battle of Waterloo, to Anish Kapoor's humungous shiny jelly bean *Cloud Gate* in Chicago's city centre, these public artworks were and are a message of our lives, a time capsule, and an offering to the world as a record of history and culture and life forever – or until a future society sees fit to take them down, for reasons we cannot now foresee.

Being asked to create a public sculpture is a true accolade for an artist; a sign that their practice carries cultural weight and importance. Their work has the power to change an area's narrative, and carry longevity in cultural value. Such works are not only for 'us' now, they were once for 'them', and public art is also most definitely made for 'those' in the future.

Overleaf:
Kara Walker, *Fons Americanus,* 2019, non-toxic acrylic and cement composite, recyclable cork, wood, and metal, installation view: Hyundai Commission, Tate Modern, London, 2019. Main: 22.4 × 15.2 × 13.2m (73ft 6in × 50ft × 43ft), Grotto: 3.1 × 3.2 × 3.3m (10ft 2in × 10ft 6in × 10ft 10in). Walker's fountain installed at Tate Modern's Turbine Hall questions power structures and historical connections between Africa, Europe and the United States.

Check out these artists, artworks and sites too:
Louise Bourgeois's giant *Maman* spider sculpture at Guggenheim Bilbao • Douglas Coupland's *Digital Orca* in Vancouver • Jupiter Artland in Edinburgh, a contemporary sculpture park with a permanent collection • Anish Kapoor's *Cloud Gate* sculpture in Chicago • Minneapolis Sculpture Garden, with more than forty iconic works • Ugo Rondinone's *Seven Magic Mountains* in the Nevada desert • The Yorkshire Sculpture Park

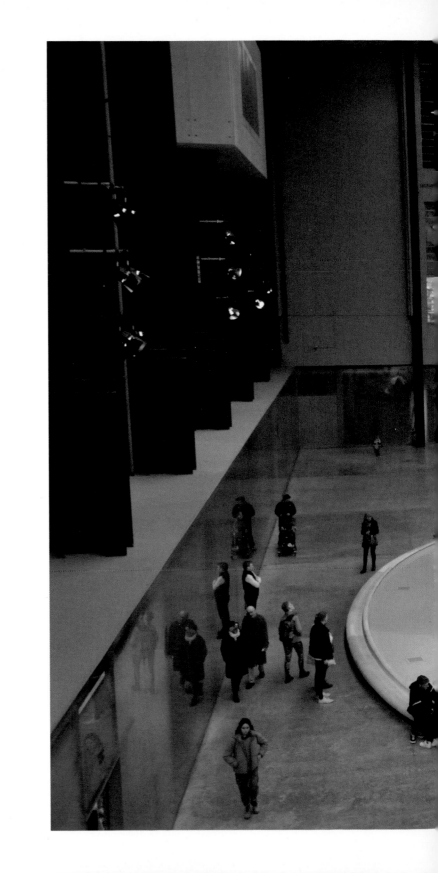

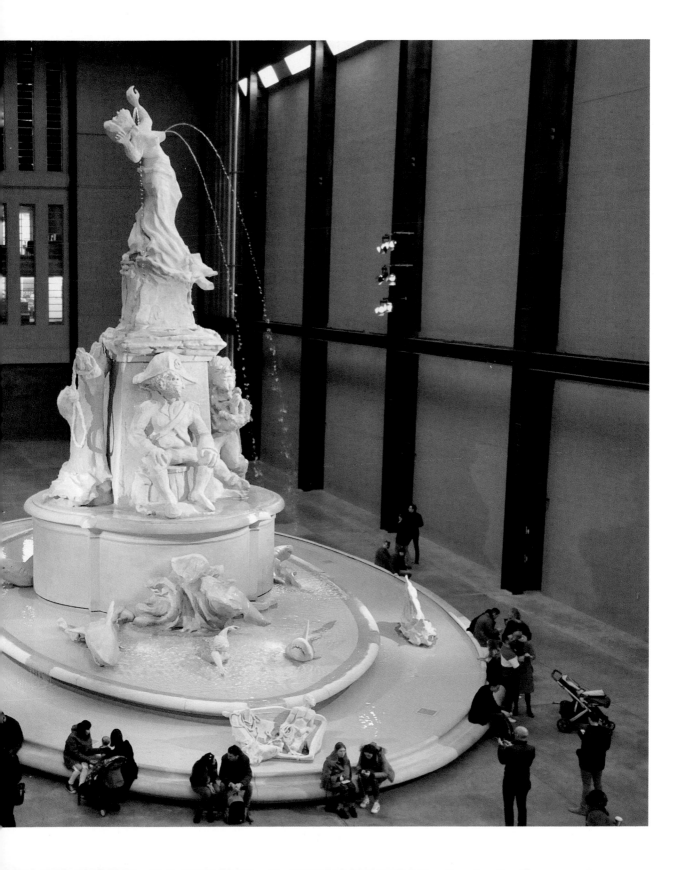

ARTIST
SPOTLIGHT

Stanley Whitney

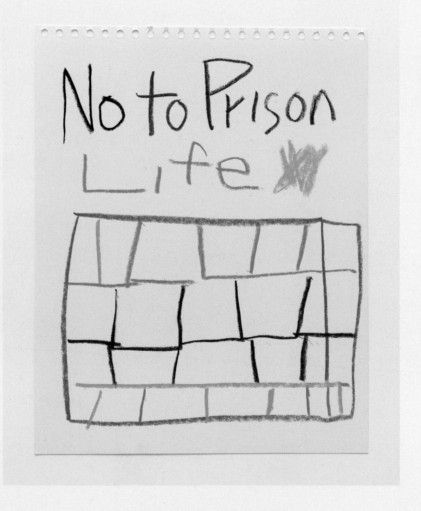

Untitled (No to Prison Life), 2020,
crayon on paper, 35.6 × 27.9cm (14 × 11in).

talk ART

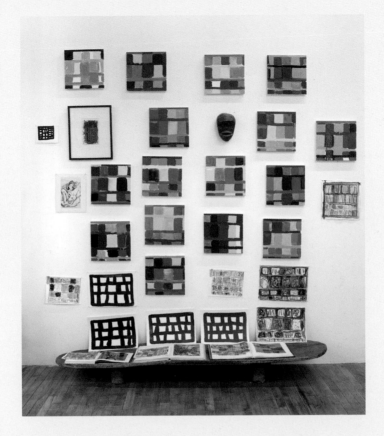

Colour fields on the wall of Whitney's studio.

A master of painterly balance, Stanley Whitney has spent many years honing and recalibrating his practice. In what seems like an infinite continuation into the exploration of colour, his colour fields – abstract grids of three to five lines – give Whitney an inexhaustible stream of dynamism and magic. Inspired by the improvisational quality of the jazz he listens to in his studio, Stanley distils a melody and discord into his work. He allows rapid musical energy to fuse with his paintbrush and his eyes, to create burst after burst of free moving, colour-saturated grid paintings. Always starting at the top and working down, he responds freely and intuitively to how one colour calls to the other. His compositional geometric abstractions, always worked freehand, allow a play on rhythm and space. Stanley's brushstrokes and linear structure hold his works together with a tension that shifts across the very large to the very intimate.

People project onto Stanley's colour dynamics in the work, looking for hidden messages and symbolism. For Stanley, 'People say the colour does this, or the colour does that. And I say the colour does what it does … I like to leave it as pure magic.'

Photography

*Tt X AB –
Teresa Farrell &
Alvaro Barrington,
3, 2020, various media,
16 × 28cm (6¼ × 11in).*

Over the years, we've all been taught to follow the rule: don't ever consider discussing religion and politics when under the influence of alcohol. This is good advice that we should all try to live by, but the time has come to add contemporary art to that list. Yes, there may have been many heated, vodka-tonic-infused debates about politics, and we've all broken down the Church and the power of religion over a couple too many bottles of Argentinian Malbec, but never, even after a platter of tequila slammers, has one ever encountered the wrath and venom of aggression spat out towards any such subject as 'Art'.

Why does art trigger so much aggravation? If we look back at what art has achieved over the years, and the degree to which at every stage aspects of it have been belittled and challenged, I guess we should only expect that art made in our own lifetime would continue the trend. The 'my kid could do that' condemnation of anything simple-looking, or pulled from the 'low' domestic sphere and elevated to 'high' art, is a well-furrowed trope. 'Why does putting an object into a gallery suddenly make it art?' 'Why do artists take paraphernalia and experiences of the everyday, give it their "artsy" spin, then claim it to be of importance?' 'Why can't artists just create the Sistine Chapel ceiling over and over again, and for anything else they think they want to make, just not bother?'

Yet nothing tugs at the spiky temper of a modern-art aggressor quite as much as photography. Photography, from its invention in mid-1820s France, has adapted with the times to become even more refined, more 'perfect', more 'truthful' in its ability to distil the world and to capture what it is to be alive. But now

'A PORTRAIT ON A CAMERA IS SO MUCH BETTER

we all have a digital camera phone, and so now we can all capture whatever we want, whenever we want, in perfect high-res finish, instantly. Comedian London Hughes' kneejerk reaction when we asked her about photographers – 'It's a thing, it's there, it don't need to be celebrated' – expresses the opinion of many. Like comedy, art and especially photography are subjective; it is, of course, the viewer's inclinations in life that affect their responses and taste. That may sound like a basic notion, but it is the life experience of an artist that, as the viewer, either you feel or you don't.

'It's an art form that I never ever recognized until I got sober. I'd had my photograph taken by so many wonderful photographers, [but] I'd never considered photography as an art form.' World-renowned singer-songwriter Sir Elton John is also a world-renowned art collector who in recent years has gathered one of the biggest collections of much-overlooked photojournalism. 'I educated myself by collecting,' says Elton.

Photography as a medium wasn't always the first choice of collectors, until Sam Wagstaff came along. In the early 1970s, after meeting the man who would become the superstar photographer Robert Mapplethorpe, and after viewing *The Painterly Photograph, 1890–1914* exhibition at the Metropolitan Museum in New York, Wagstaff went on to acquire one of the greatest collections of historical and contemporary photography of the time, propelling many photographers to the forefront of the art world and inspiring other collectors but also major institutions to really start to take photography seriously.

THAN A <u>PORTRAIT</u> ON A CANVAS' – SIR ELTON JOHN

Jamie Hawkesworth, *Preston Bus Station*, 2014.
One of Hawkesworth's memorable photographs from a series
of spontaneous portraits taken in and around the Brutalist 1960s
architecture of Preston Bus Station, which in 2012 was under
threat of demolition.

Fashion and fine art have always had a crossover, but never more so than in photography. Some of the greatest photographers have used fashion and magazine culture to build a wider audience and understanding of their work. Think Richard Avedon, Helmut Newton, Irving Penn, Cecil Beaton, Annie Leibovitz, Herb Ritts, and the more contemporary photographers such as Juergen Teller, Tim Walker, Tyler Mitchell, Vivien Sassen, Collier Schorr and even the actor Cole Sprouse, who is currently creating waves with his photography. In addition, the portrait in photography defines so many works by the good and great photographers. Elton John remarks: 'For me, a portrait on a camera is so much better than a portrait on a canvas.' It can't lie; it can be manipulated, of course, but a photograph will always tell the truth. 'The camera catches people's personalities far more than a painting.'

But how do photographers discover this art form to be their medium? One photographer is crossover art star Jamie Hawkesworth. Fresh from photographing Kate Moss for the cover of *Vogue*, he talked to us about the hows and whys. 'I was actually studying forensic science at university ... The one thing I really loved about the practical side of forensics was they had all these mock crime-scene houses ... We'd collect evidence, and then document the evidence very objectively with photography, and that was the very first time I saw photography in a different light ... It was like a little switch went off. Like wow! You can use photography in this way.'

Known for his portraiture, 'street-photography' style and fashion work, Jamie became further drawn to photography because 'I very quickly got into the details of what people would wear and how they would look, their body language and, you know, things that you might kind of miss. My eye got really in there, and I was fascinated with it.' It just worked for him. 'With a good portrait, there's a lot of space around it, and you don't really see the photographer, you just appreciate that person in all their glory, and that's it.' He has also noted how the chance capturing of a subject with a camera can be almost magical. 'It's a stranger, and then suddenly you have this relationship for a minute, then you've created something ... It's fascinating, really, that that can still happen.'

In 2010, while Jamie was living in Preston, he first noticed the city's imposing brutalist bus station, built by Ove Arup and Partners in 1969. He started a project with his ex-tutor Adam Murray whereby they spent the weekend in and around the bus station, and together produced a newspaper filled with portraits of the teenagers they saw. A couple of years later, it was announced that the iconic building was set to be demolished. Jamie decided to move back to Preston for one month, and spent each day photographing the bus station. The layout was a long loop, which he would walk around, and photograph people who caught his attention. The resulting book is a touching tribute to both the building (which has since been saved) and the people using the station at that time, and is powerful due to its simplicity and directness, with Hawkesworth's trademark use of natural light and flair for compelling composition.

Alasdair McLellan, *Arena Homme +: Blondey*, 2017. A timeless, intimate portrait of skateboarder and artist Blondey McCoy, a regular sitter and collaborator of photographer McLellan.

Alasdair McLellan, another world-class art/fashion photographer, chooses to use natural light for the portraits of his subjects: 'I appreciate the basic-ness of that, the reality of that.' Photography is his artistic medium of choice because of its ability to portray the truth. 'I like something to feel real, in a sense.'

Alasdair segued into the art world by poring over fashion magazines and then trying stuff out. 'I remember taking these pictures of my friends and I remember thinking, maybe I'm alright at this, because a lot of people liked them. So I started to take pictures of my friends, I guess, in a more composed way, as if they were by a Herb Ritts or a Bruce Weber … but they [the subjects] were just my mates from Yorkshire.' Some of his most-loved photos are his portraits of professional skateboarder and artist Blondey McCoy, who has been a long-term collaborator, resulting in the incredible book *Blondey 15–21*, charting their friendship and Blondey's growth from teenager into adult.

But the photographer who is thought of by many to have been the first to harness this photographic style, and who is considered to be the granddaddy of street photography, is Henri Cartier-Bresson. This French photographer was a master at capturing the candid comings and goings of his subjects. He rose to prominence in 1937 when he was asked to cover the coronation of King George VI and Queen Elizabeth, but instead of focusing on the monarchs, he chose to capture their adoring fans who lined the London streets. The quality of his work is a standard to which many today still aspire. Cartier-Bresson described his work as capturing decisive 'moments' in life and preserving them, which really does seem to define what all art is, but especially photography – a time capsule. When you look at the fashion crossover especially, the photograph serves as a kind of report, a recording of a moment, and a way for artists to see and feel their world.

Another photographer exploring the common man (or woman) is Martin Parr, his style instantly recognizable, mainly for his use of bright colours and for an almost anthropological documentation of what it is to be British. He gently explores the 'normal', and his quirky nod to satire means that his images go beyond the chance snap-shot street-model to continue further into a study of the folksy, culturally eccentric charms of society. A view of the UK told through its class: deck chairs in the rain, fish-and-chip shops by the seaside, and the bizarre ritual of morris dancing. Life captured and archived.

'Photography is <u>thinking</u> about the three-dimensional world on a two-dimensional <u>plane</u>' – Wolfgang Tillmans

Berlin-based Wolfgang Tillmans, who won the Turner Prize in 2000, has gone on to huge international success and become one of the biggest influences in art today. What makes a Tillmans image isn't always a person present; it's a 'freedom of possibilities'. As Michael Stipe (REM frontman, and some-time model for Tillmans) notes, a person isn't always necessary to make a portrait: a domestic scene, the simple, the overlooked, the elevation of the peripheral into a concentrated study, can feel even more intimate and personal. 'I take pictures in order to understand the world' is a quote Wolfgang now finds problematic, but it follows him around. He feels it holds a suggestion that he just takes hundreds of pictures to fulfil a mission, but in reality it's about taking

Overleaf:
Wolfgang Tillmans, *grey jeans over stair post*, 1991, c-type print, 30 × 40cm (13½ × 17½in). One of our favourite works by Tillmans, breathing new life into the genres of still life and portraiture.

the smallest things and creating with them an authentic, touching narrative and lived moment. 'If I'm really interested in something and really carefully look at something, then I'm able to take a picture of it.' Wolfgang says his practice has 'a strong origin in sculpture … Photography is thinking about the three-dimensional world on a two-dimensional plane.' He chooses his imagery with precision, looking and studying and looking again at the detail of the everyday. His polysexual, non-hierarchical universe – 'really the world that I also want to live in' – allows the viewer access to myriad voices that are 'the language of photography'.

A series that Wolfgang, as well as many of his fans, regards as incredibly successful is 'paper drop', an ongoing exploration into the photography of a sheet of photographic paper. 'It took me 15 years to go the next step, from being aware of how important that very sheet of paper is to me, to actually making the sheet of paper the subject of the photograph itself.' The work, in an abstract way, creates movement and fluidity, capturing within the paper's rolled sections droplet shapes that embody light and

talk ART

Wolfgang Tillmans, *paper drop (light) a*, 2019.
Tillman's 'paper drop' works are spellbinding. We adore the teardrop
shape formed by a simple folding of photographic paper.

colour, with ethereal poetic energy. Wolfgang ponders where their success lies. 'There is something about that shape that I sometimes wonder: why is that so satisfying? I think it's because it is the interplay between two physical forces; on the one hand, the paper tension, and, on the other hand, gravity. The gravity holds it down and the tension bows it up.' For Wolfgang, the subject is important, but at its core the fundamental of his practice is colour: 'That's what it really is about … What I'm thinking about every day and every month and at all times in my work is colour. How [colours] sit with each other,

what hues and saturations, and how it tingles and tickles the retina … what that does.'

Wolfgang's genius lies in his authenticity and his passion for his work, a man who is constantly working out the world around him, pursuing with enthusiasm new discoveries, but allowing his viewer the freedom of personal exploration. 'That play between understanding and knowing what you are looking at, and at the same time being deeply aware that you know nothing; that I know nothing … [But] if you're looking at something with genuine interest, there is … little that can go wrong.'

Catherine Opie photographs diverse subjects inspired by traditional styles, landscape photography and art historical references, including the likes of the 16th-century painter Hans Holbein. Her ongoing portraits of the lesbian and gay Los Angeles community demonstrate work that is rooted in sexual identity. Exposing an audience to a broad and very personal representation of unconventional subjects, her portraits often embody an outwardly masculine energy. Captured within her own personal narrative as an out-and-proud lesbian, her place within the LGBTQI+ community and the relationship to her own body, these significant social and political records carry an element of aggression and angst, but also act as an authentic platform for the voices of her subjects, and one that she continues to protect. Inspired by the works of Robert Mapplethorpe and Nan Goldin, Opie never shies away from controversial subjects, having made several powerful self-portrait works, including one (*Self-Portrait/Cutting*) that documents a child's stick drawing which has been carved into her own back, vividly bleeding, and another (*Self-Portrait/Pervert*) showing her sitting casually with the word 'pervert' carved across her topless chest. The reason Opie's images are so captivating is that they present the subjects of her photographs as powerful, iconic and visible. Using symbolism and constantly questioning the legacy of what it is to live in the United States, her works contain a deep love, respect and passion for her subjects and an abiding fascination for how identities are shaped.

Catherine Opie, *Justin Bond*, 1993, chromogenic photograph, 47.8 × 38cm (18¾ × 15in).
A superb example of Opie's portraits from the 1990s, with a colourful yet flat background, formal pose and meticulous presentation referencing historical portraiture.

Hauz Khas.
It must be marvellous for you in the West
with your bars, clubs, gay liberation
and all that.

Sunil Gupta left India at 15 and moved to Canada, knowing that he could never fully realize the person he was meant to be by staying within his birth community. This enabled a move to New York in the 1970s, which changed his career trajectory forever. Christopher Street in Manhattan was the epicentre of gay life in the 1970s and, for Sunil, an amazing opportunity to make a study of this community within a street photography document of gay life. Using his camera as a means of expression, he captured gay liberation movements in the United States, and also the struggle for this openness within his home country of India. His works weave storytelling narratives, which use the highly personal, his emotional journey after being diagnosed with HIV in the 1990s, and the stories of friends and lovers and the openness he continuously finds in the strangers around him. The beautiful, provocative and powerful work of the 'Lovers: Ten Years On' project, made in West London, marks Gupta out as consistent in his ability to record the significant and the sociologically important. Following on from the painful experience of the breakdown of his own relationship that had lasted ten years, Gupta photographed queer couples in long-term relationships, almost as a form of therapy to help understand and process his break-up. These images tell an honest story of homosexual love and desire, at a time of very raw and specific political agendas. Many of the subjects in this 1984–6 series died during the HIV/AIDS crisis that directly followed. Gupta continues to combine the personal and the public in his practice, giving voice to a queer diaspora, inspired by his own migration, and he celebrates and elevates those in his community who are marginalized by society.

Sunil Gupta, *Hauz Khas*, 1987, from the series 'Exiles', 48.3 × 48.3cm (19 × 19in). Gupta created this series to add images of gay Indian men previously omitted from the art historical canon.

Check out these artists too:
Roe Ethridge • Nan Goldin • Sarah Jones • Elad Lassry • Josephine Meckseper • Cindy Sherman • Gillian Wearing

Art & Political Change

Lenz Geerk, *4*, 2020, acrylic on Japanese paper, 19.6 × 32.9cm (7¾ × 13in).

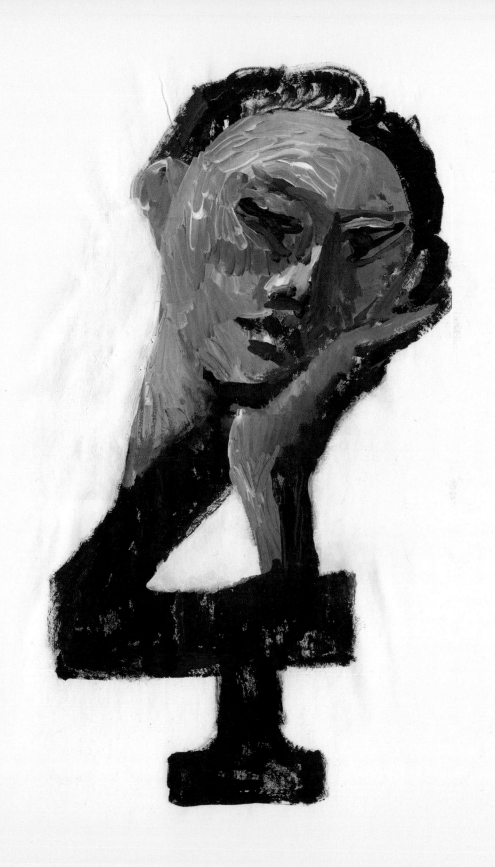

Art holds the power to bring about understanding and to educate us all in a way that is unique. Communication is art's most powerful tool, whether directly informative with crystal-clear narratives and commentary, or abstracted and seemingly obscure. We can learn from art perhaps more than we initially acknowledge. Art can identify, challenge and overcome racial, social, gender or economic inequality and prejudice, accurately reflecting the society of our time. In analysing and challenging the status quo, it can create at the very least an historical document, and at best it can encourage meaningful political change.

Art and politics are inseparable. Try to think of an explicitly political work, it's easier than you'd think. Pablo Picasso's *Guernica*, painted in response to the aerial bombing of Basque civilians; Andy Warhol's *Race Riot* screenprints memorializing 1963 protests on the streets of Birmingham, Alabama; the Guerrilla Girls' iconic 1980s feminist fly-poster campaigns; Andreas Sterzing's arresting portrait of AIDS activist David Wojnarowicz with sewn lips; Ai Weiwei's *Remembering*, which highlighted the deaths of thousands of schoolchildren in the 2008 Sichuan earthquake; Chris Ofili's *No Woman, No Cry* portrait of Doreen Lawrence, campaigner and mother of Stephen Lawrence, the Black British teenager murdered in an unprovoked racist attack in 1993. Art has a life and potential far beyond the physical location of its creator, and can continue to inspire future generations internationally, long after an artist's lifetime. The message is to persist, stay focused, and do all we can to help others and create a more equal world in which we can all live.

' THE PERSONAL IS POLITICAL '

Rob Pruitt, *The Obama Paintings*, installation view: Stony Island Arts Bank, Chicago, 18th April–25th August 2019. This colossal project commemorates Barack Obama's historic presidency. It is a document of dignity and social change.

Images can undeniably impact our thought processes. Just consider how imagery has been used both successfully and problematically throughout history for propaganda purposes and political dominance. A positive recent example is for a leader we admired greatly: President Barack Obama. Shephard Fairey's *Hope* portrait, created during the 2008 presidential campaign, captured the imagination of the American public and the wider world, thanks to its rapid dissemination across the Internet and social media platforms. It showed that images can travel globally and impact people's hearts and minds.

Obama's inauguration was an intense time of hope and potential – so much so that endless artworks were created as a tribute. Perhaps the most committed and comprehensive project was by Rob Pruitt. *The Obama Paintings* were born out of optimism and as a means of honouring Obama's historic presidency. In total the artist created 2,922 individual paintings of the president, one for each day of Obama's two terms. Each painting was 60 × 60cm (23½ × 23½in) and was created with imagery inspired by events in that day's news. When displayed together, this body of work is an impressive installation raising complex questions about power, leadership, and the dissemination of images and their influence on society.

Art can encourage personal growth. As we focus on an artwork, we decipher what it makes us feel and, in doing so, we may begin to understand whether the artist has a certain intention with the work. Art encourages us to pay attention to other people's perspectives, but ultimately it leads us to face ourselves and listen to our inner voice to understand the individual responsibility we hold with respect to the world outside and the society of which we are part.

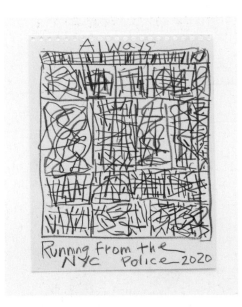

Stanley Whitney, *Untitled (Always Running from the Police – NYC 2020)*, 2020, graphite on paper, 35.6 × 27.9cm (14 × 11in). This powerful work helped raise money for the Art for Justice Fund, an organization advocating for criminal justice reform.

In 2020, numerous artists, illustrators and designers responded to the urgent political cause of Black Lives Matter and the killings of black US civilians including George Floyd, Breonna Taylor and Ahmaud Arbery with artworks memorializing those who lost their lives. They shared these works on street walls, shop hoardings, posters and, perhaps most widely, online. *New York* magazine commissioned a number of Black contemporary artists to create an original piece of art in response to the movement. Stanley Whitney's drawing included his trademark abstract grids with squiggly lines but with the added phrase 'Always running from Police'; Kerry James Marshall's portrait of George Floyd included the words 'LIBERTY JUSTICE FOR ALL'; and Hank Willis Thomas's photocollage showed protesters facing the police. Elsewhere, a young designer/illustrator Shirien Damra posted an illustration on her Instagram (@shirien.creates) of George Floyd that went on to be reposted and shared millions of times on social media, and has even been recreated as a painting on the shop window of Mahal Kita florist in Robert's hometown of Margate. This is a great example of how art can connect with people, encouraging them to consider hard-hitting political injustices. Painter Katherine Bernhardt's fundraising print for Know My Rights Camp depicted the charity's founder Colin Kaepernick on one knee, echoing the now-ubiquitous image of the American football star's kneeling protest as the US national anthem was played. Artworks like this show solidarity, as well as raising vital funds for a cause. Art can help create international unity and togetherness in the face of adversity, and inspire people to engage more in politics and social activism.

Artists and the wider art community are adept at coming together in protest, rallying and mobilizing their ideas very quickly, thanks to their strong peer networks. Consider Downtown for Democracy, set up in 2003, which campaigns for people to use their vote and, crucially, encourages the creative community to be part of the process, with the knowledge that artists and designers can shape and influence culture. Relaunching in 2017 to protest against the new Trump administration's agenda and to put the power of creative expression to work for democracy, Halt Action Group was formed by a number of artists, including Marilyn Minter, with a memorable poster campaign and gold 'Trump Plaque' depicting the then-newly elected president complete with one of his well-reported abusive, misogynistic tirades.

Katherine Bernhardt, *I Know My Rights*, 2019, colour lithographic print, 129 × 83cm (50¾ × 32½in). This vibrant portrait was made in solidarity with Colin Kaepernick's mission, raising significant funds to support his Know My Rights Camp charity.

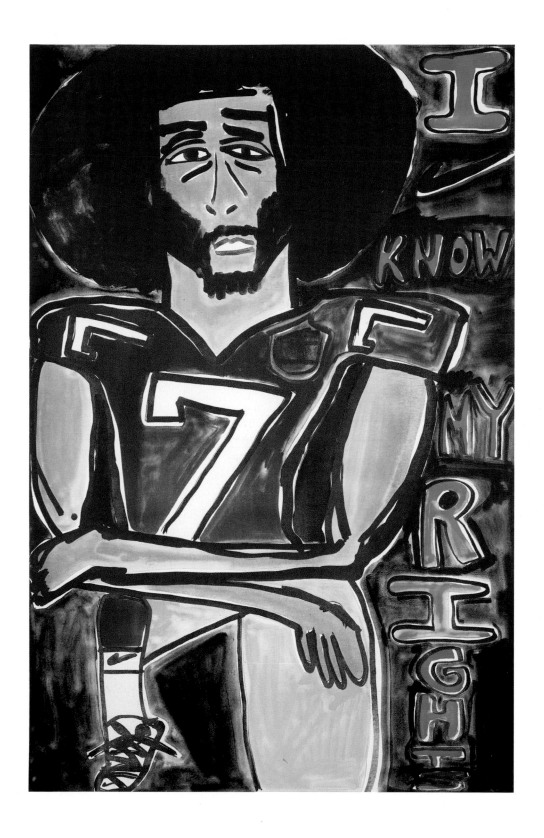

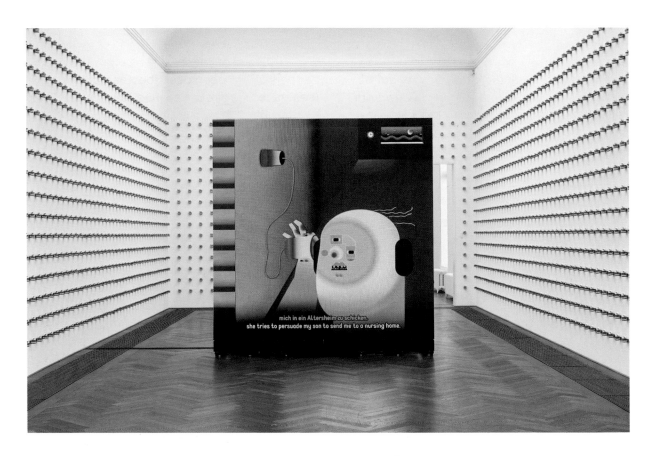

Wong Ping, *Dear, can I give you a hand?*, 2018, installation view: *Golden Shower*,
view on HD-film, 12 minutes, Kunsthalle Basel, 2019. A striking combination of humour,
graphic references and bright colours are central to Wong Ping's digital universe.

'BE THE CHANGE YOU WANT TO SEE'

Art can be a safe space for people to express themselves; to come together and share their anger and views. The very act of making art or publicly sharing your viewpoint is political. Many artists create work in relation to their autobiography and intimate personal experiences. While this may not sound political, such artworks have caused great impact – shockwaves, if you will – across the planet. The phrase 'the personal is political' emerged in the 1960s as part of the second-wave feminist and student movements, and continues to resonate today. As mentioned in our earlier chapter on 'Public Art' (see page 38), student protests frequently make global headlines, not only bringing added pressure to governments and the older generation to reassess their stance and responses to human rights injustices, but also foreseeing future crises such as environmental change and the effects of global warming. Artists are often closely aligned with such protests: for example, Wong Ping, who has included sharp political commentary within his recent work, directly responding to the Chinese government, as well as protesting on the frontline in Hong Kong. Wong holds onto the right to free speech in Hong Kong and refuses to self-censor. In his bold technicolour animated video series 'Fables', he weaves human fantasies with absurd stories, employing dark humour to explore political and cultural anxieties.

For almost four decades, British artist Lubaina Himid has created artworks that celebrate Black creativity. Her drawings, paintings, sculptures and installations analyse cultural history, the reclaiming of identities and the legacy of the slave trade, as well as racism, gender issues and the lack of representation within institutions. She was one of the first artists to be part of the BLK Art Group, founded in the UK in 1982, and her oeuvre has been described as 'activist art' (see page 86), directly aligned to the radical political Black Art Movement inspired by anti-racist discourse and feminist critique. As an artist, curator, professor and advocate, her work consistently highlights both current and historic injustice through an accessible and often witty visual language. By using an appealing palette of bright colours and patterns, and by adopting satire, Himid's work is able to educate the viewer with a light touch, rather than being heavily didactic, and in doing so has opened up discussions of racial inequality to a much wider audience. She succeeds in getting across deeply complex issues in a direct and memorable way. In 2017, she became the first Black woman to win the Turner Prize, and she has also been awarded both an MBE for 'services to Black Women's Art' and later a CBE for 'services to art'.

Overleaf:
Lubaina Himid, *Naming the Money*, 2004, plywood, acrylic, mixed media and audio, installation view: *Navigation Charts*, Spike Island, Bristol, 2017. This large installation consists of 100 life-sized cut-outs representing African slaves in the royal courts of 18th-century Europe.

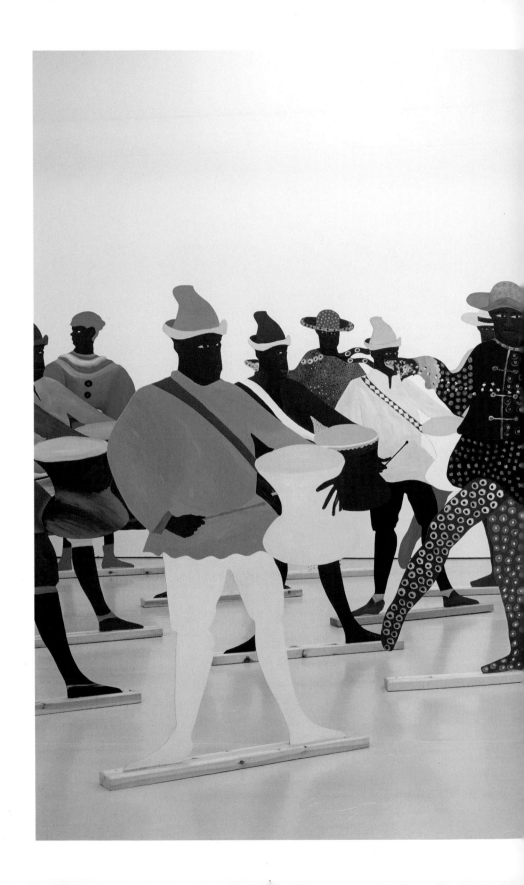

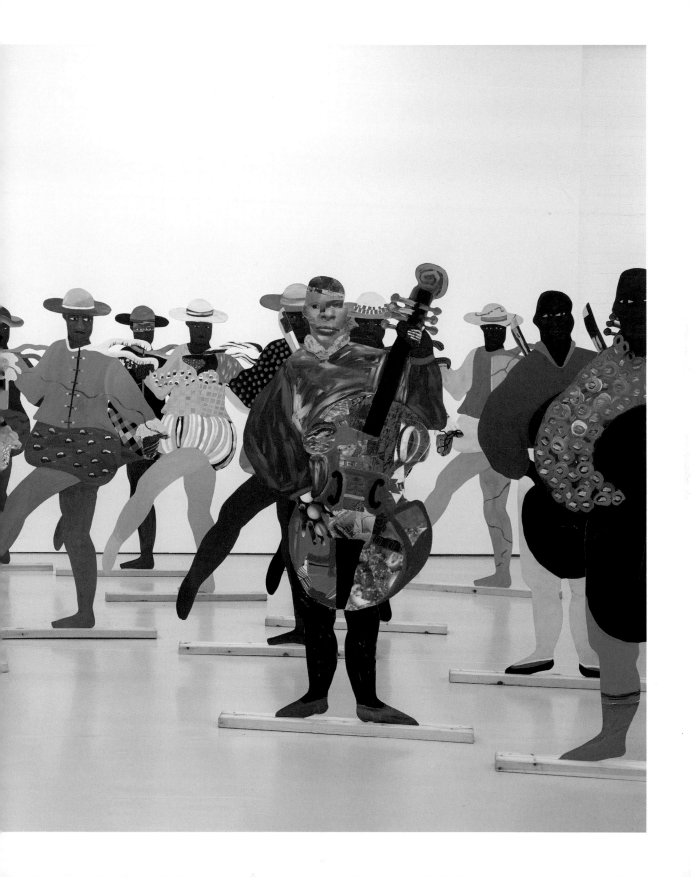

DEFINITION → ACTIVIST ART

Activist Art is the art of protest. These artworks highlight urgent social issues and political injustices in order to educate and communicate with audiences but also invite and inspire the viewer to engage with politics in an active way.

Himid's seminal work *Naming the Money* (see previous page) takes a theatrical approach to installation, informed by the artist's study of theatre design many decades before. It consists of one hundred life-sized, cut-out, wooden figures of African servants she had previously seen depicted in European court paintings of the 17th and 18th centuries. The artist gives each of the figures a name and a backstory, and thus a concrete, distinct identity. They are full of life, with their personality, individuality, skills and passions shining through. The work manages to humanize these fictional individuals, symbolic of enslaved African men and women of history. Installed in such a way that the public can walk through and be among the sculptures, it's as if Himid has taken paintings off the museum wall and more freely positioned the characters to allow them to tell their stories to the museum's visitors.

There is a phrase we remember reading in the 1990s: 'Be the change you want to see'. It puts forward the idea that individuals can make changes to their own lives. Then by challenging those surrounding them – family members, work colleagues, or even the institutions they work within – change can occur. Change starts with the individual. Using one's voice and the connection between an individual and wider society are recurrent themes in another artist's work. Helen Cammock's practice involves film, photography, print, text and performance. Research-led, she provides a platform for her own voice but also the voices of those marginalized within history, particularly women, enabling them to be heard today. Helen weaves together specific historical political events across different eras to act as a method of acknowledging that similar, or indeed identical, struggles exist in the present, and that history is cyclical in nature. Her work provides examples of the power of solidarity and demonstrates how various civil rights movements can exist at the same time. Helen's art shows that a meeting of different minds to share different countries' experiences can lead to helpful strategies and ways forward.

Helen's Turner Prize-winning film *The Long Note* explores the history of women in the civil rights movement in Northern Ireland in 1968, during a period of great political turmoil known as 'the Troubles' (the conflict that began in the late 1960s and ended with the Good Friday Agreement of 1998). Helen told us about the evolution of her project: 'Normally I find a place to site myself in the work. So, I've made work that looks at race but looks at it through conversations with my father. There's another one that has an imagined conversation with James Baldwin, but somehow it's kind of clear how I'm sited in the work, [but] this one I felt anxious about. I go in there with my English accent, and it's a context that I don't understand,

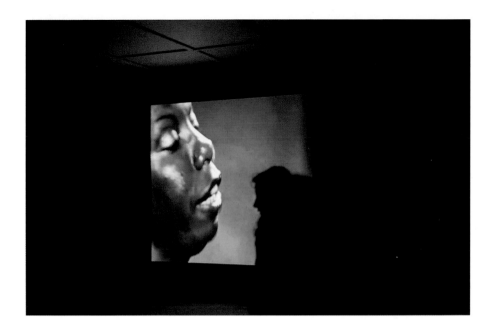

Helen Cammock, *The Long Note*, video still, 2018, installation view: Turner Contemporary Margate, 2019.
Found footage of Nina Simone at a piano singing the 1960s civil rights anthem
'I Wish I Knew How It Would Feel to Be Free' formed part of this Turner Prize-winning work.

I don't have an experience of it on any level, and so having had conversations with Mary [Cremin, curator and director at Void Gallery, Derry], who said, "Yes, but something that's really significant and important about your work is that you have these conversations about voice, you understand the idea of the marginal position, you understand what it is to weave stories together" – because they're not always my own, although I site myself in the work – and so that was the beginning of that project … I met with women who, generationally, were part of the Troubles, were part of the civil rights movement, and had something to say about that … I sat with them for maybe three hours asking them questions, but allowing them to just talk about the experiences that they'd had.' Alongside archival footage, Helen shares her series of newly recorded interviews that place women's voices – speaking about extraordinary but unspoken and buried subjects – at the fore.

Ask any artist if they see themselves as political, and the vast majority would answer 'yes'.

Check out these artists too:
Lawrence Abu Hamdan • Theaster Gates • Hans Haacke
• David Hammons • Ima-Abasi Okon • Faith Ringgold

ARTIST
SPOTLIGHT

Toyin Ojih Odutola

Anchor, 2018, charcoal, pastel and pencil on paper, 99 × 75cm (39 × 29¾in).

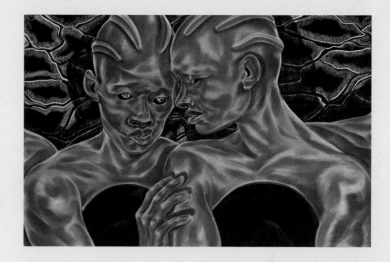

To See and To Know; Future Lovers, 2019, charcoal, pastel and chalk on board, 50.8 × 76.2cm (20 × 30in).

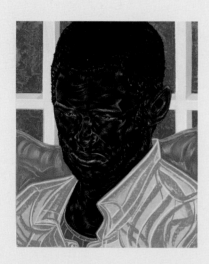

The Abstraction of a Continent, 2017–18, charcoal, pastel and pencil on paper, 74.6 × 62 × 4cm (29⅜ × 24½ × 1½in), framed.

Toyin Ojih Odutola is a storyteller, exploring identity and the malleability of identity through multiple narratives across varying surfaces. In her works – created predominantly on paper in pastel, graphite and charcoal – winding accounts are crafted into series that open up imagined family trees and histories. Bonding her characters through fictionalized unions and inspired by her friends and family, her birth country of Nigeria and science fiction, Toyin leads us through character-driven, captivating and sumptuously drafted chronicles, using the art of drawing as an act for storytelling. Her multimedia pieces, adventurous and sprawling, are structured episodically. Rooted in the written word (even the use of a ballpoint pen as a signature medium to draw with feels subtly nuanced), she creates a narrative and back story for each and every one of her characters, engaging audiences with their interior worlds and encouraging the viewer to piece together the many fragments of her stories for themselves. Developing and honing new themes and narratives, Toyin is unfaltering in her brave and bold explorations. Using distinctive detailed mark marking, which has become signature to the artist, Toyin reinvents traditional portraiture, cementing her place in art history and inspiring a whole new generation of figurative art.

Art

&

Feminism

Katherine Bradford, *5*, 2020, gouache on paper, 22.9 × 17.8cm (7 × 9in).

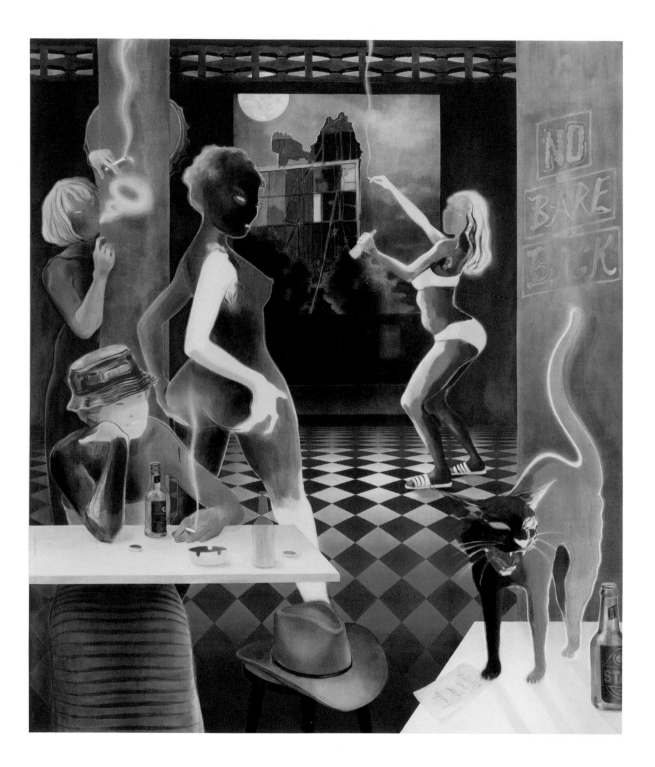

'Women aren't going to ruin your art history' – Jerry Saltz

'It fascinates me to see what comes out on the paper – not just what I do, but what other people do in class. You see all different translations of the same thing.' So says Princess Julia, superstar DJ, stylist and artist. 'It's just you and the model; and you are in the moment.' The life drawing classes she is speaking about have been a mainstay in art academia for centuries. Even if an artist didn't plan to make work based on the human figure, drawing the nude was seen as 'equipment fundamental' for formal art training. The sculptor Henry Moore described why it felt so important for him: 'You can't understand life drawing without being emotionally involved ... It really is a deep, long struggle to understand oneself.' London's Royal Academy of Arts set upon this struggle in 1768, opening the first state-sanctioned art school in the country, which at the time only allowed men to study there. Say what?! So, even though the academy co-founders included two women (Angelica Kauffman and Mary Moser), and women could exhibit their art there, they weren't allowed to enrol as students until well into the 19th century. There was only one role women could play at the academy then – that of 'the model' – but otherwise, they were excluded.

Lisa Brice, *After Embah*, 2018, synthetic tempera, ink, water-soluble crayon and gesso on canvas, 244 × 205cm (96⅛ × 80¾in). Brice's work presents a new approach to the female nude, challenging historical perspectives and misogyny.

'Patriarchy conspires to make women invisible ... That's the trope. Women are second-rate. Women can't paint. There are no great women artists. That was fed into us.' Caroline Coon was a student in London in the 1960s. 'To tell you how far we've come, there were no ladies' loos at the Royal College of Art ... We did not exist.' The battle for female artists to be considered, respected and truly seen by their male counterparts has been long-fought.

Only recently, in the last 50 years, has the female physique in art not predominantly been evaluated through a male gaze. South African-born figurative painter Lisa Brice takes the male gaze in traditional portraiture and turns it outwards, giving ownership to how women are portrayed. Typically, throughout Western art history, female figuration was only painted by white men for white men. Brice challenges the tradition and gives permission to her female nudes, seen in instantly recognizable poses taken from master paintings by Degas, Manet and Renoir, and reinterprets them from a position of power as a contemporary female artist. In her work, women are given ownership over their bodies. Even when restrained in these classical poses, Brice's women have agency and independence from their legacy. They smoke and lean against the frame, staring back at us with nonchalant ease, as if on a break from the arduous work of just simply being a powerful woman. Brice has presented a gift to these women, readdressing some of art history's most mistreated figures.

'51 per cent of handprints in the caves were female handprints. We now know this,' says Jerry Saltz, one of the world's leading art critics. 'So … 51 per cent of all art in museums, going forwards, it's fine to have it be women. Women aren't going to ruin your art history.' Alongside other art critics including Roberta Smith, Laura Mulvey, Carol Duncan and the late Linda Nochlin, Jerry is highly vocal about the truth regarding disparity between male and female artists in art history. 'It's telling much less than half the story.'

'People's attitudes have changed towards women,' notes Tracey Emin, who uses the autobiographical to access and create work. 'Before, I was considered to be whingeing and moaning and banging on, and now people realize actually I'm talking a qualified language about being a woman and how women are treated.'

It's about moving the dial forward, whether it be redressing the gender imbalances in art or considering diversity in all mediums. London-based Somaya Critchlow counts the reality show *Love & Hip Hop* as a huge influence on her exploration into the female figure. Her paintings feature women scantily dressed, or even breasts out, with 'crazy bodies … that don't seem possible'. They stare straight at the viewer with a confidence and pride that is rarely seen and felt in art. 'With hip hop, particularly the females … Cardi B, Nicki Minaj, Lil' Kim … they are such amazing and powerful forces, and they're able to do what they want, in a way that I don't often see Black women able to do, or even women in different situations, and I find that really admirable.' Inspiring stuff. Looking to popular culture, and finding strength from its contemporary pop women, has contributed to the representation of a new body in art. 'I love art, the history of art, and I adore spending time at the National Gallery, so when I was doing my postgraduate, you're looking at a lot of historical art and there aren't many people who look like me … To be aware that there weren't so many women painted in a certain way, or Black women, I just found myself feeling a bit alienated from the art history that I love.' Somaya felt emboldened to push further. 'I need to see how I can fit myself into this.' Spending time re-examining herself to understand the female form deeper, 'I decided to draw myself a lot because I've never really done that before. What kind of person am I, if I don't even know how to draw myself?' Somaya ventured into a body of work that is fresh and current. Her women carry themselves with poise, and many bare huge breasts with nipples like bullets. 'I think … it's a bit of an "F.U."!' Learning through sketching her own body, and then through life drawing classes, Somaya came to a realization. 'You're looking at naked bodies the whole time, but there seems to be this version of nudity that's OK and allowed and this version of nudity that's not OK.' And using this – which she felt was a complex injustice – to forge ahead with her ideal, 'I found it quite exciting to manipulate this idea that I was coming from the perspective of doing a lot of life drawing, [but] allowed to create forms that seemed otherworldly.'

talk ART

Somaya Critchlow, *A Precious Blessing with a Poodle Up-Doo*,
2019, oil on canvas, 9.9 × 6.9cm (3⅞ × 2¾in).
Critchlow's paintings are bold, brave and skilful,
subverting power structures within the history of painting.

'People want to hear some personal stories, other voices'

—Katherine Bradford

'I think there's a hunger for all the different lives,' muses Katherine Bradford, who moved from Maine to New York in the late 1970s to work as an artist; 'especially for the ones that were left out of the picture.' Katherine's work started as a study of the sky and horizons, of water and the sea, but she counts her inclusion of the figure as a powerful shift in her practice. Reflecting on the rise of figuration in art, she notes, 'What's interesting is when I started putting people in my work, my audience got much much bigger. I think they saw an element of humanity in my work.' There was an anxiety, as a self-taught artist, to take responsibility for the figure. 'I didn't dare put human beings in my work, because I'd never been to art school; I'd never done life drawing, all those foundation courses.' But after working out her figurative style, she gave her work power. 'The [established] art world was almost completely white males. What's exciting is that all the other characters are beginning to parade into it, so there's an increased interest in identity. I think people want to hear some personal stories, other voices, and I think if you put figures in your paintings, you're able to tell these stories, maybe even more than if you did geometric abstraction.'

Katherine Bradford, *Wedding Ceremony*, 2019, acrylic on canvas, 203.2 × 172.7cm (80 × 68in). These paintings are dream-like, experimental and at times eccentric. We love their imaginative openness and the freedom they inspire within the viewer.

An art superstar that many artists cite as being a huge inspiration and influence is Lisa Yuskavage. After seeing one of her shows at the David Zwirner Gallery in London, Somaya Critchlow was emboldened with confidence to explore her own imagination further. 'I walked in and I was like, "Oh my God this is incredible." From leaving my classroom, where I felt so restricted and frustrated, to suddenly walk into this show, that was like "wow"!' Lisa has been pushing the female form further and further in her art from the start of her career to the present day. She is also heavily inspired by popular culture and art history, and was a one-time nude model herself. Her women are busty, highly sexualized, and proudly carry ample pubic hair and bold smiles, referencing the art history canon but projected into candy-shaded, highly elevated, emotional pictorial scenes. These play with 'high' and 'low' art: they connect historically with a top-level skill, but their content is accessible in its exploration of low-level erotic art and pornography. 'I weaponized shame in my early work. I think shame is one of the most powerful emotions that everyone has felt.' Lisa created work that initially shocked her audience: 'People were really outraged by those paintings, which I rather enjoyed.' Her early subject of prepubescent girls was seen as risky and raw, but it was autobiographical. Puberty is a time in a girl's development that is rarely spoken about from the perspective of someone experiencing it, and yet here was an artist really trying to reveal what this experience felt like. 'Painting a prepubescent girl, whose nipples were unable to be hidden: I had that experience as a young girl.'

talk ART

Lisa Yuskavage, *Bridesmaid*, 2004, oil on linen, 77.2 × 87cm (30⅜ × 34¼in).
This work breaks with tradition to create an entirely new,
bold language of painting. Her mesmerizing use of colour has
without a doubt inspired the next generation of painters.

Tracey Emin also felt a responsibility in her work to show the truth behind what it was to be a young girl. 'I wasn't looking for credit,' Tracey says. 'What I didn't want is to be slammed down, or told here's Tracey Emin moaning on again about abortion, or moaning on again about being raped at 13 … I wasn't moaning on, I was stating the facts, that teen sex happens; I was stating the facts.' Artists who channel an honesty about human sexuality and who are willing to bare themselves open to criticism are truly among the bravest we have. 'I'm an out and out expressionist,' Tracey states. 'I wear my heart on my sleeve. Everything is coming out of me.'

Lisa recalls her own adolescent humiliations and notes that her paintings 'were about wanting to disappear and not being able to'. Discovering her voice, and allowing herself permission to paint what her instincts were telling her, wasn't an easy journey. She counts two breakdowns as being fundamental to her practice, both due to her need for 'pleasing authority', listening to outsiders when her own voice wasn't being heard. 'When I was at Yale, I was so down because [I was being advised to take away] the very thing that makes me want to do my work, which is: I was painting in some ways a manifestation of myself. I don't

consider the images in my paintings, even way back then, "me", but I painted a human form.' Tracey feels, similarly, the work is her, but then it also isn't her at all. 'God, is this my mum or is this me? What is it? It's like a stain of a human being.' The magic of Lisa and Tracey's work is that of an artist revealing to us the deeper, psychological side to human sexuality and the body. The work is challenging. Lisa states that for a while reception was muted and sales very low, but channelling her own style has created an artist that many now hail as revolutionary and fundamentally significant. 'All the paintings are in important collections, [and] they've been in museum shows, but at the time I couldn't give them away.'

It is, of course, only in hindsight that we can evaluate an artist's career in this way. Younger, emerging artists have the good fortune of knowing that a lot of the hard work for women in art has been done for them, granting them licence to depict a body as they see fit. Titans of female art such as Lisa and Tracey are heroes, yet we still have a long way to go, and there is surely excitement for that. The artists of now still have such a huge opportunity to find their own language and to mine further the never-ending resource of being human; of the body and the human psyche. Through the magic of making art, so many stories that really do need to be shared are now being told, and will continue to be.

Tracey Emin, *It was all too Much*, 2018, acrylic on canvas, 182.3 × 182.3cm (71¾ × 71¾in). Emin's paintings are bold, brave and expressionist, with layers and layers of paint that reflect deeply personal emotional states.

Check out these artists too:
Marlene Dumas • Nicole Eisenman • Chantal Joffe • Elke Krystufek • Sarah Lucas • Jenny Saville • Tschabalala Self • Amy Sherald

ARTIST SPOTLIGHT

Rebecca Warren

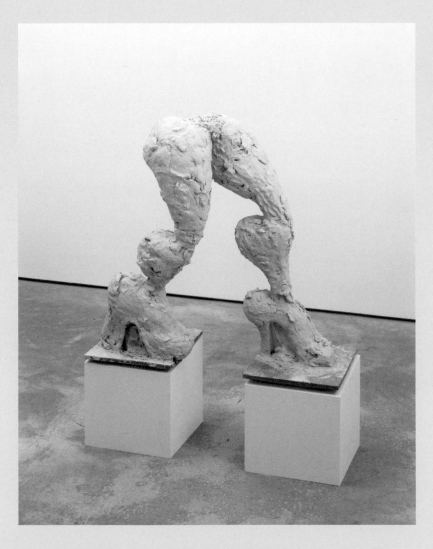

Croccioni, 2000, clay on two painted MDF plinths, 85 × 84 × 34cm
(33½ × 33 × 13⅜in).

Rebecca Warren is a sculptor working in a variety of materials including clay, bronze and steel. We both love that she said (in an interview with Carl Freedman in 1996), that she'd like her work 'to look like it had been made by a sort of pervy, middle-aged, provincial woodwork teacher,' which was a gambit in order to discover her own license as an artist.

Her sculptures range from figurative to abstract and from amorphous to more clearly recognizable forms. They are sometimes cartoonish or eroticized, tender and droll, often like beings made from parts of other beings, or figures in different postures at different times.

When painted, their surfaces blend areas that evoke flesh, fabric, light reflection, or pigment itself. She also constructs vitrines and wall-based collages using neon, wool, pompoms, paper, thread, and less identifiable materials. Always evident in Warren's work is the continuous negotiation between thought and process. While acknowledging a somewhat fractious debt to certain key elements of Modernist sculpture and pop culture - in particular the work of Auguste Rodin, Willem de Kooning, Lucio Fontana, Alberto Giacometti and cartoonist R. Crumb - she has latterly said of the origins of her work, in an interview with Tate Etc.:

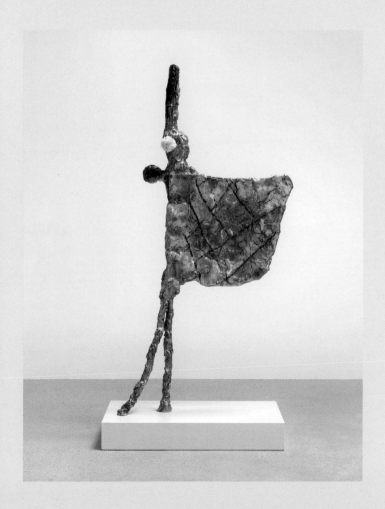

`'I don't really know where it comes from. From a sort of strange nowhere. Then gradually something comes out into the light. There are impulses, half-seen shapes, things that might have stuck with you from decades ago as well as more recently. It's all stuff in the world going through you as a filter.'`

Los Hadeans III, 2017, hand-painted bronze and pompom on painted MDF plinth, bronze: 212 × 103 × 30cm (83½ × 40½ × 11¾in); plinth: 17 × 106 × 68cm (6¾ × 42 × 27in).

Art &
Representation

Jon Key, *Violet No. 6*,
2020, digital drawing.

As far as time goes back, humans have been obsessed with depicting themselves in artistic form. The cavewomen (you might think it was the cavemen, but over half of the oldest-known handprints were created by women, see page 94; as in the rest of art history dogma, the female-made works have been unrecognized) produced extraordinary stencils, which often appear alongside illustrations of humans with weapons held aloft – shields, bows and arrows, staffs and clubs – a-leaping in powerfully audacious stance, stalking out prey with finesse, prowess and grace.

We all need to be able to see ourselves up there on gallery walls. It's a human drive, it's the human experience, to want to be shown in public spaces, as a documentation of what it is to be alive, to truly be represented, to be seen. The power of art and of seeing ourselves up there, on gallery walls, is the reason human beings first started mark-making, on those cave walls, all those tens of thousands of years ago. To see ourselves is to know ourselves.

Capturing a community can start as ideas-based, then develop into the major driving force for any artist making work. It can manifest into almost political advocacy, giving voice to an overlooked or ignored section of society, and elevating, highlighting, preserving and celebrating hidden and marginalized communities around the world.

Cassi Namoda, *Fishing Men In Namacurra Whilst the Moon is Still Pronounced*, 2019, acrylic on canvas, 152.4 × 188cm (60 × 74in). Cassi's work offers personal reflections and memories of everyday moments from life growing up in Mozambique.

Cassi Namoda, born in Mozambique but now based in New York, makes work that captures the people of her childhood. Her formative years have shaped and inspired her practice. 'My interest and curiosity lies in a rural Africa. I'm thinking about the culture of African life.' The community that appears in her colourful vignettes opens up 'philosophies around living'. Featuring family and friends, a combination of her memories and imagination, Cassi comments: 'My approach to painting is very narrative-based: a person, a place, a time'. Her works record the everyday people of Maputo, the capital of Mozambique: workers within village infrastructures, fishermen chilling on the sea wall, families shopping, couples eating and relaxing, women carrying heavy loads or sitting in the cool shade of acacia trees. However, the works muster mixed emotions: 'an ominous feeling', serene calmness yet sadness, an exhaustion that is carried across the many faces of her characters. Conveying the suffocating heat of an East African summer, these paintings serve to educate us, holding as they do a community's history and trauma. 'They've gone through a lot, as a country, as a people, and they still continue.' In Cassi's scenes, we experience a dialogue around pain, and the sensation that the smiles we are presented with hide deep suffering and fatigue. Cassi uses spiritualism and symbolism to invite us into a narrative that isn't our own. 'Everything around us is some sort of symbolism, if we adhere to it, if we are sensitive to it' and through it, we can witness 'people with very different lives'. Thus Cassi creates a powerful and important representation of a proud culture. Her paintings are a life-force and provide a legacy that we can all feel, share and learn from.

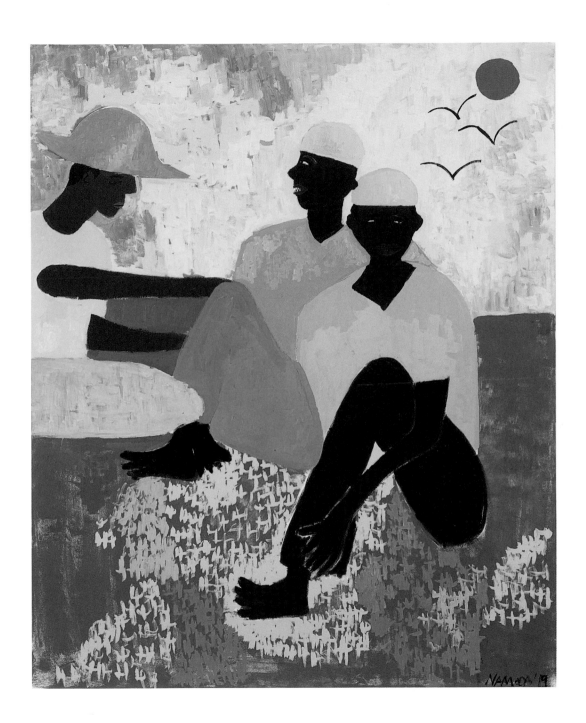

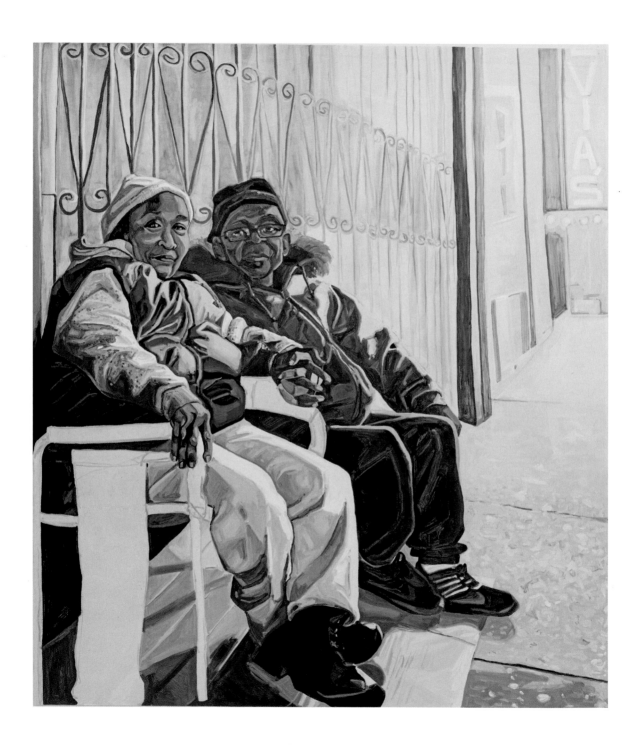

TO SEE OURSELVES

IS TO KNOW OURSELVES.

Jordan Casteel is a New York-based portrait artist. Fundamental to her practice, and a major objective for making her work, is giving her community, her loved ones, friends and family, visibility. 'One of the best things art can offer is the ability to see ourselves represented … I'm on the wall; all of a sudden, I'm just as important.' Using the camera as a source tool, Jordan photographs the subjects she encounters, rooted in her community, and then creates almost life-sized figurative paintings from these subjects in their natural environments. 'I'm sure that people could mistake me for a photographer first, but I do not consider myself a photographer.' The connection Jordan has for the people she chooses to paint is incredibly important. 'I have a first-person relationship to the paintings … I have a really emotional connection. I have the history and the stories.' What is it about certain people that makes Jordan feel they are the right subject for her to paint? 'There's something very intuitive that happens when you're moving through space with the intention of trying to capture someone's essence and energy.' Jordan uses this intuition as a way to 'street cast,' instinctively though tentatively approaching people in public to start a connection. 'Usually it's a return gaze in some capacity; they show some curiosity about me in the same way I'm experiencing some curiosity about them.' Collaboration is something that Jordan holds dearly in her practice: the transaction between artist and sitter, and the permission to enter a private space and share something with her subjects. 'I want them to feel empowered and powerful, and I want that to happen from the beginning of the process all the way to the end, when the painting is living its life in a gallery or a museum.' Jordan allows her subjects to look at us directly; she wants them to continue catching our eyes and making that very human connection. That's the power of Jordan's paintings. Having an honest, valuable connection to your subjects can create magic and set up a dialogue that can change lives. 'You feel the sense that people are letting you in, and you take that cracked door and you fling it open!'

Jordan Casteel, *Yvonne and James*, 2017, oil on canvas, 228.6 × 198.1cm (90 × 78in). We adore the warmth and kindness that emanate from the sitters' eyes, skillfully depicted by Jordan Casteel, in this touching portrait of an older New York couple.

Brooklyn-based Louis Fratino creates figurative portrait work that stands on the shoulders of Modernism and juggles Freud, Bacon, Hockney, Picasso, Hartley. 'There's this particular stylization of the human figure that I'm just deeply attracted to, intrinsically.' He takes the autobiographical and weaves it in with art historical references and gay sex. His subjects range from friends to partners and past lovers. Asked if he worries about revealing who these people are, or the sharing of intimate moments in his work, Louis replies: 'I think my family feels very proud and touched by it … My work is so much about love – I love this material, I love this action, I love this content, I love this person – so it's kind of like I have no choice.' His figurative works are painterly, confident and uniquely Fratino, with a bold nod to the past early cubist masters, but he is always striving to bring them back to himself. 'I feel like my figures, because they're such a potpourri of art history, are hard to identify sometimes, so there may be a tattoo or a ring or the earring or the haircut.' Proudly queer, Louis is driven to show the queer narrative in his paintings and drawings, pushing further to secure a position for queer figuration and queer love in the art historical canon. 'I think a lot about trying to place images of gay sex into biology or natural history, because that's part of what I'm trying to do – put it into this universal context. For so long I feel like erotic gay imagery gets sequestered into some corner … like "that's gay art history" [as opposed to just art history].' As you get to know Louis's practice, you come to recognize the common features and motifs in his players: they draw you in, with their exaggerated hands and feet. 'When you love something about someone, in your mind it probably does become enlarged' – shell-like ears, cropped hair and doleful expressions – but it's the eyes that expose his true language. 'It's the first thing you look at in someone's face, so it makes sense that, if you would try to represent a face the way you experience it, it might be the biggest thing, because it would force [the viewer] to look at it immediately.' Having a distinctive figurative style, carrying the baton on from the likes of David Hockney and reinventing it for himself, creates remarkable possibilities, but at the core Louis's people are always rooted in authentic realism. 'Even though it feels stylized or warped or manipulated, it's even more about a real person or a real experience of being near a body.'

Overleaf:
Doron Langberg, *Daniel Reading*, 2019, oil on linen, 243.8 × 406.4cm (96 × 160in). Doron's masterful use of colour and light is second to none. His paintings conjure up a mood so succinctly and effortlessly, they transport the viewer into another time and place.

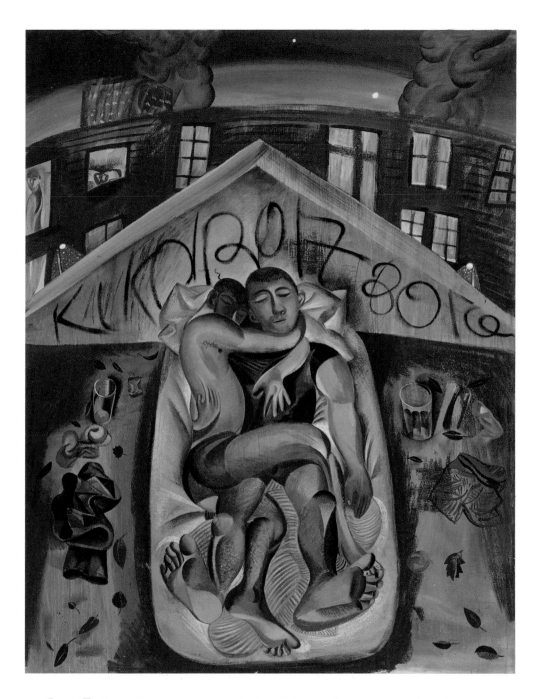

Louis Fratino, *Sleeping on your roof in August*, 2020, oil on canvas, 215.9 × 165.1cm (85 × 65in). Fratino's work stands out thanks to his tender representation of queer love, bonding and intimacy. His ability to work fluently across different mediums from painting and drawing to sculpture is astounding.

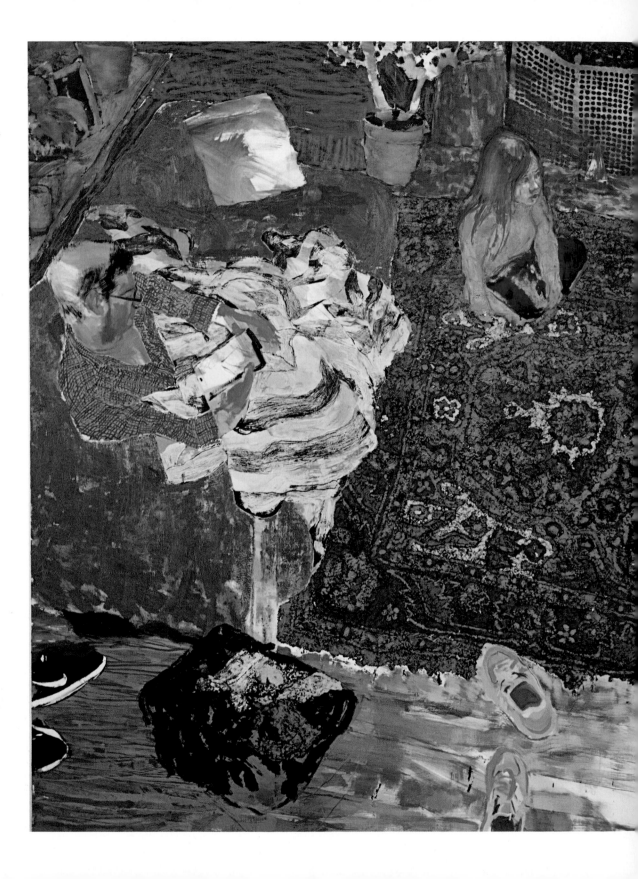

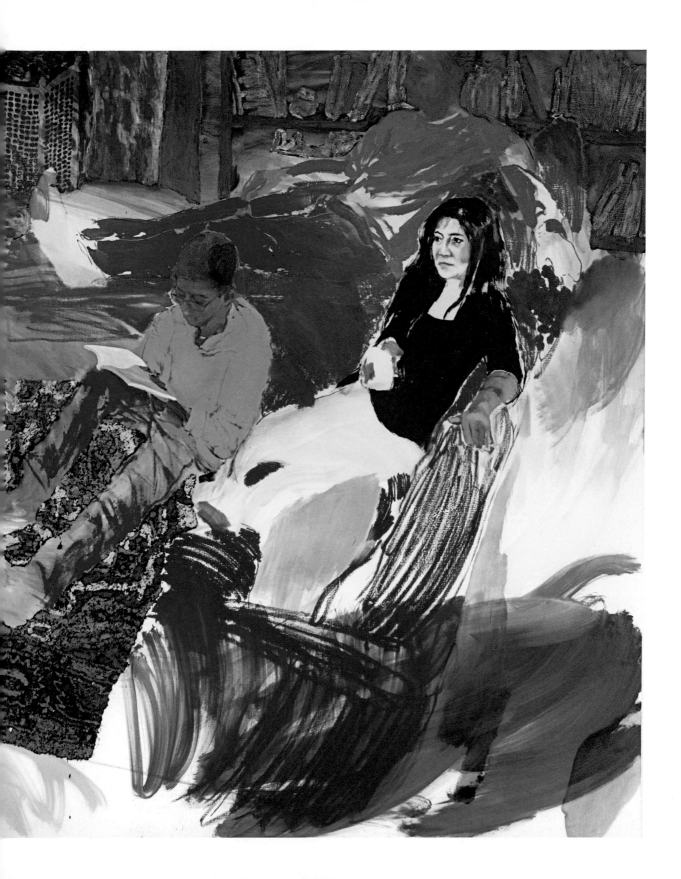

Representation in portraiture is knotted into the political. It carries weight and importance for the representation of marginalized voices, be that queer artists, people of colour or outsider artists: we must all see ourselves represented. An amazing painter, making works that carry dream-like qualities, is Israel-born, New York-based Doron Langberg. Also proudly queer, his subjects are seen in the throes of passion in the most explicit way, but washed over with poetic smoky light and nostalgia. 'For me, by humanizing a queer experience, that's a political statement.' It took Doron many years to give himself 'permission' to draw and paint these figures, which are defining of his own life, and to focus his work predominantly on queer portraiture. He describes his explicit work as 'a meeting point between the gap of how I experience my sexuality and how it is experienced publicly'. A master colourist, he captures casual domesticity – a bed, a picnic, a beach scene, breakfast – yet these lives are shown from a queer experience: through the lens of the gay gaze, if you will. They also never shy away from the truth of gay sex, in supremely intimate, revealing ways. Doron counts the use of his own body as imperative to the work and his interactions with members of a queer community in his life, be it sex or friendship: 'dick pics' on his cell phone, his partners, but also his own relationship to the canvas and his body. 'I think that, for me, using oil paint is a part of my body. Being hyper-sensitive to how a brushstroke moves, smearing it with my hand, finding different ways to touch the surface, is a huge part of the painting.' In 2020, making work that is proudly queer, open and showing the total truth of a queer life is still considered groundbreaking, shocking, or even revolutionary. Doron is able to show us that the experience of human sexuality, of all kinds, is still so open to interpretation and still so deep a well to delve into and to offer up for figuration in art. We still have so many stories to tell.

Amoako Boafo is a Ghanaian artist, based between his home city of Accra and Vienna. His work is a celebration of Black life, and an ongoing exploration into the Black diaspora. His works carry emotion, intimacy, and a unique serene energy. Using his fingers – 'I moved away from the brush, because it didn't give me what I wanted' – he creates the skin of his subjects, giving them a luminosity and depth that seem to go beyond the painterly surface. Hugely inspired by Egon Schiele, an Austrian discovery for Amoako, he says: 'Everything I learned from the art world, I learned from Vienna.' His work channels this master painter, as well as Gustav Klimt, Maria Lassnig and Kerry James Marshall, among others, to continue the art history conversation forward. What is important for Amoako is the face. 'Just the human figure, the human body, is interesting – [and] I learned landscape and still life – but it doesn't get me like portraiture.' Capturing figures where their Blackness is celebrated, that Black life is represented in a positive, joyful way. Giving these figures power is the mission in Amoako's practice, which has taken on different bodies of work to deal with identity. In 2018, he created a show called *Detoxifying Masculinity*, and later he created *Body Politics*. In these shows, Amoako comments on stereotypes – and, exposing them, what it is to be a man from Ghana – through an exploration of gender, masculinity and sexuality in contemporary art. 'It became something I was trying to deal with ... Is there really a way that you should look ... that identifies your gender?' Amoako's figures wear highly decorative floral patterns and bright colours, much like Amoako himself. 'What has a Ghanaian guy got to do with flowers?' He likes to play with fluidity for both his sitters and himself, which in turn has troubled many, but, as he says, 'I don't want to give into society's idea of what is what.'

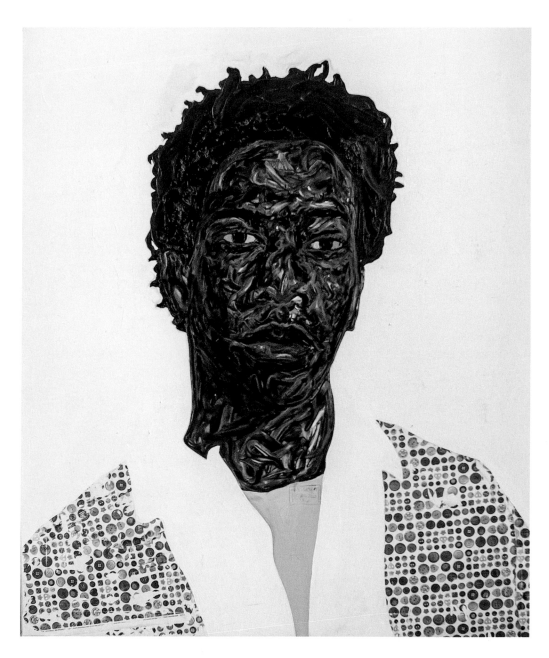

Amoako Boafo, *Buttoned Jacket*, 2020, oil on canvas, 120 × 100cm (47¼ × 39⅜in).
Boafo's unique approach to portraiture is inventive and joyous. We love his use
of pattern and the way his sitter's energy radiates from each painting.

WE MUST ALL SEE OURSELVES REPRESENTED

Hannah Quinlan and Rosie Hastings are an art power duo, a queer couple, driven by a need to preserve a record of the queer community in Britain today. In 2016, the artists presented their seminal work, *UK Gay Bar Directory*, a moving-image archive. 'We travelled around the UK. We went to 14 different cities. I think we filmed in over one hundred gay bars and spaces … It was just us two, with a GoPro camera, a tiny tiny camera.' The artists went outside of normal opening hours – 'we were being snuck into sex clubs at 9 a.m.' – to film the environments where queer people can go and feel welcome, safe and represented. The work allows for an understanding of how communities need to have their own spaces and how, with austerity measures, lack of funding and consequent closures, their absence can completely erode the foundations and security of a community. Often, the artists discovered, such spaces serve communities beyond the specific need for which they were created. 'In Blackpool we went to a bar that opened around 9 a.m. "Why open at 9 a.m.? That's crazy!" And the guy said,

"There's a really big homelessness problem in Blackpool and I'd rather that the people come here and have somewhere to sit all day in the warmth."' That guy needs an award. Another example of a venue providing not just a safe space but a lifeline was 'a bar in Brighton where everybody was over 80 … We spoke to the owner and he said, "It's basically an LGBT old-people's home."' Community-based art became the conduit for a whole body of work, which Hannah and Rosie are still continuing, and which 'is intended as a public resource. Things like the *Gay Bar Directory*, it was an artwork but we wanted it to be more than that. We wanted it to be something that people could use for research, or something that could be used for education.' The work was acquired by the Walker Art Gallery in Liverpool, with Art Fund money provided specifically for investment into queer art – as the artists conclude, 'the most validating thing in the world ever'.

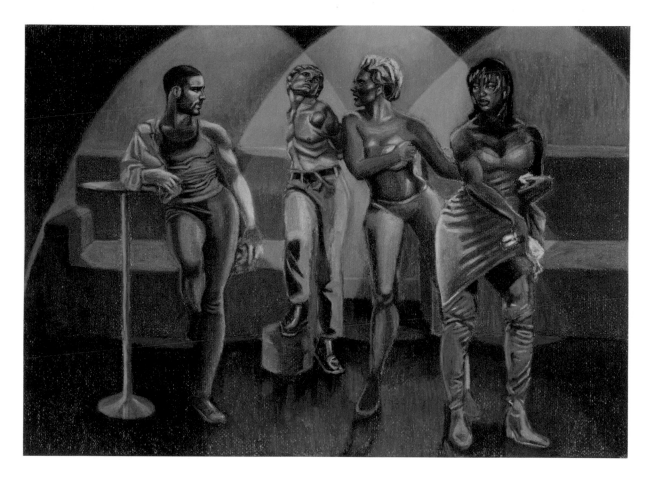

Hannah Quinlan and Rosie Hastings, *Lonely City*, 2019, pastel on paper, 69.5 × 50cm (27⅜ × 19⅝in). Through drawing, video, performance and installation, Quinlan and Hastings explore and memorialize queer spaces and venues that are increasingly under threat of closure.

Salman Toor, *Four Friends*, 2019, oil on panel, 101.6 × 101.6cm (40 × 40in).
Toor's paintings are intimate, highly personal reflections of queer Brown men living between
South Asia and the United States, informed through both imagination and autobiography.

Using both real and imagined experiences as an art source, Brooklyn-based South Asian-born Salman Toor presents highly skilled figurative works, which offer intimate views into an idealized queer community of Brown men, residing somewhere between New York City and Toor's home city of Lahore, Pakistan. 'Sometimes, merging them together, I can bring these two cultures – that are otherwise considered to be far off from each other – into one context.' Working in oil paint, Salman projects a narrative within each scene of a lived experience meeting a fantastical one. 'Autobiographical fiction' is a term that seems to come up a lot to describe this method. Growing up in Pakistan, Salman felt as if he didn't fit into 'a very macho atmosphere', and so he retreated to a world of drawing. 'I'd make friends with the drawings … One of my earliest embarrassing memories was my father standing behind me and giggling, because I was drawing and giving voices to them.' As he got older, Salman focused the story of his drawings and paintings. 'There's a story of friendship … among queer people of colour, who have intellectual and artistic pursuits and exchange ideas, and who have an unorthodox sense of family.' We are shown scenes of power in a 'queer bohemia': friends drinking martinis, dancing, 'consuming intellectual literature, deliciously', swapping pictures on smart phones, playing with kittens, watching Netflix. These figures carry 'dignity and glamour and a knowledge for the arts, which always goes across borders and cultures … I like to imbue the characters with that.' From the challenge – socially, politically and commercially – of being an artist, and an immigrant of colour living in the United States today, Salman channels anxieties into 'finding a community of people like myself'. Rejecting 'humiliation and the reduction of the self to basic documents and colours', he aspires to the notion that, through his images, 'someone in Utah can understand someone in Lahore'. By making representational work that appeals to the wider community, and by capturing a mood that can act as a beacon of hope, a message for the world, artists can reach far and wide. As Salman put it: 'it's a great love of the stories that can be told through oil painting that brings people together.'

Check out these artists too:
Njideka Akunyili Crosby • Alvaro Barrington • Gilbert & George • Juliana Huxtable • Jon Key • Nelson Makamo • Wu Tsang

ARTIST SPOTLIGHT

Jon Key

Family Portrait No. 6 (The Key Family), 2020, acrylic
on canvas, 152.4 × 121.9cm (60 × 48in).

The Man No. 6, 2019, acrylic on panel, 61 × 45.7cm (24 × 18in).

Jon Key is a writer, designer and painter whose work investigates themes of self-portraiture, ancestry, history and identity through four central themes: Southerness, Blackness, Queerness and Family. In recent works, he has introduced members of his family including his twin brother and fellow artist Jarrett Key, his parents and grandparents. Key employs numerous mediums including painting, printmaking, photography and drawing, always employing four colours: green, black, violet and red. The artist associates these central colours with intimate, personal memories both past and present. Jon is a co-founder and the design director of Codify Art, a Brooklyn-based multidisciplinary artist collective whose mission is to create, produce and showcase work that foregrounds the voices of people of colour, in particular highlighting women and queer people of colour.

The Man in the Violet Suit No. 14 (Violet Bedroom), 2020, acrylic on panel, 91.4 × 182.9cm (36 × 72in).

Sound

Art

Salman Toor, *Boy Ruins*,
2020, watercolour on paper,
24 × 19cm (9½ × 7½in).

Haroon Mirza, *Digital Switchover*, 2012, installation view: \|\|\|\| \|\|\
Kunst Halle Sankt Gallen, St.Gallen, 2012.
Haroon Mirza creates sculptures, performances and
immersive installations that generate audio compositions.

When considering sound art as a medium, many have assumed it to be the awkward middle sibling – not as easily understood and worthy as its older, wiser painting brother, and not gifted with the punky fresh clarity of its younger, film-making sister. But in the last few years there has been a resurgence in sound art artists. Noise has fully entered the arena, backed with doubled-down support from institutions, and many art prizes and grants specifically tailored to sound art. It's time for this medium to be properly heard.

Many artists connecting through sound do so using its purest form – literally, 'noise', and the vibrations of noise. They thus convert the experience of simply listening to an art form. Think of mediated noise – your favourite song or type of music – and how, through hearing this music, channels open up in your body, tapping into and releasing your very core, often allowing deeply ingrained emotional paradoxes to be revealed. Heavy stuff. But by reducing music down to its essentials, and using that base molecular form of sound, artists can create an extraordinary experience, and this can be explored.

Detaching sound work from the music world seems to be the ongoing bugbear for sound artists. Many artists find that music and sound are grouped together under one big noisy umbrella and that picking them apart, for most people, proves sticky. Ironically, many sound artists have found their way into this art form through music.

'Mostly I grew up with … what you would remember as '80s pop music.' We spoke to leading artist Haroon Mirza, who, through music and painting, discovered his love for a rarely explored world of sound expressionism – and that it was there, in essence, from the very beginning. 'I was obsessed with painting seascapes, then [that] fizzled out. But I understand now that I was already obsessed with waves.' Sound waves – the way that noise can travel, be tracked, recorded and harnessed – have fascinated Haroon for many years. 'Waves in various forms: sea waves, sound waves, light waves, brain waves. It's this obsession with waves that is still happening in my work now.' Haroon creates work that an audience experiences live, by being placed into a chamber where they can literally feel sound. His environments are charged with electrical currents, through light installations and pulsing sound vibrations. The air tingles and our bodies react. 'When you encounter these pieces and you have the sound of electricity being amplified and you're hearing it, you have a physiological response to it. It's not explicable. It's not understood. You wouldn't really know that it was happening. You might not even know that the sound is a live sound, but somehow your body knows.' As Haroon points out: 'Electricity is a live phenomenon, a natural thing like rain, wind or fire … A lot of people see my shows and come out with a headache: that's also a physiological response.' Tapping into something deeper, that goes beyond the surface level, is a magic that is being uncovered and explored by sound artists across the globe.

'Sound has this ability to do something that sight can't'

—Ima-Abasi Okon

Creating an immersive experience through the power of sound is a necessity for sound artists. Emotions and feelings are a fundamental 'mechanism' in viewing *all* art, but sound art truly transports you somewhere. To make and receive this work requires a different type of focus and a fresh set of attention skills. 'I want whoever is engaged in the work to sit and study with me. It's almost like the more you spend with it, the more it will reveal.' Ima-Abasi Okon uses objects and environments to construct an architecture through which her sound can be channelled. 'Sound has this ability to do something that sight can't do.' Ima's breakout show in 2019 at the Chisenhale Gallery in London adapted the gallery space into a tomb-like holding room, with an odd calmness, cool temperature and otherworldly sensation. 'I made it for the dead, but it doesn't necessarily mean people who have passed away.' Using eleven industrial fans, performing at various speeds and durations, some adapted with a speaker through which a music track plays at a super-slowed-down, ghost-like pace, Ima allows sound to wash over the viewer, creating a slowing down of energy as well as a feeling that something is about to happen. We discussed her use of 'tarrying'. 'Tarrying was a gesture I am familiar with. For instance, in the church that I go to, "to tarry" is almost like a form of prayer where you're waiting for an answer ... It's like, I am so desperate I'm going to wait for this, I'm not going to move.' Just how Ima is able to translate emotion into sound, or vice versa, is the key to her genius. 'How do I take this ability of sound to do this thing to you? How do I make work out of that, or how do I utilize that?'

Scientists have proven that hearing is one of the closest senses to the brain, in that we 'hear' with our brain, rather than with our ears. The brain can create audio-visual maps of an environment just through sound waves. With this in mind, joint 2019 Turner Prize winner, Beirut-based Lawrence Abu Hamdan, explores the 'politics of listening'. He felt that there was little understanding of the way in which amazing qualities can be harnessed through sound. 'People's obsession with sound was that ... it was somehow ghostly, ethereal; treated as this medium which was so far behind all of the thinking that had been done around the image ... People weren't ready to think *with* sound; they were too busy thinking *about* sound.' Through his groundbreaking work, Lawrence has become an 'earwitness' authority within human rights organizations. In 2016, he was approached by Amnesty International regarding advocacy for six survivors of Saydnaya prison in Syria, who had been kept in darkness or blindfolded or made to avert their eyes, resulting in an acute sensitivity to sound. Lawrence was invited to interview the former prisoners, 'based on what they'd heard, because they'd had such a limited visual experience of the prison in which they were held. I was looking for

Ima-Abasi Okon, *Infinite Slippage: nonRepugnant Insolvencies T!-a!-r!-r!-y!-i!-n!-g! as Hand Claps of M's Hard'Loved'Flesh [I'M irreducibly-undone because] – Quantum Leanage-Complex-Dub*, 2019, installation view: Chisenhale Gallery, London, 2019. Okon's works are complex and at times immersive installations.

precedents for how to do these interviews – to do dedicated "earwitness" interviews to really access their acoustic memories – and there was almost nothing.' Lawrence was able to craft the accounts he gathered – 'all the vital information was sound-based' – into a show, also at the Chisenhale Gallery. Through other 'earwitness' testimonies from legal cases across the globe, Lawrence has created an expansive library of sound effects. Such testimonies 'taught me about the relation of sound to architecture, to violence, to human memory, to the voice, to what is a voice.' A building collapsing made a sound 'like popcorn'; a gunshot 'like a rack of trays dropping to the ground'. In 2018, Lawrence made *Earwitness Inventory* (see overleaf), using taped recordings, but also filling the room with objects to which various 'sonic descriptions' had been linked: squeaky new shoes, a pine cone dropping to the floor, dry cannelloni pasta, unwound video tape. In the Saydnaya interviews, 'we were using sounds and tones, and mouthing sounds with our mouths, and using objects around us, and playing sound effects from films, to try and create a language for something that was essentially unspeakable'.

'WE THINK WE KNOW HOW TO <u>LOOK</u>,

BUT DO WE KNOW HOW TO <u>LISTEN</u>?' — DAVID TOOP

Another groundbreaking institutional show, which has been seen by many sound artists as informing and encouraging their practice, was *Sonic Boom: The Art of Sound*, shown at the Hayward Gallery, London, in 2000. This group show brought together a huge array of artists thriving in the field, and was one of the biggest exhibitions ever attempted of its kind. Curated by artist David Toop, it took over a darkened museum, allowing visitors to zone in and out of works. Introducing the exhibition, Toop asked: 'we think we know how to look, but do we know how to listen?'

Since the general feel of the exhibition was a cacophony of noise, rather than individuals' work having the opportunity to be fully engaged with, many found it frustrating. There was one specific work in the show that is now regarded as a defining piece of sound art history: *Guitar Drag* by the Swiss-American artist Christian Marclay. In this piece, an amplified Fender guitar is attached by rope to the back of a pick-up truck and towed across a rural Texan landscape. The sounds emitted

through an amp are a series of painful whines, screams and howls as the guitar's body strikes and scratches against roads and gravel tracks. Finally, as its battered and bruised outer casing is destroyed, it hums quietly in exhaustion. When Marclay created this work in 1999, he had been struck by the real event of the lynching of James Byrd Jr, a 49-year-old African American man, who had been dragged to his death behind a truck in Jasper, Texas, the previous year. Marclay's 14-minute-long work, politically loaded and carrying much metaphorical weight (a video was made, along with the soundtrack), thus invokes images of Black males dragged to their deaths by white supremacists. It also echoes the much-repeated ritual performed by buzzed-up rock stars when they smash their guitars at the end of a gig, exiting the stage and leaving the amp droning to a salacious crowd. 'I want the video to have these multiple layers and trigger people's imagination in contradictory ways,' Marclay has stated. 'The piece ends up being seductive and repulsive at the same time.'

talk ART

Lawrence Abu Hamdan, *Earwitness Inventory*, 2018, installation view: Chisenhale Gallery, London. Abu Hamdan's powerful and award-winning enquiry into the political effects of sound and listening.

Zoe Bedeaux, *From the Mouth of Babes Speak I*, 17 April 2015, film still. We first saw Zoe's film at the exhibition *Get up, Stand Up Now* at Somerset House, London, and it stood out as a compelling, unique and urgent artwork. Poetic, political and soulful in equal measure.

'Sound is one of the most powerful vibrations in the universe, it has the ability to clear and change the energy that surrounds it,' says artist Zoe Bedeaux. 'That's why music is so influential. When you strip a song back without any music and there's nothing else to get lost in other than words, you're transported to a different field.' Zoe's work frequently incorporates spoken word and sound, alongside her ongoing interest in masking, invisibility and the voice. By masking the body, the voice becomes a communicating force more powerful than it usually is. 'It becomes distilled. That's all you've got to work with, there is nothing else.' It's almost as if her voice is floating in the air. Because it's live, you can feel the person is there, but she's not visible. By the end of it, as an audience member, you join in with the trance of it all. There's a pulse to it, a rhythm.

Describing these live-action works as 'non-performance', Zoe told us: 'People get to see aspects of me, but they don't see who they think I am. I'm never in front of the camera where you can see my face. There's always an element of masking. As I dissolve the body, people actually get to experience who I really am. So by not seeing me you get to really see me. I associate performance with entertainment and what I'm doing is not performance. I've never had a desire to be a performer or to be performative in my work. My desire is to convey. As a person of colour, growing up I was aware that this is one area of few in which we have been allowed to be seen, recognized. The status quo dictates 'you can entertain us, but you can't challenge us', and that makes me uncomfortable. In the height of the Civil Rights Movement, the Jim Crow laws were even more strident as the struggle for equality continued. Black entertainers were still having to use separate toilets and entrances. It was disgusting, and still is, 400 years on. The injustice, brutality and discrimination still continues.'

Zoe also creates film work. Her *From the Mouth of Babes Speak I* can be described as a visual poem, but 'it's all about the audio. [In that piece] I'm heavily made-up, but the make-up is made to look like a mask … The reveal is also the integral piece, a soft sculpture that I made, which I am wearing and have become part of. It is not about how the poems are written, it's really about how they are delivered, how I articulate and manipulate the words, that creates the rhythm and the groove. There's a hypnotic aspect … with my use of semantic satiation and incantations. Through Shemanic practices, I inhabit the world of magic, raising vibrations as I go. The invisible poetess is a textual healer, an oracle of all time that is now! The poems go beyond your immediate field of consciousness. Even if people can't remember the words, they are left with the power and the resonance.'

Check out these artists too:
Tarek Atoui • Janet Cardiff • Florian Hecker • Susan Philipsz • Samson Young

Been Around the World (oceanfront property), 2018,
yarn, mixed media, found used postcards, clothes pins, paper on burlap,
167.6 × 167.6 × 6.3cm (66 × 66 × 2½in).

ARTIST SPOTLIGHT

Alvaro Barrington

For artist Alvaro Barrington, art world traditions hold no boundaries. Within two years of graduating from Slade School of Art in 2017, he'd captured the hearts of so many gallerists that, breaking art world tradition, they all decided to work together. They fused into a collaborative Power-Ranger network of top-tier international galleries, collectively facilitating the visionary, dynamic and erudite artist. Best known for using burlap – the fabric from which sacks are usually made that he then covers in thick, brightly coloured paint – Barrington builds up his images with a proud muscularity, at times using raw yarn to create stitches. Creating sexually nuanced arrangements of hibiscus flowers, with phallic stems protruding and fleshy fragmented body parts like pink bubble-butted clouds, he entices and invites an audience in. Influences from boundless sources, including Joseph Beuys and post-war German Expressionism, the late rapper Tupac Shakur, histories of the Black diaspora and, of course, Picasso play pivotal roles in the shaping and creating of Barrington's oeuvre.

A key lesson he learnt from his childhood growing up in Brooklyn is the importance of togetherness, an ethos he carries through into his work today, bringing in multiple collaborations all rooted in a sense of community. Jerk chicken and Caribbean food vans during art openings, Notting Hill carnival floats, club nights and music events – Barrington works alongside fellow artists and allows his platform to amplify and elevate other voices. Bursting with colour and zinging with life and energy, Barrington's work excites and inspires and his rule-breaking advancements allow space for new conversations, fresher audiences and unique organic environments and spaces.

Ceramics

Shawanda Corbett, *Hot Comb on the Stove*, 2020, acrylic, 56 x 76cm (22 x 30in).

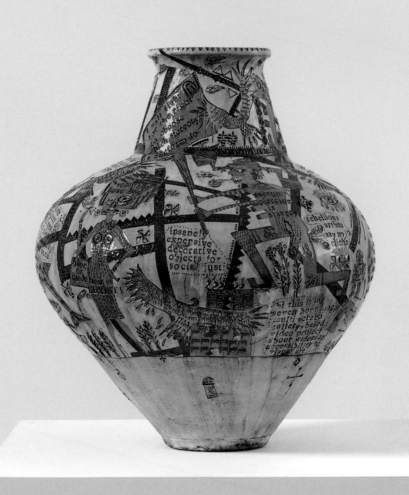

Ceramics have become a major passion for both of us. You could say we have gone potty for clay! As ridiculous as it may sound, we can regularly be found gossiping about a newly discovered ceramicist or lusting after a bowl or pot. Russell, in particular, has developed a keen eye and knack for discovering emerging artists working with clay, getting Robert on board and thus equally obsessed. In the early days of our friendship we would regularly visit Camden Arts Centre in London, where they have a long-running Ceramics Studio with regular classes and courses. They even have residencies and a Ceramics Fellowship with the mission to facilitate research and support artists who wish to push the boundaries of their ceramics practice. Their bookshop, which sells artist editions, became something of an obsession for us. We discovered and collected numerous affordable ceramics and sculptures by artists as wide-ranging as Caroline Achaintre, Jesse Wine, Francesca Anfossi and Anya Gallaccio, to name a few highlights. Still, to this day, there's a magic and compelling excitement about being able to acquire an edition from a unique series of handmade works that are fresh out of Camden's Ceramics Studio.

When you think of ceramics now, the first artist that may come to most people's minds in the UK will be Grayson Perry. His autobiographical and politically charged pots have garnered mainstream attention, and the Turner Prize-

Grayson Perry, *The Sacred Beliefs of the Liberal Elite*, 2020, glazed ceramic, 57 × 51 × 51cm (22½ × 20⅛ × 20⅛in). Perry's iconic pots employ numerous decorative techniques to highlight social issues including identity, class and sexuality, and provide satirical critiques of the art world.

People's very personal familiarity with ceramics is a powerful tool to use to communicate serious ideas

winning 'mad potter' (and his female alter ego Claire) is now a beloved national treasure. When he first started making and exhibiting in 1980s London, ceramics were deeply uncool, and it was considered 'un-modern' to be working with such a material. This turned out to be a liberating place from which Grayson could unlock his creativity. So-called serious art circles were incredibly snobby about ceramics, as there was still a hangover of the concept that ceramics were functional, utilitarian objects for drinking out of or eating off, unequal to the prized, elevated paintings or sculptures that graced the galleries of Cork Street. The legacy of the domestic, rustic studio pottery of Bernard Leach and Janet Leach, and even the more delicate works of Lucie Rie, perhaps upheld an idea that pottery was craft, or so everyday that it was not something that could be part of art world discourse. Even now, as a successful artist, Grayson continues to challenge art world elitism. 'There's still a snobbery between the kind of high-minded, political, intellectual part of making art and the decorative, sensuous, covetable side of art. I try to sit in the middle on that. I try to use political, social ideas and I'm also trying to make objects that people *really want* ... I think the art world is often mired in this idea that seriousness is only the sort of right-on, intellectually obscure, difficult idea. You come out of an exhibition feeling like you've done your homework. But people go to galleries on their day off. It's a leisure activity, folks!'

In the past decade there has been a major re-evaluation and acceptance of ceramics in the art world, as well as other fields such as textiles (tapestry is another medium of choice for Grayson; we have also fallen head over heels with patchwork cushions and quilts, particularly the ones made using unsold clothes by French fashion house A.P.C.). This growth has been so fast and significant that, in the past five years, ceramics have become omnipresent in commercial galleries, art-fair booths, museums and collectors' homes alike. From Sterling Ruby's monumental pots to Nathalie Djurberg's fantastical handcrafted clay characters, to Jonathan Baldock's eccentric face plaques and masks, to the wild exaggerated anatomy of Ruby Neri or the mysterious, otherwordly beings of Francis Upritchard, we've seen ceramics in major Miami museums, hip Los Angeles or Peckham galleries, and prestigious European art festivals such as the Venice Biennale. Artist Florence Peake makes clay sculptures, but also creates captivating, choreographed, live performances and films in which unfired clay meets a performer's nude body to expand on the relationship between movement and material, all to a soundtrack of Stravinsky's *The Rite of Spring*.

Gallerist Tommaso Corvi-Mora made a conscious decision to integrate ceramics into his exhibition programme. For the past ten years, he has also dedicated his time outside running the gallery to making and exhibiting his own pottery. We are both proud owners of many of Tommaso's vessels, having first unexpectedly discovered them in Duro Olowu's store in Masons Yard, London. Tommaso now also represents a number of ceramic artists, including Welsh potter Adam Buick, alongside artists in other fields. 'The one thing that brought me into making – or that I learned through making, really – was the whole tradition of British studio pottery, which is incredible … Even before Bernard Leach you have people in the very early 20th century, such as William Staite Murray for example, and you have a moment in the 1920s when pots, sort of big decorated vases, are shown with Ben Nicholson, with sculpture, with

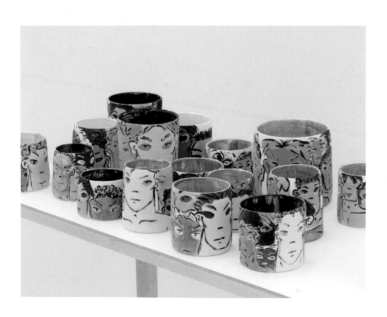

Tommaso Corvi-Mora, *Untitled*, 2018, underglaze paint on earthenware, 17 parts, overall approximately 120 × 110 × 46cm (47 × 43 × 18in). Corvi-Mora's work is a fresh, vibrant approach to ceramic making, informed by a keen interest in British Studio Pottery traditions.

talk ART

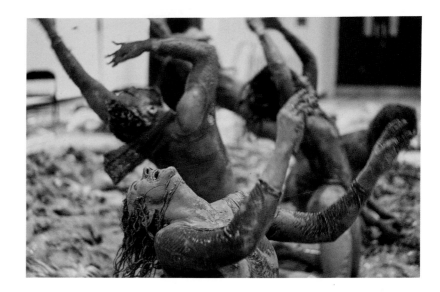

Florence Peake, *RITE: on this pliant body we slip our WOW!* 2018, performance view: De La Warr Pavilion, Bexhill-on-Sea. Responding to Stravinsky's *The Rite Of Spring*, Peake's work creates a political statement celebrating the joyous, bold physicality and power of the body.

painting, and it's considered all on a par, and that was an amazing moment. Then there's something that happens. There's a shift with Bernard Leach, where he starts talking about the importance of the functional side of pottery, and it's so weird because it's a practitioner who drags it back into craft. That's been such a huge, problematic dichotomy between art and craft that's been dragging on for decades and decades. So my idea was to go back to the '20s, to say, well OK, I have these objects that are just as individual and original as artworks. Let's put them together and see what happens … I really like showing artists with ceramic artists. It creates all sorts of interesting connections and links. It's wonderful!'

Recently, Tommaso has begun working with Shawanda Corbett, an interdisciplinary artist who has worked closely with ceramics. Her practice addresses the question of 'What is a complete body?', by looking at the different cycles of a human's life through cyborg theory. Awarded one of ten Turner Prize bursaries in 2020, Shawanda uses her perspective as a woman of colour with a disability to root theory into reality. Her first commercial gallery solo show, *Neighbourhood*

Garden at Corvi-Mora, included a series of ceramics intuitively and fluidly painted with glazes in response to the music of different jazz musicians, such as John Coltrane. Her meditative process of making has been strongly influenced by the culture and history of Japanese pottery, as well as of other ancient civilizations. Growing up in Mississippi and New York, and then studying at Oxford University, Shawanda makes sculptures that can be seen as 'bodies' exploring common tropes from 'the Hood': characters that are often invisible, or reduced to stereotypes. The desire is to give them the dignity and humanity that they seldom have in mainstream perceptions.

Overleaf:
Shawanda Corbett, installation view: *Neighbourhood Garden*, Corvi-Mora, London. Corbett's works find their origins in a reflection on the artist's experiences growing up, her memories of childhood and an appreciation of her community.

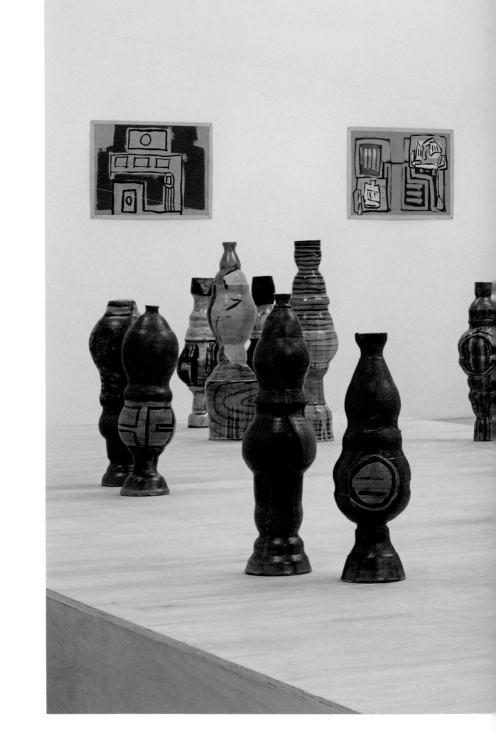

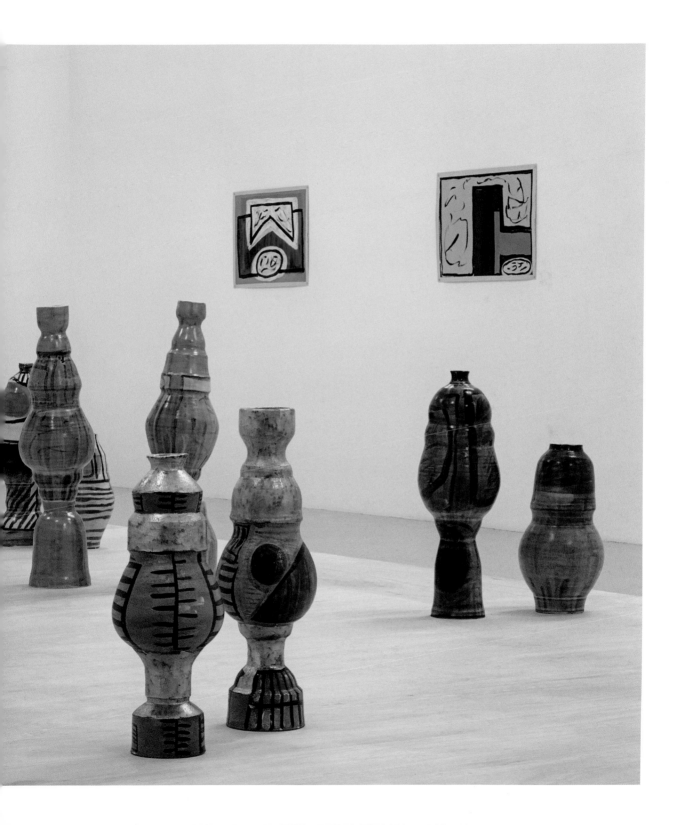

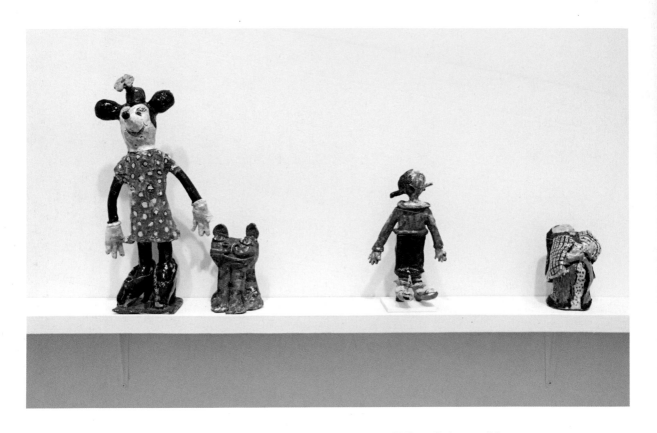

Magdalena Suarez Frimkess, installation view: White Columns, New York, 2014. Since the 1970s, Suarez Frimkess has been creating hand-painted glazed ceramics with wide-ranging influences, from mythological motifs to pop characters and advertisements.

We have come to learn more about ceramic art through other, unexpected routes, such as the depiction of pots in Jonas Wood's paintings. His admiration for and love of ceramics is clear and direct, almost becoming a form of celebratory advertisement, introducing us to the joys of his wife Shio Kusaka's vases and Magdalena Suarez Frimkess's Walt Disney-inspired ceramic figurines, mugs, plates and vases.

Born in Caracas, Venezuela, Suarez Frimkess began making art aged 18, after moving to Chile, and was very early on hailed by *Art in America* magazine as 'the most daring sculptor working in Chile'. A year later, in 1963, she made the move to the United States, where she began collaborating with potter Michael Frimkess, a member of the California Clay Movement.

Perhaps ceramics provide us with a reminder that there is a natural world outside.

DEFINITION → CALIFORNIA CLAY MOVEMENT

This American school of ceramic artists grew in popularity during the 1950s, with Peter Voulkos at the forefront. An influential teacher for a generation of artists, such as Ken Price and Nancy Selvin, Voulkos helped to shift the focus of ceramics from craft to art.

For fifty years Magdalena and Michael worked in tandem to create joint artworks, though separately focusing on their individual passions from different sides of the same studio. Michael's focus was on meticulously throwing the pots and vessels, followed by Magdalena adorning them with her idiosyncratic freeform visual language, hand-painted in colourful glazes. Together they created a prolific and compelling oeuvre, transporting ceramic art to a new place very much their own: two opposing forces brought together in one object. Their work, which had been overlooked for decades, is now collected and exhibited by leading museums, such as the Los Angeles County Museum of Art and the Hammer Museum, while international collectors have been attracted to the work's playful, joyful energy and relationship to comic books, animation, folk art and the dismantling of classical traditions. One such collector is leading fashion designer Francesco Risso, who successfully incorporated Magdalena's drawings and handwriting into printed fabrics that appeared throughout the Marni Spring/Summer 2018 collection. Now in her 90s, Magdalena has gone on to work alone: fired clay sculptures, figurines, teacups and tiles that are small in scale, yet more spontaneous than her earlier collaborative work. The vital, passionate dynamism of her most recent pieces has led to them becoming incredibly sought after, bringing her an even bigger audience.

Giles Round, *Still Sorry!*, 2016, partially glazed
stoneware, 25 × 24 × 8cm (9¾ × 9½ × 3¼in).
Round's ongoing series of ceramic phallic vases
reference the iconic 'Shiva' vase by Ettore Sottsass.

In recent years, other leading creatives have helped redress the stigma towards craft and pottery – most notably the fashion designer Jonathan Anderson, who has celebrated and elevated craft by incorporating ceramics and other mediums, such as basket weaving and tapestry, alongside and within his collections. His committed collaborations have helped to educate his audience, which is international and far-reaching thanks to his creative director roles at both his own eponymous label and, since 2013, the Spanish luxury fashion house Loewe (he has also been a central proponent of the Loewe Craft Prize). In 2016, a series of creative exhibitions were held in JW Anderson Workshop stores, with artists including Giles Round.

Round has created an ongoing series of ceramics, each a misappropriation of the iconic 'Shiva' vase by Italian designer Ettore Sottsass. The phallic vases, remembered badly and rendered flaccid, are both homage and apology to Sottsass. This entertaining exhibition

talk ART

also provided the stimulus for Round to create wearable art: a series of handmade, ceramic, sew-on bone-like phalluses were sold at the show for £30 (US$40) each, in ten different colours. The result was an introduction not only to Round's contemporary work but also to the earlier ideas and influence of Sottsass, founder of postmodern design and architecture group Memphis. Round himself is best known as co-founder of the Grantchester Pottery with Phil Root. His practice spans ceramics, sculpture, furniture, print, painting and textiles – a great example of the increased interest that artists have in architecture, design and functional domestic objects.

Fashion and art have a long and successful history of collaboration; see, for example, Alexander McQueen (Damien Hirst), Raf Simons (Sterling Ruby), Louis Vuitton (Richard Prince, Stephen Sprouse, Takashi Murakami, Yayoi Kusama, and many many more), Dior (Amoako Boafo, Raymond Pettibon and Mickalene Thomas, among others) and Yves Saint Laurent (he collaborated with Claude Lalanne, but was also famously inspired by Mondrian and Matisse). However, it must be said that occasionally fashion collaborations can feel forced, awkward or at worst cynical, coming across as nothing more than a marketing ploy. Anderson is an example of how to get it right. His depth of research and knowledge is evident and has led to a serious and authentic commitment to the arts. In 2017, he curated a group exhibition, *Disobedient Bodies* at the Hepworth Wakefield, which showcased a vast array of contrasting artworks by artists including Sarah Lucas, Henry Moore, Barbara Hepworth, Louise Bourgeois and Dorothea Tanning, and featured ceramic vessels by Lucie Rie, Hans Coper and Sara Flynn.

The ceramic zeitgeist was further illustrated by Tate St Ives's major retrospective of ceramics that same year, underpinning the new narrative that ceramics were no longer to be sneered at. This major survey explored the timeline of the last hundred years, bringing together works by fifty makers and contemporary artists who had adopted the medium as a central part of their practice. It included the collaboration between Bernard Leach and Shoji Hamada, highlighting the strong bond between Japan and the UK between 1910 and 1940; the aforementioned Californian Clay artists of the 1950s; the UK scene of the 1970s–80s, with Richard Slee and Gillian Lowndes; right up to the present day with Aaron Angell's Troy Town Art Pottery. What becomes apparent is the power ceramics seems to offer artists, in providing a very particular creative outlet that encourages freedom of expression, often joyful, but equally one that can be used to tackle serious political or social issues. Consider Lubaina Himid's work *Swallow Hard: The Lancaster Dinner Service*, which incorporates 'found' domestic crockery. She painted onto one hundred second-hand plates, jugs and terrines portraits of Black servants, African patterns, landscape imagery of vistas and buildings, as well as slave ships, uncovering hidden histories. There was an element of surprise and intrigue for the viewer, thanks to Himid's decision to paint onto already existing crockery. People approach such ceramics with openness, because of an existing understanding of or relationship to the material, the vast majority having used such ceramics in their own homes and kitchens. This very personal familiarity is a powerful tool to use within an art context to communicate serious ideas (see also 'Art and Political Change', page 83).

We adore the autobiographical works of Lindsey Mendick, whose personal memories are launchpads for complex, ambitious immersive installations filled to the brim with wild and exuberant ceramic sculptures and more recently paintings and textile works (on which she collaborates with her mother). Mendick's work has a gothic sensibility with gruesome themes of disgust and repulsion frequently reappearing. Her oeuvre is an exhilarating exploration of the abject in everyday banality.

Numerous books have recently been published to mark the ever-growing appetite for and fascination with ceramics. But why ceramics? And why now? Could it be that we are yearning for the earth, for something so directly connected to nature, for something we can hold in our hands, something REAL? At a time when we are divided between the polar opposites of digital and natural – many of us tied to our computers, to the Internet, to social media – perhaps ceramics provide us with a reminder that there is a natural world outside. Or is it some kind of inner desire to go back to simpler times, to some kind of childhood joy, when we got creative and messy? The

idea of working and kneading clay in our hands could also be linked to the vastly popular return to people baking bread at home and growing sourdough starters. Not forgetting the resurgence of knitting … Perhaps this is not a coincidence.

You only have to look to the high street, with design and homeware stores offering numerous handmade products. We have bought one-off pots and bowls from London stores such as SCP by designers such as Max Lamb or Fort Standard. Margaret Howell carries a selection of vintage homewares and Ercol furniture, and has promoted domestic forms by contemporary British studio ceramicist Nicola Tassie, including handmade lamps, vessels and sculptures. We've discovered hand-painted bathroom tiles from the New Craftsman, and spent hours scouring eBay for vintage bowls, and the market stalls of London, Paris and Berlin, and the medina in Marrakech. Artist-designed kitchen products have become all the rage, with museum gift shops beginning to sell high-quality porcelain or china teapots, eggcups and mugs by some of our favourites, including Tracey Emin, Katherine Bernhardt and David Shrigley.

Lindsey Mendick, *First Come, First Served*, 2020, glazed ceramic, 40 × 28cm (15½ × 11in). Mendick's ceramics are bold, ambitious and revolutionary, breaking new ground with her inclusion of deeply personal autobiographical references.

Other artists have produced unique ceramic works with the aim of pricing them affordably, such as Noel McKenna's democratic approach to making paintings on ceramic tiles, proving it's a medium where people are able to explore the value and accessibility of art. Heal's in London has offered the exquisite mugs, plates and bowls of South African ceramics expert Mervyn Gers. Habitat stores have followed suit, with a noticeably increased number of rustic ceramic plates and so on available in their stores, where they even have stickers to warn consumers that each product is handmade and therefore will slightly vary in shape. This move to individuality in something as simple as a domestic mug arguably speaks volumes about where we are in current society. Perhaps we are all longing to be unique, to hold something handmade, in a time of uniformity and homogenous globalization.

Francis Upritchard, *Wetwang Slang*, 2019, installation view: Barbican, London.
These vessels were perhaps inspired by 1970s studio pottery that Upritchard saw growing up in New Zealand.
Upon closer inspection, strange faces reveal themselves like lost creatures from another world.

talk ART

Noel McKenna, *Dog looking at door*, 2016, hand-painted ceramic tile, 14 × 19cm (5½ × 7½in). McKenna's ceramic tiles and paintings present domestic spaces; recurring themes include heart-warming depictions of cats and dogs.

Check out these artists too:
Lynda Benglis • Fischli & Weiss • David Gilhooly • Elisabeth Kley • Klara Kristalova • Takuro Kuwata • Peter Shire • Sebastian Stöhrer • Rosemarie Trockel • Ai Weiwei • Betty Woodman

In late 1970s Philadelphia, a box containing close to 1,200 small, wire-framed sculptures was found abandoned in a back alley on 'trash night' by a passing art student. There was no known artist and, in a rapidly changing neighbourhood, nobody was aware of who they had once belonged to, or how and why they had been made. For the past 30 years, these totemic sculptures have baffled and intrigued curators, collectors and critics alike. The 'Philadelphia Wireman' was born: an 'outsider artist' whose discovery shared similarities with that of the granddaddy of the outsider art world, Henry Darger. But what exactly is an 'outsider artist', who is Henry Darger, and where do these artists fit within the art world canon?

Henry Darger was a quiet man, who kept himself to himself in his part-time job as a hospital janitor in Chicago in the 1900s. At the age of 19 he committed to what was to become his lifelong project – completing an illustrated manuscript of over 15,000 pages, containing intricately drawn watercolours. Darger made this huge body of work in private, in a tiny rented one-bed apartment. The manuscript was only discovered in 1973, around the time of his death, by his landlord. The content of his work took the American civil war as its core, but added depictions of very young girls battling soldiers and escaping to freedom. Not much is known about Darger, but what we do know

Philadelphia Wireman, *Untitled (Baseball)*, c. 1970–1975, wire, found objects, 14 × 12.7 × 18cm (5½ × 5 × 7in). The Philadelphia Wireman sculptures were found on a street in Philadelphia but the artist's identity was never discovered.

This is work that shows humanity at its most authentic, raw and honest

is that this was a man who was spurred on by creative impulses to make this work – not for an art market, not for an audience, but simply for himself and his own deeply personal obsession. Darger falls into two art world categories: 'self-taught', meaning that he taught himself to draw and paint outside of art academia, and 'outsider' or 'outlier', as he made work outside of the traditional art world conversation. Marginalized and secretive, mysterious and fascinating, Darger has become one of the most talked-about and referenced artists in this field. He joins the Philadelphia Wireman as something of an outsider hero. Darger's authorship was known, but the identity of the wire sculptor of Philly will probably remain the stuff of legends.

But how did the 'outsider' term come about? In Britain, in 1972, art scholar Roger Cardinal wanted to write a book on the art brut movement (see overleaf), but for an English-speaking audience. His publishers were troubled by the term, as '*brut*' literally translated as 'raw' or 'brutal'. So after much compromise and debate, the book was titled 'Outsider Art' and since then the term has stuck, much to Cardinal's dismay, as he considered the term problematic. To be classed as an outsider carries a weight of exclusion, the prospect of never being considered an 'insider' – a perception that so many, still even today, work so hard to change.

DEFINITION → ART BRUT

This term was coined in the 1940s by French artist Jean Dubuffet to categorize a movement of marginal artists working in France and Switzerland. Himself an art school drop-out, Dubuffet conceived the title to encapsulate an unorthodox way of making and creating art. He strove to destigmatize this art, which was being made on the fringes of society by 'mad' people, and to legitimize it by bringing it out into the mainstream culture.

A lot of the work created in this genre is defined by being made without the pressures of the commercial art market, and conceived without any responsibility to conversations around art history. Many artists who are classed as having mental-health issues, autism or disabilities whether learning or physical (including deafness and blindness), and those who are defined as 'adult survivors', create work that shows humanity at its most authentic, raw and honest. There are many champions of outsider art: many contemporary artists look to art brut for inspiration in their practice and language, and many curators now consider this work within the art canon.

There are fantastic resources around the world for artists working in this field: superb studio systems, and grants and funding, to support the expression of the self through the making of art. Jennifer Gilbert runs a commercial art gallery, representing self-taught, evolving and overlooked artists from around the world. Based in Manchester, UK, and without a physical space, Jen relies on pop-up shows, social media and her website to raise awareness for and interest in the artists she champions. 'I've been working with artists in the field for a very long time … I started

Pradeep Kumar, *Carved Toothpicks*. Kumar's highly-detailed sculptures are precisely carved with a razor blade onto matchsticks (see page 156). These tiny works depict figurative images of birds as well as portraits of people.

working with artists with schizophrenia in local community art classes … and with artists who are isolated.' Jen's drive is to solidify a place for outsider artists in the 21st century and to protect them from being taken advantage of. 'I really wanted to become this driving force, to be that person that stops the work being exploited and to stop these people being exploited; to really nurture and take care of them, and take care of their ethics in this field.' With a background of working with disabled people, and supporting artists with learning difficulties as a trustee for The Barrington Farm Trust, Jen is an incredible supporter of overlooked artists working outside of the mainstream. 'Ultimately I want the artist's voice to be heard.'

Recently, a major shift has happened in the way contemporary outsider artists are exhibited, curated and collected, largely because of the way that historical outsider artists are now being celebrated and positioned within art history. Two artists who have created incredible possibility and opportunity for the artists of today are Bill Traylor and William Edmondson.

Self-taught, Bill Traylor didn't start making his drawings until he was in his mid-80s. Born into slavery, after his emancipation he would spend the majority of his life as a sharecropper, before moving to Montgomery, Alabama, in 1939 and becoming a sidewalk artist, selling his drawings to passing collectors. He produced over 1,500 drawings in his lifetime, on small scraps of paper and cardboard, inspired by observation of the people and things around him. Recognized with a public exhibition in 1940, he has since come to be hailed as a master in the folk art movement, and is now considered central in modern art history. His work, naïve in style, has attracted the audience of the larger art world and his prices have rocketed – both fantastic devices for changing the perception and reassessing the importance today's practising outsider artists.

DEFINITION → FOLK ART

An artwork or object made by a skilled artisan – not particularly trained in traditional fine art – can be considered folk art. These are cultural objects created within the context of a given community. Often intended for practical, utilitarian purposes rather than purely decorative, they can take on and cover all forms of visual art such as basketry, ceramics, leather crafting and quilting. Historically many artists have been inspired by folk art. For example, Picasso was heavily influenced by the sculptures and masks of African art.

In 1937, William Edmondson became the first-ever African American man to have a solo show at New York's Museum of Modern Art (MoMA). Historical, groundbreaking and culturally important, his work was seen by a whole new audience. Like Traylor, his relation to slavery was very close: the son of freed slaves, he was born into hardship, afflicted by poverty, and received very little formal education. After twenty-five years as a hospital janitor, he lost his job in the Great Depression and was forced to seek other employment, finally settling in the role as assistant to a stonemason. Through tombstone-cutting, his interest in sculpture began. Working in limestone from found curbstones and demolished housing, he wielded a sledgehammer, picks and found objects to create his religion-inspired carvings. Driven by God to make his stone masterpieces, he didn't find motivation in celebrity or money and so, rarely making any money in his lifetime, he never lived to see the record-breaking figures that his work would make across international auctions, almost 70 years after his death.

Unique creative <u>liberation</u> can occur when there is total <u>freedom</u> from the system.

Shinichi Sawada, Pradeep Kumar and Misleidys Castillo Pedroso are three international outsider artists whose work is shifting the dial for evolution and representation in this field. All nonverbal, they make work in their own private, insular worlds. Sawada, bread-maker by day and sculptor by night, works in a studio in Japan. His creations inhabit a world inside his head, where mythical sea creatures carved out of clay roam the land. In the afternoons, Sawada is taken up to a hut in the mountains to work. 'This hut was built for him in the early 2000s. It's literally a shack, in the middle of the mountains, surrounded by rice fields,' Jennifer Gilbert told us, and here he works in near silence, building his spiky ceramic monsters for hours – not for an audience in any sense, just for himself. His work is now collected all over the world, and even by the likes of superstar artist KAWS, who is a massive champion of the work of many contemporary and historical outsider, self-taught and folk artists. Sawada now has museum shows, and his work is discussed within an art historical context. The money he makes from his art goes back into his family and his production, sustaining the ability for him to keep on making his inspirational art.

In the collections of multiple prestigious museums, including the GAIA Museum Outsider Art in Denmark, Pradeep Kumar's work has secured him a solid position in the canon of art. Deaf and unable to speak, he struggled at school and was ignored by teachers as he sat at the back of his classes carving blackboard chalks into detailed shapes. Finding a matchstick one day, he challenged himself to carve into it, and what followed was a realization of exceptional ability. He could create works of beauty, with the skill, patience and intense focus needed to carve into the solid wood of tiny matchsticks and toothpicks. He makes small birds, and women in dresses, every animal you can think of, and men in traditional dress, then adds paint to his miniature sculptures to highlight their intricate details and clothing. As well as interest from galleries and collectors, Pradeep has secured much respect from his home country of India, where he has received multiple awards and accolades.

Shinichi Sawada, *Untitled (53)*, ceramic, 20 × 18 × 34cm (8 × 7 × 13⅜in).
This prolific Japanese self-taught artist creates charismatic ceramic creatures, covered in little thorny spikes.

No one knows where Misleidys Castillo Pedroso first found the inspiration for her work. One day she just began to paint and cut out silhouettes of hyper-muscled bodybuilders, men and women, scantily dressed, in bold, bright colours, with large hands and feet, then stuck them all over the walls with small tabs of brown Scotch tape placed evenly around them. This young Cuban-born artist has gained a humungous following. The subject of reviews in the *New York Times* and *Art in America*, Pedroso has shown her work in over ten international exhibitions, and continues to find collectors and institutional fanbases. Born deaf and showing signs of developmental difficulties, she was placed in specialized care until her autism was fully diagnosed around the age of five. Living apart from her mother and brother, she started to create this muscled figurative world, many of her pieces larger than life, and it has since branched out into wildlife and demons and studies of singular feet, hands, eyes, heads and cut-away sections for the figures' clothing and faces. Those close to the artist claim she has inherited clairvoyance and is sometimes seen communicating with the figures by using her hands. She has created a community for herself, in which she lives and seems to find peace, while her striking works continue to captivate an international audience.

These art brut/outsider/outlier/self-taught artists may make art only for themselves, but how they are received in the world is centrally important. They hold within them the mysteries of the human condition. They have found their audience from a place of fascination and respect, showing us a part of ourselves where innocence can allow a talent in creativity, unaffected by considerations of the world in which the rest of us live. In some ways, these artists are fundamental to the understanding of what and who we are, and they show us the unique creative liberation that can occur when there is total freedom from the system.

Misleidys Castillo Pedroso, *Untitled*, c. 2015, gouache on paper, 56.5 × 33.6cm (22¼ × 13¼in). Cuban-born Pedroso has developed a unique visual language of bodybuilders, mythological creatures and imagined demons.

Check out these artists too:
James Castle • Nek Chand • Gerry Dalton • Madge Gill • Lee Godie • Clementine Hunter • Susan Te Kahurangi King • Adolf Wölfli

ARTIST
SPOTLIGHT

Lotus Belleek Bottle, 2019,
glazed stoneware,
38.5 × 25.5cm (15 × 10in).

Plum Tree No. 2, 2019, Dehua Blanc de Chine Porcelain,
52.1 × 26.9 × 18.5cm (20½ × 10½ × 7¼in).

Jeffry Mitchell

Fragrant Bottles and Golden Alphabet, 2019, glazed stoneware with gold lustre, Bottles 22 × 24cm/ 8¾ × 9½in (size varies), Golden Alphabet 3 × 3 × 7cm/1¼ × 1¼ × 2¾in (size varies).

Treating clay with a universal familiarity, like a child making mud pies or squeezing shapes out of PlayDoh, Jeffry Mitchell imbues his pieces with a joyful everyman quality, a lightness of touch and playful immediacy. Covering his complex pieces with a world of imagery, from bunny rabbits, elephants (or Elefants as he likes to call them) and bears wearing leather jackets to flowers in full bloom, his ceramic works feel accessible and universally familiar. Relating to chapters within his own personal life story, the playfulness that he imbues into

his work contains complex emotions. Even if on the surface his artworks may seem decorative and simple, within them they vibrate with an unfettered shared human experience. His incredibly skillful works are developed from the many years of looking at ceramic traditions from around the globe, with references to early American glazes, Dutch pickle jars, Japanese asymmetrical aesthetics and Chinese lion dogs, making his pieces exude a satisfying vitality and directness.

Cartoon Art

KAWS, TEN (Talk Art),
2020, ink on paper,
27.9 × 35.6cm (11 × 14in).

In some ways, the most important and most highly political messages of our times can be filtered best through the means of the cartoon. *The Simpsons* and *South Park* are so on the nose with their ability to satirize and prophesy who and what we are as a society. The 'safe' use of cartoon imagery – imploring bug eyes, rainbow-spectrum-colour skin, cute forest animal exteriors with naïve sweet baby-voiced outpourings – can lull an audience into a false sense of security, so they don't immediately realize what they have seen. Artists who can fuse together work inspired by the cartoon and create a melting point for the visually captivating in combination with subliminal messaging offer up some exciting and fresh ways to tell a story. Equally, cartoons aimed at younger audiences often have jokes for the intended audience but also further layers and in-jokes to amuse parents. Animation is an accessible and fun way for children and teenagers to begin connecting with the visual world and to discover art and creativity, much like Russell did (see page 19), which led to his adult passion for contemporary artists who reference animation and cartoon iconography.

Like being run over by a monster truck, the visual assaults of New Jersey-born Jamian Juliano-Villani's paintings smack you in the face with a giant neon claw hammer. Growing up within her parents' silk-screening business, flicking channels between American network and cable TV, Jamian acquired a skill set for image collage and graphic design from an early age. She presents us with a barrage of imagery, playing with our sense of déjà vu. Her appropriated images, referenced and sourced from counterculture, form an 'arranged marriage' for her audience. 'I want them to cancel each other out, so you become totally confused … not confused, but your brain can't make a decision.' She allows her paintings to hang out on the canvas, pulled from so many obscure sources that only she can truly understand them. 'I have an encyclopedic brain … They never co-exist in any other way.' In addition to magazines and album-cover imagery, the Internet serves Jamian as her biggest tool and asset. However, appropriating elements for her imagined, hyper-real, saturated scenes isn't always possible. 'Sometimes the thing doesn't exist in real life or online, so you have to make it yourself.' A one-time studio assistant to the visual art stars Dana Schutz and Erik Parker, Jamian observed and learned, but her work doesn't always come from an insular imagination. She likes to crowd-source ideas for her imagery. 'If it's just your voice in it, it's like a lecture, but if it's a group of people, it's more like a chorus.' Many people coming fresh to Jamian's work are struck by the placing of her complex motifs – 'it's not random' – but at the end of the day she wants the audience to do the work, connecting the dots. In excavating popular culture and continuing to take her work forward with even more extreme imagery, she concludes: 'How the paintings function is, you wanna like it, but you also don't want to admit to liking it.'

Jamian Juliano-Villani, *Hand's Job*, 2019, acrylic on canvas, 152.4 × 123cm (60 × 48in).
Juliano-Villani's highly skilled paintings collage together long-forgotten imagery
from the vaults of culture in new and unexpected combinations.

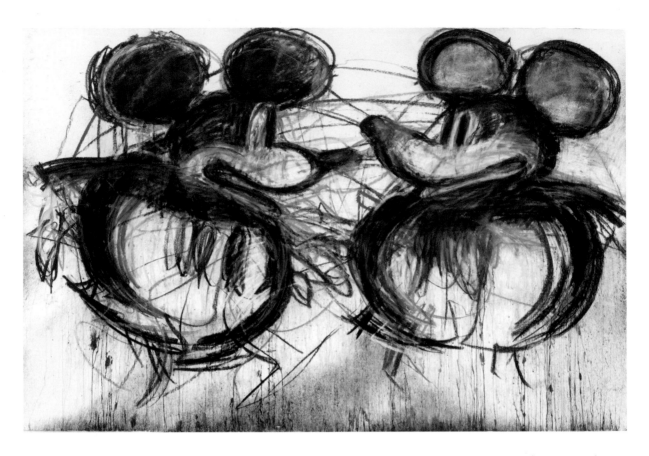

Joyce Pensato, *Underground Mickeys*, 2019, charcoal and pastel on paper, 152.4 × 229.9cm (60 × 90½in). Pensato's monumental paintings of cartoon characters and comic-book heroes were frequently created with dripping, layered thick black enamel brushstrokes.

Pushing the boundaries in imagery is hard for many artists. But using and being influenced by cartoon culture is a big go-to for many, including the late, great Joyce Pensato. She made a career out of mutating recognizable cartoon characters and superheroes into chromatic black-and-white expressionistic paintings and drawings. She said: 'I was resisting working with the traditional still life—apples and pears and all that crap. I just fell in love with Batman. I think it was the ears.'

American culture amalgamated with a beautifully messy imagination allows Batman and Bart Simpson to drip enigmatically down the canvas, staring out at us with queasy, sinister unease. Classed within a lineage of action painters – 'I totally love to be physical' – Joyce smeared and spread, flicked and splashed black and white enamel house paint onto her canvases without any need or care for careful application. The characters loom into her work from a place of darkness. 'What I had deeply was anger and emotional expressionism … Death, Holocaust, that was a part of me. I was into the German Expressionists, anything with death scenes and pain.' Her cartoon characters created a close family, and a device through which Joyce could express her innermost anger. But you'd be mistaken in thinking she was a super-fan of her innocent, happy, child-friendly subjects. 'I'm not about cartoons, only the images … I can't watch them, all those voices.' She made cartoon portraits that are deeply and emotionally complex, comedic and furious, humanizing them and then giving them clinical depression, fearless as to how revealing this could be. Instead, her paintings liberated her with their rawness and angst.

Taking inspiration from the likes of Alex Katz, Chris Ofili, Laura Owens, Stanley Whitney, Josh Smith and Mary Heilmann, self-confessed Coney Island fan and St Louis native Katherine Bernhardt creates sprawling, visually striking pattern paintings. Full of isolated pop images, jampacked against each other with no sense of connectivity, they buzz with an Andy Warhol energy and a Keith Haring continuity. Taking African fabrics as a concept idea, Katherine infuses her work with lush contemporary iconography: shark fins appearing and disappearing, Doritos, watermelon slices, sea turtles swimming, toilet rolls, Nike trainers, Scotch tape, and 'cigarettes have always been there'. They repeat and appear across canvas after canvas, first made with specific details and bold outlining, then taking up the more jumbled energy of the action painters. 'I just want to mess it up more, like I can't stand it, I just want it to be more puddles and do its own thing.' Cartoon characters first appeared in Katherine's drawings from an early age: 'Weird figures like ET. That was the first one I painted … I was obsessed with the movie.' Then, later, after observing what her son was watching, 'Pink Panther and Garfield and stuff; it's figurative again.' Her goal is for the work to have no meaning: a nothingness of things, full of clashing colours, comedically silly and illogical, art made for art's sake. Painting like she's running out of time, she continues to actively look for ideas and inspiration in what has come before. 'I saw that [Jean-Michel] Basquiat *Xerox* show uptown … He xeroxed all these paintings he'd made of crocodiles, and there's crocodiles all over the paintings. It's kinda awesome, and I was like, I'm gonna steal that crocodile image.'

Overleaf:
Katherine Bernhardt, *Jungle Snack (Orange and Green)*, 2017, acrylic and spray paint on canvas, 304.8 × 457.2cm (120 × 180in). Bernhardt's wild and expressive paintings have inspired a loyal following around the world thanks to her iconic grid paintings that feature everyday objects as varied as cigarettes, toilet rolls and batteries, and elements from nature such as sharks, toucans and orchids.

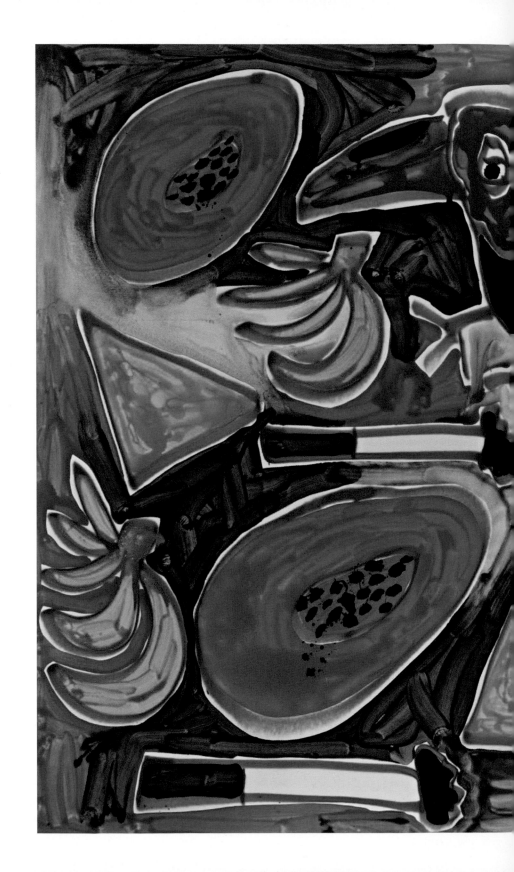

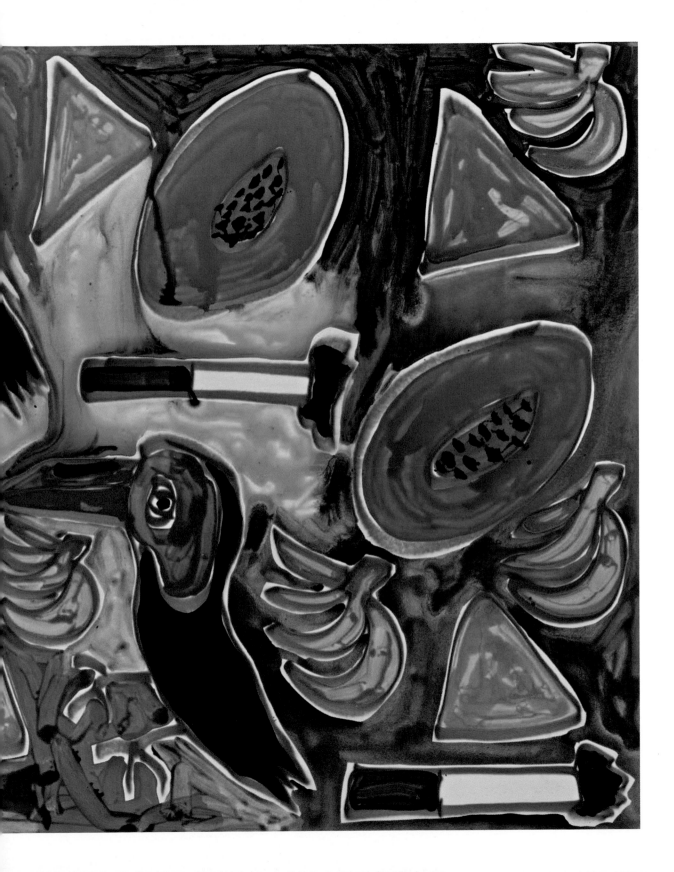

CARTOON IMAGERY CAN LULL AN AUDIENCE

INTO A <u>FALSE</u> SENSE OF SECURITY

Subverting high and low culture through visual art has thrown up so many of the greats. 'I grew up loving cartoons, I love people, and I love storytelling.' Bronx-based Cheyenne Julien is an artist who tracks both her history and the present day through an ongoing series of self-portraits, portraits of her family members, and imagined characters. 'The work is so much rooted in the people and [the] place that I am.' Mixing the device of the cartoon with her signature style and a love of science fiction from the likes of writers Octavia Butler and Nalo Hopkinson – 'using sci-fi as a space to redefine Blackness and talk about Black bodies' – Cheyenne's work bears witness to a life growing up and living in the Bronx. Visually striking, her work lures you in, only for you to discover unsettling messages that jolt with nervous energy and anxiety, exposing societal, architectural and environmental racism. 'Architecture is something that's imposed upon your body, but also the way that you navigate that space depends on how you're situated

in the world ... Race and architecture are completely intertwined at all times.' Through her use of 'comic formalism', the characters who populate Cheyenne's community are given large, expressive, cartoon bug-eyes, full of love or terror, and they dart around, seeking out impending danger or attention. The figures, rooted in their bodies by large strong hands and feet, carry honesty, depth and sincerity. Rather than looking to Disney or Hanna-Barbera, Cheyenne first found her influences in manga. 'I watched a lot of anime growing up; I still do.' Within our everyday lives, the cartoon is considered outside of reality, but for Cheyenne, by projecting her personal life through a comic-book style, they become a way to bring us closer to her truth, and they make it even more real. But does an artist find this exposure of the personal hard to reveal to the world? 'If I didn't think anything was at stake, it wouldn't really feel good for me ... I've always measured if the work is good or not, by if I'm embarrassed by it or not.'

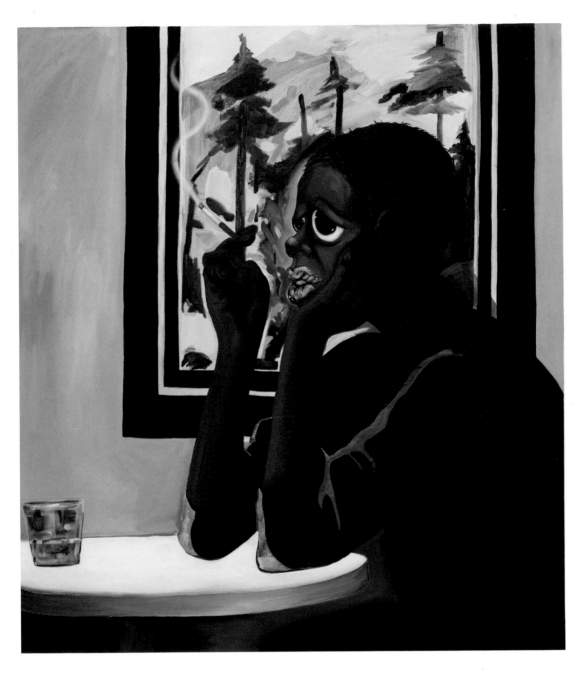

Cheyenne Julien, *Morning Cigarette*, 2018, oil on canvas, 152.4 × 132.1cm (60 × 52in).
Cheyenne's figurative work presents personal and autobiographical memories whilst considering
wider social issues including environmental racism and generational trauma.

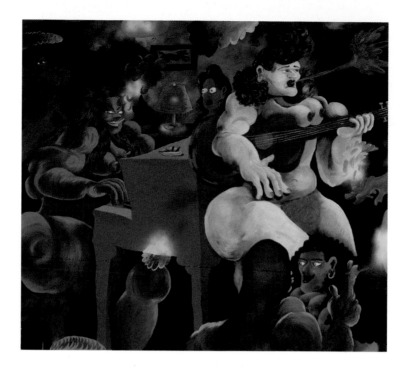

Ana Benaroya, *Hot House*, 2019, spray paint, acrylic paint and oil paint on linen, 190.5 × 210.8cm (75 × 83in). Benaroya's intensely colourful paintings of exaggerated, muscular female bodies reference cartoons and caricature with a fresh, queer perspective.

Also US-based, the artist Ana Benaroya grew up playing with the action figures of the 'Silver Surfer' and 'Green Lantern', animating them through imagined back-and-forth conversation. She has managed to harness this innocent energy into her artwork today. Liberated on the canvas, Ana draws on the freedom she felt in her childhood to create her bold, colour-saturated work that almost screams at you from across the gallery wall. Always imagined, bright, toxic, neon-coloured parades of an exaggerated female-led carnival of sexuality and life sprawl across her scenes. As a queer female artist, Ana champions the importance of populating her world with a strong female-led cast of characters, and creating highly comical and highly sexualized interactions. A hyper-muscled, purple-skinned woman with a wrestler physique and bright yellow mullet haircut clambers over a piano, her nipples erect, doubling as page-turners for her intricate sheet music and as a finger substitute for the minor keys. Women hold each other up, as they dance and spin around, biceps bulging, calf muscles vibrating, smoking and chatting as plumes of cigarette smoke billow over half-full martini glasses, the women's thick wrists shaking with potential, as the thought of next-level mindblowing aggressive sex looms large in the air. Exaggerating the human body, Ana's work, always figurative, grants her women agency. With their physical power, she upends traditional gender roles and the role of female sexuality in

talk ART

art. Heavily inspired by illustration, a one-time illustrator herself, she amalgamates the world of cartoons in her imagination – *Garfield* and *The Teenage Mutant Ninja Turtles*, comicbooks including *X-Men* and *Spider-Man*, and nostalgic commercial pop culture – and vomits them out onto the canvas. By making the human body so extreme, Ana allows her darkly funny characters to express a much louder version of herself and to play out deep fantasies and anxieties.

Philadelphia-born-and-raised artist Jonathan Lyndon Chase channels childhood 1990s cartoons to allow them to reveal a deeper understanding of the body, mental health, queer life, sex and Blackness. Their heightened autobiographical scenes are charged with memory and pride. Bright and highly sexualized, these works scream out to be noticed by the viewer – a paradox to Jonathan in private. 'Surprisingly or not surprisingly, I'm a bit more quiet and reserved and shy in real life.' Allowing their work to be louder than their own interiority, Jonathan uses the device of the 'cartoon gaze' to free their players, inspired by the drawings of mermaids and cartoon characters that their mother made for them as a kid. 'I give so much in my work. I try to be as honest and as vulnerable as possible.' These 'solitude-centred', authentic and revealing paintings have been hailed as courageous. 'Other people have described it as brave; I describe it as liberating.' Jonathan likes to play with the viewer's perceptions, entangling bodies together, or confusing multiple bodies with one, or using bodies to express different parts of personalities, in a multi-faceted approach that allows a fuller human experience to be explored. Erect penises and fully exposed, throbbing, bright red and purple butt holes open and close across the canvas, while queer Black men kiss and hug in domestic environments, their skin flecked in glitter, proudly sporting the latest Nike sneakers and Timberland boots. 'It's important to talk about the complexities of the human experience and how things aren't so cut and dried. Bodies are messy, people are messy, and that's OK ... Sex is something that is very natural and down to earth, and also really complicated and, like, gross.' Collaging his paintings with disparate references, Jonathan invests private photographic imagery into the invention of these hyper-real representative scenes, allowing the viewer access to a genuine lived experience.

Check out these artists too:
Nina Chanel Abney • George Condo • Philip Guston • Tala Madani • Gladys Nilsson • Jim Nutt • Ed Paschke • Karl Wirsum • Rose Wylie

ARTIST SPOTLIGHT

Rose Wylie

Rose Wylie, *Ray's Yellow Plane (Film Notes)*, 2013,
oil on canvas, 216 × 168cm (85 × 66in).

talk ART

Rose Wylie, *Blue Girls, Clothes I Wore*, 2019,
oil on canvas 183.5 × 325.5cm (72¼ × 128in).

Rose Wylie's work is centred around painting and drawing. With childlike directness and inventiveness, she creates work that is equally fundamental and humorous, and can be political: it combines what you know with what you don't know in closely observed and often surprising new ways. Wylie has developed a dynamic, free-flowing line that is uniquely hers and instantly recognizable, and which she combines with her love of bright colour. Her studio in the Kent countryside can be described as a nest thanks to its position at the very top of her house with layers of new and old newspapers lining every inch of the floor. When we visited, we learned that these papers provide Wylie with a rich source of inspiration – while she paints, she encounters a vast array of photographs and news headlines which later appear as motifs within her paintings. Wylie's art also includes cultural references from fashion, photography, mythology, art history, literature, sports, and as a passionate film lover, she frequently references film stills or even paints from the perspective of a swooping camera angle. Her paintings celebrate icons such as tennis superstar Serena Williams as well as Quentin Tarantino's films, while also reflecting on personal memories from her experience of the Blitz during World War II.

How to get

involved

in

Contemporary

Art

WHERE & HOW TO SEE ART

VISIT GALLERIES

Art and cultural spaces are so valuable. That's not to say, however, that they're always that inviting or approachable to newbies. We remember in the early 2000s the fear we had of stepping into private galleries in the East End of London or, even more scary, in Mayfair or Fitzrovia. Even something as simple as ringing the buzzer and then crossing the threshold into a hushed, hallowed gallery space was a nerve-wracking experience. We soon realized, however, that these commercial galleries long for visitors. Their business model is not necessarily reliant on large visitor numbers in the way that a museum may be, nor do they need to satisfy grants or funding with visitor results, but nonetheless these galleries passionately believe in the art they are showing and want as many people as possible to see it. They will have curated and organized exhibitions many months ahead. They will have encouraged and helped facilitate artists to push themselves to explore their creative practice, create new works and make never-before-seen, adventurous installations. It's crucial for galleries to create and nurture an audience to be able to widely share their artists' work. Word of mouth is also an important part of the art world, so more people seeing and then talking about an artist will massively help and contribute to that artist's success.

A note on galleries and museums: A private gallery is one owned by a private individual and run as a commercial business. They generally operate by selling unique works to private collectors, not by generating revenue from ticket sales or gift shops. They often represent artists on the primary market, selling artworks made by the artist for the first time. A museum, on the other hand, is a public gallery, often with its own collection of art that it cares for and displays. Museums also regularly stage exhibitions of loaned works, curated on themes that can be educational and inspiring.

START A CONVERSATION

Exhibitions, at their core, are a way of starting a conversation. Artists make work to communicate ideas, so what is art without a viewer? Always remember you are more than welcome in galleries and, without your curiosity, an exhibition wouldn't be fulfilling its potential. Sure, there's an argument that art doesn't necessarily need an immediate audience to develop, to exist or to be worthwhile, but – aside from outsider artists (see pages 150–59) – even the shyest of artists make their work to be shared and to connect. Don't be afraid to ask questions, and never apologise for enthusiasm! Gallerists love nothing more than to meet another passionate art lover and to hear that you've enjoyed their exhibition: that's why many galleries have a visitor book, to record people visiting the show and sometimes their thoughts.

ENJOY THE HOBBY

One thing we've learned is that once you start visiting smaller galleries and exhibitions it gets addictive. It's a really fun and free hobby, and one you can share with your friends or family. You usually won't need to buy a ticket, and most exhibitions will have a list of notes or a press release that you can take home. There's also the incredible resource of gallery websites, and even Instagram accounts, for those unable to travel or wanting to learn more.

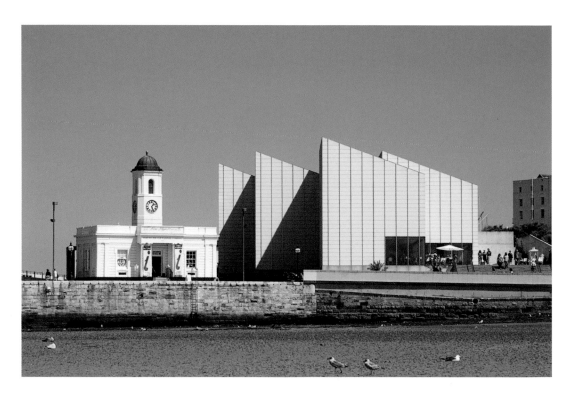

The Turner Contemporary, Margate. Named in celebration of the artist JMW Turner's connection to Margate, Turner Contemporary is one of the UK's leading art galleries and has held influential exhibitions by artists as varied as Tracey Emin, Michael Armitage and Grayson Perry, as well as hosting the Turner Prize 2019.

BE AWARE THAT YOU WON'T ENJOY EVERY EXHIBITION

We regularly encourage each other to go and see shows most weekends, and also take friends who thought they weren't as interested in art as us to join. We must caveat all this with the truth that you won't enjoy every exhibition you see. Just as with music or film or any creative medium, there will be some artists' work you just won't connect with, care or feel passionate about. But that's part of the wider experience, and we've also learned that occasionally there are works you don't immediately appreciate that can be the ones that two years down the line you suddenly have that 'Eureka!' moment and they surprisingly become your favourites. Sometimes artists make works that are seemingly ahead of their time. This is definitely true of some contemporary art, as it's being made in 'the now', responding to current society. It can take time for us all to catch up, to process events we are living through, or even be ready to reflect.

LEARN A NEW VISUAL LANGUAGE

The interesting part of regularly visiting shows is you begin to learn a new visual language, of how artists communicate ideas, and how works are brought together and installed by a curator or by artists themselves to bring out meaning and narratives. You'll begin to understand the possibilities of different artistic techniques, and essentially new ways of seeing the world. You can be challenged with a one-hour film or a series of black-and-white photographs, with a giant mural, an intimate framed sketch, or even sculptures made of melting ice. It's so varied, and there's always something or someone new to discover. Exploring exhibitions – particularly ones by artists you've never encountered before – can be extremely rewarding, and helps to build up reference points that will not only guide you in understanding other artworks but also society itself and our place in the world. It's great to be able to follow an artist over many years and see their work grow and change. It's like a big connected web of ideas: some will be more meaningful to you than others, but it's useful to accumulate this wider knowledge, as it will inevitably lead you to somewhere unexpected and enriching.

DON'T GET HUNG UP ON CONTEXT

Something we both struggled with at first was the idea that we needed to understand what an artist was saying prior to even having looked at the work itself. Think of how frequently you see wall texts in museums, and gift shops offering text-heavy books: we used to find ourselves spending ages reading about the context or life story of an artist before approaching their work. This can of course be important, particularly in a retrospective looking at an artist's oeuvre across a lifetime, taking into consideration their relationship to significant moments in history. However, we began to enjoy going to commercial galleries for the opposite reason! With emerging and mid-career artists, they're still very much evolving, and you can be part of and bear witness to their journey. In some ways it's a much more open proposition, as instead of having already been canonized, analysed and exhibited extensively, living artists' works have usually been created in the weeks, months and years before the exhibition opened. This in a way frees us up as viewers to go in without feeling the pressure of having all the knowledge in the world and just to see how we feel standing in front of the art. This was an important discovery and realization.

DISCOVER YOUR OWN PERSPECTIVE

Part of the joy of viewing art is about your own perspective and getting to know yourself and how your mind works through experiencing art. Try to be as present as possible, just forget what's been going on in your day or what you have to do next, escape all your worries for half an hour and allow yourself to absorb the exhibition and the individual artworks: we've come to treasure this time and positively encourage it. It's also something you can do alone, so if your other half isn't convinced or if your friends would rather go to the pub, then don't let that deter you. If you're interested, never be afraid to make this a solo pursuit. It's a wonderful thing to have 'me time' and a hobby that is a personal passion. And soon enough, we can pretty much guarantee you'll meet other like-minded art lovers along the way!

FIND A COMMUNITY

We mentioned earlier this idea of galleries being hallowed places, and in a way it's true. The art world can at times feel like a religion or even a religious experience, and we don't mean that in an exaggerated sense of 'oh wow, you're going to be forever spiritually altered' by an artwork. It's more that art is something we believe in. It can provide you with meaning, but also with a community. The more you immerse yourself in contemporary art, the more you'll get to meet the artists or other art lovers, or get to know the people running the gallery, whether it be the person greeting you on the front desk or other members of the team. Private views are free to attend, as are a lot of artist talks or curator tours, details of which are more accessible than ever before, increasingly published clearly on galleries' websites or social media, and they really are open to all. We always say it's a good idea to get there early, so you can see a show while it's still quiet, but it's also a great way to meet new people and share your thoughts about the show.

Phyllida Barlow, *untitled: upturnedhouse, 2,* 2012, timber, plywood, cement, polyfoam board, polyurethane foam, polyfiller, paint, varnish, steel, sand, PVA, installation view: Twin Town, Korean Cultural Centre UK, London, 2012, 500 × 475 × 322.5cm (196⅞ × 187 × 127in). Barlow is one of our favourite sculptors, best-known for using unconventional materials such as plaster, cardboard and cement. Highlights include the Tate Britain Commission 2014, and her epic installation for the 2017 Venice Biennale British Pavilion.

AN INTRODUCTION TO THE GALLERY SYSTEM

Walk into a commercial art gallery, and you're walking into a secret ecosystem going on below your feet and behind the walls, out of sight, keeping your art-viewing experience calm, clean and serene.

AT THE ENTRANCE

You'll normally be greeted by someone sitting at a front desk just inside the entrance door (if they choose to look up). They will probably have a guest book splayed out in front of them – this is for you to sign and add personal details such as email and phone number, if you wish, for the gallery to add you to their email subscribers list (which, if you like the art and the gallery, definitely do, as they keep you involved with their programme). On your way out, you are also welcome to leave feedback like 'Great art' and 'Very important show': galleries like that. Alongside the guest book is a printout containing titles of all the works in the show, plus information such as medium and size: this is yours to take, keep and do with as you wish.

WALKING INTO THE SPACE

As you walk into the gallery, don't be spooked by how quiet it may be: art is a religion and the galleries are our churches. You may notice younger people sitting or standing in corners of the rooms, normally reading books. Again, don't expect them to look up. They are acting as invigilators and are there in a casual role, providing visitors with information and assistance if needed. They are usually art students, working part-time to get first-hand experience of the system.

SECURITY

If the work has the requirement, a security guard or two may also be present, watching how close you get to the artworks and maintaining order within the gallery. These are required as part of the gallery's insurance. If the works are of a certain value, insurance companies won't insure the gallery against theft and damage to the works unless a guard is present at all times.

GALLERY STAFF

Depending on the size of the gallery, the staff family tree can range from just one person – normally the gallery director – to any number of people. The bigger galleries – such as Barbara Gladstone, David Zwirner, Sadie Coles, Larry Gagosian, Maureen Paley, Sperone Westwater, Paula Cooper, Hauser & Wirth, Victoria Miro and White Cube – support a whole dynasty of staff members:

1. The director is the head honcho – such as Ms Paley, Ms Westwater, Mr Zwirner, Mr Jopling, Ms Gladstone and Mr & Mrs Wirth. They are at the top-top-top of the gallery pyramid.

2. The next person down will be the associate director(s). These act as the right-hand person to the gallery director and as a conduit for the rest of the gallery staff. They are the person that all information trickles through.

3. Then come gallery managers. They manage certain areas within or aspects of the gallery, presiding over an army of gallery assistants, who are at a more junior level than the gallery manager. All of these roles deal with sales.

4. The director of sales and the associate director of sales have the exclusive role of selling.

5. At bigger galleries, there will be artist liaison managers. They have the responsibility of an exclusive roster of, say, three to four artists who they have direct day-to-day contact with, keeping the artist happy and feeling looked after. These big galleries can feel intimidating even to insiders, and so it's important for artists to be able to communicate with someone who knows them. This role also covers sales and the placing of artists' works in institutions, private collections and shows.

6. Some of the bigger galleries also employ a full-time, in-house curator, who may themselves have curatorial staff. The gallery curator deals with the hang of the shows, but also – as many private galleries are now competing with museums and institutions for major exhibitions – behind-the-scenes negotiations in the likes of securing, say, a Picasso or a Bacon work for a certain show.

7. There will usually be a small, tight squad of gallery technicians. Their role is the packing and unpacking of art, and the careful and perfect hanging of all artworks on display and in exhibitions. These technicians are usually artists themselves, many still in education or early on in their careers.

8. The artworks are stored in climate-controlled, heat- and moisture-protected warehouses, either in the gallery or off-site. These spaces need warehouse managers, who check and protect all the art that comes and goes. They may have a whole network of assistant warehouse managers and staff to carry out these requirements and to protect the art.

9. Within the warehouse system are the art shippers. These people are responsible for the safe packing and crating of artworks that are to be sold, lent or shipped out for shows all around the world.

10. Then, finally, we have the ARTISTS! Finally!! They make the gallery world spin around, but sometimes they can be considered after everything else. It's the responsibility and test of a good gallery director and manager to make sure artists feel nurtured, safe and protected – because without the art and the artists, what have you got, right? The artists have the most crucial role within the entire gallery system.

Storage area of the Government Art Collection, London.
They say you are a collector when you run out of walls to display the art you collect.
Art storage is an important and often very costly part of being an art collector
or when looking after a museum collection! It's also vitally important to ensure
artworks are stored correctly and protected for future generations to enjoy.

ART AND THE COMMUNITY

There's a saying that wherever art and artists go, industry follows. Art can be found countrywide, and there are often strong artist communities in smaller towns and villages, as well as numerous exhibition spaces connected to art colleges and universities. Art galleries and museums can help local communities grow and evolve thanks to tourism and education and the exhibition programme itself can enrich the local area with related cultural events. In London, you only have to look at places such as Shoreditch and Hackney to see where they are now, compared to 30 years ago when the Young British Artists had studios and homes there, and the change that's followed similarly in Brooklyn or Berlin and so on.

ART AND REGENERATION

There can of course be negatives to regeneration, in particular the homogenization of residents, cultural offerings and even the high street, not to mention the pricing-out of smaller grassroots arts and cultural venues as well as artists being forced out due to higher rents. A decrease in arts productivity is a serious problem, especially when you consider that 80 per cent of visitors to London in 2017 confirmed that culture and heritage had inspired their visit.

However, there can be a lot of positive changes from art moving into an area if it's carried out responsibly, thoughtfully, and with a commitment to work with and support the local community. A reinvigoration, if you will. It's widely considered that museums can help kickstart and support local industry. In the UK there are numerous examples, from South London Gallery in Peckham to the Hepworth Wakefield in Yorkshire, to Focal Point in Southend-on-Sea, to MK Gallery in Milton Keynes, and Margate's Turner Contemporary. Regarding the latter, there was a lot of cynicism about a museum opening in the seaside town that was in one of the poorest areas of the UK but, since Turner Contemporary opened in 2011, Margate's creative community has drastically increased and the town is now a cultural destination. In 2019, it hosted both the Turner Prize and its own Margate Festival (which Russell curated); and it has a commercial gallery, Carl Freedman Gallery (where Robert works), artist studio complexes such as Resort, LIMBO and CRATE, alongside art schools including Open School East and the Margate School. Artists have moved their studios to the town, as rents are cheaper than in London, and numerous homespun restaurants and grocery stores have opened, creating a critically acclaimed food scene.

As regards the initial setting up of Turner Contemporary, director Victoria Pomery has explained: 'There was a group of local people and also politicians who were very concerned about what was happening in Margate and felt it needed to be regenerated, and they looked at places such as the Guggenheim in Bilbao and Tate St Ives [in Cornwall], and at the same time the Lottery came online [in 1994; funding for the museum would later come from this]. There was a feeling amongst people at the Arts Council that actually there needed to be more cultural infrastructure outside London ... In those early years, lots

of people didn't want an art gallery; they wanted an extension to the hospital, a new school, an ice skating rink. All of those things are great things to want to have, but the money had been ring-fenced from Arts Council budgets for arts, and so it was a kind of process of persuading people that actually an art gallery could be fantastic … It's a resource in terms of education and learning, it can help tourism, [be] something to be proud of, engender civic pride, [be] something that visitors would come for, and [it's] for everyone.'

ART INTERNATIONALLY
Art can of course be seen far and wide. Naoshima, a tiny island in the Seto Inland Sea, is known as Japan's art island and boasts impressive artworks such as Yayoi Kusama's *Pumpkin*. Naoshima was once a remote and quiet island, but this rapidly changed thanks partly to the vision of a Japanese businessman whose passion for art led to it becoming one of the world's most talked-about destinations for travellers searching for a one-of-a-kind experience: it's a must-visit for contemporary art fans! Other global art destinations include the Museum of Old and New Art (MONA), a privately funded art museum in Tasmania, Australia. MONA presents a combination of ancient, modern and contemporary art, with more than 1,900 works from the collection of museum owner David Walsh. Noted for its central themes of sex and death, the museum has been described by Walsh as a 'subversive adult Disneyland'. In the United States, Dia:Beacon in upstate New York is super-popular, boasting important installations by pop art leader Andy Warhol, minimalist icon Dan Flavin, and legendary sculptor Richard Serra. Public spaces such as MoMA PS1 and SculptureCenter, both in Long Island City, have helped bring culture and crowds of art lovers to the Queens area. The biggest buzz of all surrounds Marfa in Texas. Marfa has become something of a pilgrimage site for all art fans and professionals. In the 1970s, minimalist artist Donald Judd moved to Marfa and created giant works of art installed outdoors under the huge desert skies. Since then, numerous galleries, including the Chinati Foundation and the non-profit Ballroom Marfa space, have opened up. Popular art installations have followed, such as artist duo Elmgreen and Dragset's infamous 2005 *Prada Marfa*, a faux boutique displaying luxury bags and shoes in the middle of the empty desert!

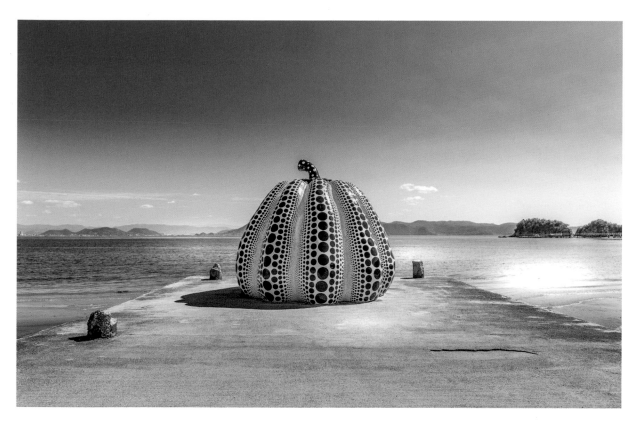

Yayoi Kusama, *Pumpkin*, 2004, fibreglass, height: 200cm (6ft 6in), circumference: 250cm (8ft 3in).
Naoshima, commonly known as Japan's art island, is a tiny island in the Seto Inland Sea,
and many art lovers describe it as their favourite place to visit in Japan.

ARTIST SPOTLIGHT Lenz Geerk

Spaghetti, 2018, acrylic on canvas, 45 × 60cm (17½ × 23½in).

Apple, 2019, acrylic on canvas, 40 × 49.9cm (15¾ × 19⅝).

Lenz Geerk's paintings vibrate with a charged atmosphere as his cast of heavily stylized characters feel weighed down with contemplation, the pressures of life far too overwhelming for them. Their lithe bodies bend at their waists and necks, their heads needing the support of tables and beds, as they gaze dreamily out but never quite connecting with the viewer. With highly theatrical body language, Geerk's subjects prostrate and pose, gesturing to an intense psychological interior, at once ambiguous yet fascinating. Geerk's subjects are painted with blurred and softened skin, while their tender gazes allow a feeling of antiquated nostalgia, a timelessness not held in any particular moment or space. His repetitive motifs, such as fruit, insects, croissants and flowers, load each composition with cryptic messages, encouraging an audience to decipher them without ever fully acknowledging the answer. Based in Dusseldorf, Lenz paints almost everyday, continuing his narrative into creating extraordinarily captured private moments in paint.

HOW (TO) CREATE YOUR OWN COLLECTION

Sophie von Hellermann, *Urania*, 2019, acrylic on canvas, 200 × 190cm (78¾ × 74¾in).
The paintings created by London-based Sophie von Hellerman conjure up forgotten dreams,
fairytales or traditional fables. They are romantic, brave and expressive.

WHY EVERYONE SHOULD COLLECT ART

FINDING ART YOU LOVE

Collecting art should be – and can be – for everyone. While for hundreds of years there has been a notion that collecting art is the sole pursuit of royalty, landed gentry or the rich and famous, it's not true. Many of us have the desire to live with art, to collect and protect objects, and to fill our homes with inspiring artworks. Some people are minimalists, sparsely hanging a few paintings, whereas others, like us, are utter maximalists, installing as many artworks as we possibly can – seeing the screaming potential of any available empty wall, no matter how large or small, as perfect spaces to house the artwork we adore! Whether it be collections of postcards, fridge magnets or tea coasters, posters, limited-edition prints or multiples, there's nothing better than finding art you love, framing it and getting it up on your walls. Living with art can spark inspiration and encourage your own creative juices. From a young age, we've all made drawings or paintings that our parents have put up on the wall or fridge, and we know the pride that comes from your creativity being recognized, and in a similar way it can be really exciting to start searching for artworks that you love and bringing them into your home.

A note on edition prints or multiples: Limited edition prints or multiples, such as screen prints, etchings or lithographs are made with and signed by the artist. Often created in small runs of only 50, 100 or 200, these prints will each be numbered too, making them very special and collectable.

A CREATIVE PURSUIT

Art can be like a window into another world. It can add energy and colour to your everyday. Bright colours, muted colours – whatever takes your fancy. You can express yourself through the art you choose. Over the years, we have met many different collectors from all over the world with a vast array of budgets. One thing all these collectors possess is that spark in their eyes, an enthusiasm that grows and grows the more they've collected and discovered art.

Page 193:
David Shrigley, *Art Will Save the World*, 2019, colour screenprint, 76 × 56cm (29⅞ × 22in).
Shrigley's funny and provocative drawings, sculptures and installations succinctly sum up what many of us think or feel inside, but rarely say out loud!

DISCOVER ART YOU LOVE

BOOKS

One good way to begin your collecting journey is to buy books dedicated to the artists you admire, and study their works and read the essays. Some artists even make limited-edition books that may come with a print or have a unique element to the book cover. Karma in New York has published some incredible artist-made books in recent years and their Karma book store is definitely worth visiting, as well as Dashwood (also in New York). Other great book stores to visit are Printed Matter in New York, and Koenig Books, Tender Books and Claire de Rouen in London. Charity shops and eBay are also surprisingly good places to find second-hand affordable art books. We both started by buying books and poring over the images, as it's a great way to work out what you like and what your taste is. Is it painting? Photographs of still lifes? Ceramic vases?

ART FAIRS

We also started to visit art fairs, with the knowledge that we didn't have to buy anything. Some of the biggest collectors visit art fairs with the rule that they can't buy at the fair itself because it can feel too pressurized an environment to spend money. So instead they attend and use it as a time to walk around slowly and learn about new artists' work. We both get so much pleasure from just taking photos and writing down artists' names to take back home to further research. Taking photos can become a collection in a way itself — a sort of visual archive — and definitely helps our collecting pursuit, as you have a rich library of personally gathered reference material.

VISITING MUSEUMS AND GALLERIES

While it's great to read as much as you can, it's also significant to just trust your eyes. Get out there and start looking. By regularly visiting museums and galleries you will begin to understand what you like and don't like, simply through the act of looking. Group exhibitions are a wonderful introduction and provide an overview of art being made now. The Royal Academy in London has a Summer Exhibition that usually includes more than 1,500 artworks!

ONLY CHOOSE SOMETHING YOU REALLY, REALLY LOVE

We always tell our friends: don't go to buy straight away, and when you do feel ready to buy, only choose something you really, really love and can't live without. That way you'll never feel the pressure that you've spent money on something you don't like! Buying for investment never really works, unless that's what you get your kicks from — buying and selling, which some dealers do enjoy. But for us, it's more of a passion hobby: we are on a mission to find the art with which we deeply connect. Of course, eventually you'll feel the need to fill the bare walls of your home. We started out by framing affordable posters and postcards. It doesn't need to be an original artwork: it could be a Patrick Caulfield postcard, or a Velvet Underground album cover designed by Andy Warhol. We've even found old David Hockney posters or original Sonia Delaunay exhibition posters on eBay that you can frame up and feel like you have something from art history!

talk ART

WHERE TO BUY ART

GRADUATE EXHIBITIONS

In London, the Royal College of Art, Goldsmiths, Central Saint Martins and Slade all put on incredibly diverse exhibitions of graduate work, as do all colleges and universities across the world, from New York's School of Visual Arts and Yale in New Haven to Frankfurt's Städelschule and the Universität der Künste in Berlin. Not only is it exhilarating to witness new ideas and artworks, but also if you do discover something you love, the prices are often within reach – anything from £100 to, say, £1,000 (US$130–1,300) for a unique work! It's also rewarding to see how showing an interest can help an artist to advance. Your enthusiasm, and the fact you chose to buy their work can, on a very basic level, give them a sense of pride that their work is connecting to the world outside of college. It's also a great way to get to know artists and you can perhaps keep in touch, visit their future exhibitions and grow together. Often the artists you meet at the start of their career will eventually go on to have museum shows or commercial gallery shows. Nothing beats the excitement of feeling like, in a tiny but meaningful way, you've helped them on this journey. It's also a great way to get access to unique works before the prices become out of reach and the works unobtainable. Often, once an artist joins the art market, their prices quickly rise into the thousands and tens of thousands – not to mention the politics that can surround galleries, which can be choosy over who they sell works to and will encourage their collectors to donate works to museums and so on.

DIGITAL PLATFORMS

These days, there are great digital platforms such as AucArt, a website and app that promotes and sells artworks by recent graduates. They frequently host charity auctions, and we both recently acquired a small painting each by an emerging British painter, Sola Olulode, for around £500 (US$650) per work to help raise vital funds for the Stephen Lawrence Trust (afterwards, we both messaged Sola on Instagram and are now in regular contact; Russell even got to visit her studio). Other websites making art accessible include Artsy and Artspace.

INSTAGRAM

Social media has become a magical tool for finding new art and artists. While Russell was acting in New York, he saw the work of Jon Key in a group show, *Punch*, curated by Nina Chanel Abney. Within a matter of hours, he was meeting Jon at his studio thanks to Instagram's direct messaging (as with Sola Olulode, this shows how, as well as collecting, there is also a possibility to spark up a friendship; not every artist, of course, will be able to or want to have studio visits, but it does happen and is without a doubt one of the greatest experiences). Following artists, galleries, collectors and museums on Instagram is a great, free learning resource. It brings us all – the global community of art lovers and makers – closer together.

GIFT SHOPS

Commercial galleries also have amazing gift shops at their venues. It's worth looking out for artist-made multiples in such places.

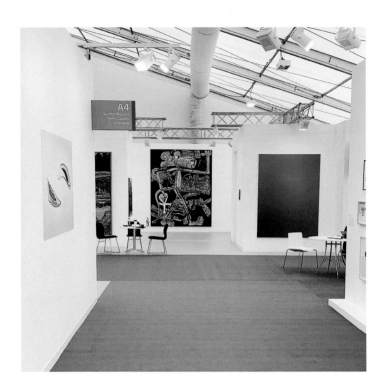

Left:
Frieze Art Fair, London, 2019.

Below:
Carl Freedman Gallery, Margate booth at Frieze Art Fair, London, 2019.

Over the past decade, art fairs such as Frieze and Art Basel have become increasingly significant for both international art collectors and art fans alike. They are a great place to discover and experience an artist's most recent works, often straight out of their studios, all under one roof.

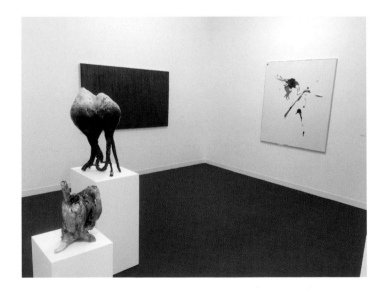

PRINT PUBLISHERS

Some print publishers have popular online platforms for buying art. One of our favourites in the UK is CounterEditions.com – yes, we are a bit biased as it's where Robert is director, but in fact we have both collected prints from Counter regularly since the early 2000s. Counter Editions commissions and produces prints and multiples by over 70 international contemporary artists, including Tracey Emin, Rachel Whiteread, Frank Bowling, Anthea Hamilton, Rebecca Warren, Luc Tuymans and many more, and collaborates closely with the artist to produce exclusive editions in different mediums. Their prints usually only exist in the form of the print, and are not reproductions of existing artworks, which also makes them feel very special.

AUCTION HOUSES

Auction houses have websites where you can search up-and-coming lots from their regular art-dedicated auctions. Auctions have become more accessible than ever, thanks to online bidding and video streaming of the live bids. While auctions aren't for everyone, you can sometimes find artworks for affordable prices. It's very much about who else is bidding, but you may get lucky and pick up, say, a Peter Blake print in the hundreds of pounds. Early on in our collecting days, we enjoyed reading old auction catalogues as a way of learning about obscure artworks. You can also attend the auction house's viewings, where they hang all the works in the auction for you to see. They don't charge for entry, so it's free, and these viewings provide a vast overview into contemporary art, as you get to see lots of different kinds of artists' work all under one roof that you wouldn't usually get to see side by side!

MUSEUMS AND GALLERIES

Get out there and start looking. By regularly visiting museums and galleries you will discover what you like and don't like. As well as pricey unique works by famous artists, major exhibitions sometimes offer much more affordable prints for sale – etchings, screenprints, photographs, works on paper. You may find prints by artists such as Grayson Perry or Rose Wylie, which is a perfect way to acquire a signed limited-edition work by someone well known for a few hundred pounds, instead of thousands. Art fairs have also begun to offer a range of prints. Frieze Art Fair in London and New York has a wonderful section dedicated to prints called Allied Editions, which is a collective yearly booth featuring prints to fundraise for not-for-profit art spaces, including the Institute of Contemporary Arts, the Whitechapel Gallery and Studio Voltaire in London. What's nice about these is that they aren't just money spinners; they also have curators with a certain level of critical analysis and taste. Each of these galleries has their editions available to buy on their websites as well, and Studio Voltaire has its own successful pop-up shop series titled House of Voltaire. In New York, Nottingham Contemporary (UK), Printed Matter, Inc. (US), Queens Museum (US), SculptureCenter (US) and Skowhegan (US) all formed the Allied Editions booth. Other spaces, such as New York's White Columns, have sold sets of prints by amazing artists in the Frieze New York fair, with their own dedicated booth.

Bonham's auction house.

THE RULES OF BUYING ART

SET YOURSELF RULES

Some collectors set rules for themselves. These could be budget-related: for example, 'we will only buy artworks that cost under £500'. Alternatively, some collectors decide to focus on a single theme. Anita Zabludowicz, for example, has focused on supporting emerging artists and curators, or Valeria Napoleone has collected the work of women artists since the 1990s and has dedicated years to championing women in art (her patronage has extended to financially supporting exhibitions in public spaces). Such collectors' enthusiasm is infectious and leads to other collectors paying attention to the artists they advocate. It's good to narrow your focus because just the sheer number of artists making work out there can be overwhelming!

CHECK CONDITION

When buying in the secondary art market (when a work has been sold at least once before) it is crucial to check condition

reports. The artwork will have been living with other collectors prior to being sold and it's vital to check condition as this will affect the price. It's best to buy works only in great condition, especially photographs or prints. The last thing you want is a photo that has greasy fingerprints on the surface, or folds and bends in the paper, as we learned from chatting with art collector and music superstar Sir Elton John. 'Anything I collect as far as photography goes has to be inspected first, because a lot of photographs get damaged by the sun. You know, people don't look after them, so before I buy a photograph it's taken out of the frame, it's examined and it's put back ... Sometimes if you want an image, you have to be incredibly patient to get it ... The Diane Arbus that I'd wanted for a long time – it's the boy with the toy hand grenade in Central Park – I'd wanted that for about 20 years, and it came up at auction about 10 years ago in New York. Newell [Harbin, director of The Sir Elton

Sotheby's fine art auction, New York.

John Photography Collection] went up to look at it. It had coffee stains all over it, but it still sold for $500,000. I would never pay $50 for a damaged thing. It's got to be in perfect condition. Towards the end of last year I was offered two images of it that came from private homes, and I finally got the one that I wanted!' Damaged works might still sell, but usually for significantly lower prices.

FLIPPING.

One thing that is frowned upon is flipping. This is when you buy a work, then sell it very fast to make a profit. If an artist's work is being sold at auction like this, it can really damage their career – either because it doesn't sell for what it should, thus devaluing the artist, or it sells for too high a price which can lead to hype, with other collectors flooding the market with that artist's work and therefore making it harder to maintain the high prices. So we recommend always offering back the work to the gallery or artist you bought it from before taking it to an auction house. This is not only a mark of respect, but also allows them to consider where they'd like the work to be placed next.

FRAMING

Framing works correctly is vital. It's something a lot of us may not think too much about, but, particularly with works on paper and prints, it's vital to ensure you get them framed right, using archival materials, acid-free boards and UV-filter glass. Yes, it can mean you will need to spend a further £150–£300, say (US$200–400), depending on the size of the work, but it's so worth it to go to a good framer. You just need to ensure, when taking the print to them, that they know how to safely protect the artwork. The last thing you want to happen is for it to be damaged during the framing process.

INSURANCE

It's also vital to add your artworks to your home contents insurance, if you can, as this will protect you against any damages. You may need to update the insurer if you have taken the print to the framer, or you can ask the framer to put it under their insurance while it's in their hands. It's also worth having this confirmed in writing, even over email, to ensure that the framer and you are both clear as to what has been agreed!

KEEPING THE ARTWORK YOU'VE COLLECTED

We've often said to each other that some artworks are like windows to another world. They bring with them new energy to your living room, kitchen, bedroom or hallway. You begin to have a complex daily relationship with these artworks, almost like you do with people. We've both experienced times when one week you are crazy in love with a painting, say, but two months later you find it incredibly challenging. Of course the work has not changed, but our tastes do change! Human emotions are complicated, and moods can alter over time. Also, with new knowledge accumulated, you may start to be more passionate about other types of work. But it must be emphasized that it's OK to fall in and out of love with the art you've collected, and we recommend just sticking with what you've bought for at least five years, because often those more challenging artworks are the ones that in the end will become your most treasured.

MOVING WORKS AROUND

We've found that moving pieces around your home, trying them out in different locations, can suddenly breathe new life into a work that you had lost enthusiasm for. Just remember that it's fine to switch things up, and move works around until it feels right. Let the art curator within find their voice.

HANGING WORKS IN GROUPS

Hanging works in groups can be fun, too, as works can complement each other and conversations can be had between artworks. The juxtaposition of hanging a painting with a photograph, for example, can bring out a new meaning for you as a viewer, enhancing your connection to the work.

TIMING

Timing is key. Some works are ahead of their time. It can take a decade or longer for artists' work to evolve, and suddenly you can look back at the earlier work and see how it was a precursor to what they've gone on to do.

PERSONALITY

The best collections have one thing in common: personality. We've seen so many identikit collections that are solely filled with art by big names that are a recognizable investment; that people buy for status, and not because they actually like the work. Of course, this is what makes some parts of the art world tick, but we prefer to take a more personal route. Try to listen to yourself, and not follow trends or fashions. Always remember that the art market and what it is to be part of art history are very different things. Art can be a slow process. In today's high-speed culture of fast information it can be easy to lose sight of that. It's about working out who you are and what you like. A great, meaningful collection can be built from your passions and interests, and in a very strong way reflect your character. You don't need to have big named artists: start young, or discover older artists that aren't as well known yet. Your support can really help them, and it's much more enjoyable to connect with new ideas and feel like we've been part of supporting the emergence of new artists. Collecting art is a lifelong journey, so what are you waiting for? Get out there!

talk ART

Lindsey Mendick, *Nose to tail*, 2018, glazed ceramic, marble table, 90 × 40cm (35½ × 15½in). Mendick combines high- and low-cultural influences to create wild and entertaining installations often with a memorable personal narrative.

ADVICE FOR BUDDING ARTISTS

Simon Denny, *Mine*, installation view: K21, Dusseldorf, 2020.
The artist Simon Denny, originally from New Zealand and now based in Berlin, creates
work that interrogates the impact of tech and advertising industries on shaping global culture.

BE YOURSELF

Being an artist can often feel like a solitary, lonely journey but it is also one that has the potential to bring you closer to others in a very powerful way. The most important single piece of advice we have learned is: be yourself. Jerry Saltz describes it perfectly: 'Your story is interesting!' It may at first seem VERY dull to you, but your view of the world is ultimately the thing that will connect you to others more than anything else.

THERE IS NO ONE CORRECT ROUTE

Some of the world's most successful artists didn't go to art school. Some were terrible at life drawing, so packed it all in before developing and discovering where their talents lay. Know that there is no one correct route to becoming an artist.

JUST START...

Half of the struggle is beginning. It's so easy to procrastinate and distract yourself. The key is just to force yourself to start. You'll be very surprised how, once you get going, it's really fun and exciting. There's also something to be said for allowing yourself just to flow, stream-of-consciousness style, trusting in yourself and letting ideas pour out of you. Sometimes the pressures of over-thinking, or feeling like your work must have a strong conceptual idea behind it, can prevent you from creating something; or if you do make

work it might not end up feeling like it's truly representative of you. Sometimes the unconscious is more 'us' than the controlled, intellectual side. We've also learned that doing what comes easily is often the most powerful. You may think, 'Oh, drawing comes so easy to me, so I'm now going to paint', and you make yourself try something completely different when in fact drawing was your greatest talent and ally. If you push yourself to improve an existing 'easy' talent, then you may actually achieve greatness, because your aptitude for that skill means you can get better and better and better.

... AND CONTINUE

Consistency is the key to success, and self-discipline and self-sufficiency are vital. Again, discipline can be something specifically tailored to you and the way your mind works, but it's key to work out what your method is to be productive, inspired, and thus creative.

STAY FOCUSED

When writing this book, we were given ideas and advice by so many friends and colleagues as to how best to approach the writing. In the end, we deciphered what worked best for each of us: for example, Robert preferred writing either first thing in the morning or last thing at night. Understanding how you function best is the key to anything in life. We also had other jobs, and the recording of the podcast to continue, and we did fear that we had so much going on already, how on earth would we ALSO write a book! But we've learned that the old adage of 'if you want something done, give it to a busy person' is true. The reason we're sharing this story is to show that you can still have an artistic practice and career if you also have to work another job to pay the bills.

Page 205:
Katherine Bradford, *Superman with Color Border*, 2014, oil on canvas, 17.8 × 12.7cm (7 × 5in). This is Robert's favourite artwork in his personal collection – a tiny painting with big ideas about transformation and hope.

LIMITED TIME

Sometimes having limited time to do something is helpful. For example, if you can spare just one hour each evening to focus on your art-making, that regular routine of creating will all add up. It also somehow takes the pressure off: you don't have long days ahead of you filled with the unknown. If you approach your practice in a matter-of-fact way, you may find you're much more open and relaxed, and can allow your creativity to flow within those limitations or restrictions.

GET OUTSIDE

While living as a hermit in total Isolation is a good option for some people, we're sure that most people need to get outside and live life in order to have something to say in their work. By living and experiencing the world, you will have more ideas to include in your work.

LOOK AROUND YOU

Spend some time each week reading or looking. It doesn't have to be art-focused books or other artworks. Look at the world around you; think about how you feel and what you are responding to, what's happening in your local community, and in wider society or internationally. Remember that your voice is important, and that you can contribute and help move things forward.

CREATE YOUR OWN WORLD

We always say the artists we love have created their own universes. It's comparable to a new language: they have signs and letters and words they have created through visuals that become instantly recognizable but are also infinitely intriguing and of interest because their sets of rules or values are unique to that artist.

DIG DEEP

Get to know yourself, take care of yourself and be responsible for yourself. It's like the old cliché in love, 'you have to learn to love yourself before you can love another', and this is true for art-making. Dig deep, work out what your fears are, what terrifies you about yourself, what you like about yourself, and bring all of that to your work. We're not saying you have to make autobiographical work, but your viewpoint, your way of seeing, is what is special, and that's what will be interesting to others, and this could be your approach to making abstract art, installation art, performances, films, and so on.

IMPROVE YOUR SKILLS

Another valuable lesson we've learned is it's never too late to start. We all develop at different times. There's nothing scarier than an empty page in front of you, but the best thing to do is to start to draw, start to write, and BEGIN the process. And then stick to it. Focus, hard work and being consistent will inevitably pay off, at least in that you will learn and deepen your skill base.

Failure is also part of the process, and an important part of it. By doing and failing you are learning the entire time, and that will lead you to your next discovery and next step on your journey. If you've always wanted to learn how to do life drawing, then join a class NOW! You'll only improve by doing it. So start! Get going! Be creative! Passion, focus and drive will get you a long way. If you've always wanted to paint with gouache, then get a book and learn it. Even a very well known artist at the top of her field, Lisa Yuskavage, recently bought a book on how to paint with gouache and has been perfecting her skills. Learning is for life: it's a mountain you climb, and

you continuously accrue new knowledge. That's where greatness lies. By constantly learning, your work will keep you interested, as it'll never get dull or stagnant.

TRY SOMETHING NEW
Don't be afraid to try something new. If you become successful for one type of work, then great, but this doesn't mean you can't push yourself to try something else out. Numerous artists are now expressing themselves across different mediums, describing themselves as 'interdisciplinary'. While studying for her DPhil at Ruskin School of Art in Oxford, Shawanda Corbett decided she no longer wanted to continue making the ceramics for which she was best known, and instead she wanted to create performances. Her tutor, Lynette Yiadom-Boakye, asked her to give a good reason why she wanted to stop making the ceramics, then encouraged her to do both, as one could exist alongside the other. Looking at her performances now alongside her ceramic vessels, you can see they are intrinsically linked: they inform each other, and the two separate elements not only make the experience for a viewer more interesting, complex and dynamic, but they also allow the viewer to see the strength and inspiration the artist herself is being rewarded with. Out of taking a chance, out of being brave, out of pushing yourself to do something that scares you, you will feel more creative than ever before.

BE PROUD
Be proud of yourself, and the work you make, by saying what you mean and what you believe in. That way, if you do get a bad review or negative feedback, you will know deep within yourself that the work you are making is solid and true to yourself,

and therefore the best work you could have made at that point. It's really good to listen and consider constructive criticism to be able to grow, but equally you need to know when people are just being mean or unhelpful; or perhaps just completely misinterpreted what it is you are doing. Stay on your path, stay honest, and everything else will fall into place.

DOCUMENT YOUR WORK
Keep an archive from the beginning. This is power! Know where your works are, and who bought them and when and for how much. Get all your works professionally photographed, or request this from your galleries.

PEER SUPPORT
Peer support is vital. Build up a group of friends — other artists or people whose opinions you trust. It's very important to listen to your instincts and thoughts, but often the friendships you make early on in your artistic journey will be the ones that last, and what a joy to grow together and share in each other's highs and lows. And that is an overriding fact: even the most successful artists have ups and downs. Any career has difficult moments and serious challenges. To have people you trust to help you navigate unexpected difficulties is invaluable. The art world is like a smaller version of the actual world: it has wonderful, inspiring, great people but it also has tricky, complicated and downright out-of-order people! So find those who do care about you and your work, and protect that. Nurture those loyal, meaningful friendships.

KEEP BACK ART

There's been a trend in the past ten years whereby art market interest – particularly in emerging artists' work – has meant that studios are emptied as soon as the work is finished. As Robert has often advised the artists he works with, hold back 10 per cent, or even 20 per cent if you can, of all the work you produce for your own collection. That way, once a show is over, you can get a few of the works back to your studio, which can be helpful not only to remind you how your work has developed, but is also useful in the long term. Of course, you need to be able to sell works for numerous reasons – to be able to live and pay your studio rent, to help promote your work to wide audiences and curators – but, if you can, do try to keep back something, even if it's one painting, or your preparatory drawings or collages.

GET INVOLVED

Katherine Bradford has some incredible advice: 'give attention to get attention'. Get involved with your peers as much as you can without taking too much time away from your own practice. Instagram is an amazing way to connect to like-minded artists. Stage group exhibitions, or help out. Collaborations are VITAL! Working with others will also help you realize ambitious ideas or visions for your own art. Think big! Work out which gallery programmes you love most, and start to follow them. Commit to it for the long term. Become part of that community. You can't expect to get to know people overnight, but if you go to private views, turn up early, meet the assistants and gallerists working in a gallery, meet the artists and other visitors, you'll be surprised how quickly you can create a supportive network. We are aware this is harder for some people who are shyer or less sociable, but another thing we've learned is that the people who appear to be sociable and chatty and gregarious are often very sensitive, thoughtful characters who have moments of shyness themselves. Get to know the artists you admire. Be brave: artists don't often get told how much people love their work and will be surprisingly supportive of *your* work if they feel you admire and connect to theirs! We've seen so many examples of other artists helping share their platform with younger or lesser-known artists through curating shows or mentioning artists in interviews and so on. There is a phrase that we are 'stronger together', and that is definitely true for artists.

TRUST THE GALLERIES

Trust the galleries you work with, and work on building good communication with them. An artist's relationship with a gallery can be long-term, so like any relationship it's something that needs to be nurtured. The art world has often operated on a handshake. Many of the artists represented by galleries don't have a contract for the representation side of their relationship, but we do strongly recommend making/requesting consignment or loan agreements with any gallery showing your work. They need to insure, ship and protect your work during the exhibition, from the moment it's collected from your studio. Having clear agreements is best for both parties. So many artists we know have had negative experiences when they didn't get a consignment agreement. This can be a simple one-page Word document signed by both parties. It doesn't need to be a long legal contract, just a clear statement of how you will work together.

COMPETITION

It can be good to have healthy competition, but don't get too hung up on competing or comparing yourself to others. Everyone's journey is different, and while there are certain steps you can take to grow your career, it's all about timing. Sometimes the work you are making may not immediately resonate with the tastes of the time: please remember THIS IS A STRENGTH! Being different is a good thing. Never feel pressured to make work that looks a certain way in the hope you will get an exhibition or success. Just be yourself as much as you can.

TAKE INSPIRATION

By all means, however, take inspiration from artists who have gone before you. The best artists steal but also take what they've learned and recontextualize it, use it as inspiration, reframe it, make it theirs. It can be good in your early career to look back and mimic works of art by your heroes, to go to life drawing classes, to push yourself in terms of acquiring skills for drawing and painting. Once you've learned as much as you can, you then have the full weaponry needed to tear it all apart and create something of your own. It's good to take strength from earlier artists, to passionately connect and stand on the shoulders of giants, as the famous quote says.

HOST STUDIO VISITS

Many artists we've met over the years are reticent to let people into their studios. While you don't need to have an open weekend every week, it can be useful to get people you trust to visit your studio and chat about the work you are making. Sometimes keeping it all secret for long periods of time can actually be unhelpful. The more you can chat about your work, the better, especially once you're no longer in art school or if you're working alone outside a particular system. Talking through your ideas can help unlock new ones, and gain you new perspectives into the work you are making and the work you will make.

DISPLAYED AND INSTALLED

Be specific in how you want your work to be displayed and installed. If you make works that need to be installed under particular conditions, make sure you write a list of instructions, and perhaps even make this a document that can travel with the work to its new owners. Make sure you back this document up and store it for the long-term in case it gets lost.

STAY OPEN-MINDED

Stay open-minded and encourage new opportunities by allowing spontaneity! Opportunities will come your way, consider them, and only say no if you really feel it's the wrong context. Sometimes exhibiting your work in the smallest of spaces can be such an important step. It takes you out of your studio. Yes, it's nerve-wracking to have people see your work at last, but it's also vital for your growth. Be brave! Share your work.

GET ONLINE

Join Instagram. Make a website, but don't spend too long on it. The most important thing is to share your contact details and maybe your CV and selected images of your art, but it doesn't need to be an extensive archive. A simple holding page is enough.

APPLY FOR GRANTS

It's dull filling out forms, so if you struggle with that side of things, ask for help. Get advice from friends who are also applying, or reach out to the foundation and explain you're struggling to complete the forms. Lots of our artist friends find paperwork the most alien or challenging thing, so don't avoid applying for this reason, as you may be missing out on a great opportunity. Also, face the fact that you will be rejected. Over and over and over. But all it takes is for one person to say yes. Without applying and trying, you will never get to the yes!

Overleaf:
Tracey Emin, *The Last Great Adventure is You*, 2014, neon, 450 × 172cm (177 × 67¾in).

FINALLY...

Finally, what does it really all boil down to? Well, as we mentioned at the start of this chapter, the most fundamental objective of all is to BE YOURSELF. This is one message you really must hold onto throughout your artistic career; for if an artist is honest and truthful to themselves, sharing their voice, their own story, their perspective, while holding hands with the past, then art has the power to connect, intrigue, fascinate and start conversations to facilitate lasting change. And for us, the viewer, it's essential to be open-minded, to come to artworks with empathy and a willingness to learn. Making art is a generous act for both the artist and the viewer, encouraging a deeper understanding of our interior and exterior lives, our passions, our struggles, our desires and our crucial, inseparable need to communicate. There's the age-old cliché of 'Why is that art?', or 'I could have done that' or, worse, 'My five-year-old could have done that'. The indisputable truth is that the best artists spend their entire working lives developing a visual language – so to reach a point where it looks easy or straightforward is their greatest achievement. To transcend the external noise and opinions, to take confidence from years of fine-tuning and perfecting, in order to be able to sift talent into its purest and boldest form: that's individuality. That's finding your voice. That's having something to say. Progress.

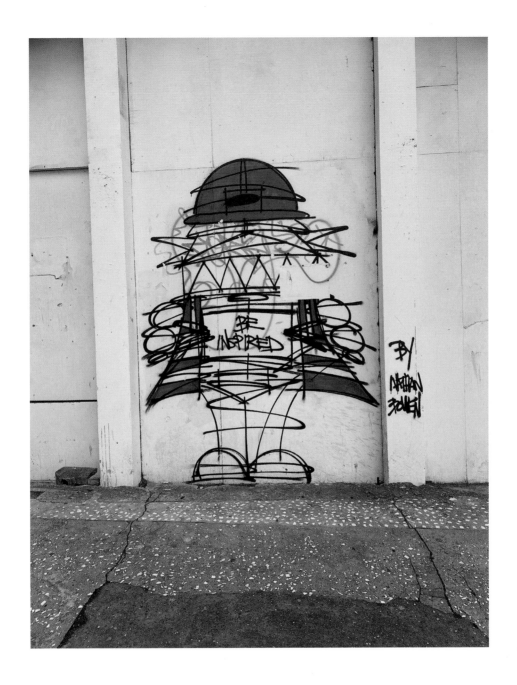

Nathan Bowen, *Builder Demon*, 2020, Margate seafront.
London-based street artist Bowen is the founder of a movement called 'After Lives', but he's best-known for painting 'demons' inspired by the 15th-century Dutch painter Hieronymus Bosch, who famously painted hugely disturbing visions of hell.

Great
is you

WHAT TO READ

Art Collecting Today: Market Insights for Everyone Passionate about Art
– Doug Woodham, Allworth, 2018

Art is the Highest Form of Hope
– Phaidon, 2016

Art Studio America: Contemporary Art Spaces
– Hossein Amirsadeghi & Maryam Eisler, Thames & Hudson, 2013

Black Refractions: Highlights from The Studio Museum in Harlem
– Connie H. Choi & Thelma Golden, Rizzoli, 2019

Collecting Art for Love, Money and More
– Ethan Wagner & Thea Westreich, Phaidon, 2013

Commissioning Contemporary Art: A Handbook for Curators, Collectors and Artists
– Louisa Buck & Daniel McClean, Thames & Hudson, 2012

Could Have, Would Have, Should Have: Inside the World of the Art Collector
– Tiqui Atencio, Art/Books, 2016

Defining Contemporary Art: 25 Years in 200 Pivotal Artworks
– Daniel Birnbaum, Cornelia H. Butler & Suzanne Cotter, Phaidon, 2017

Great Women Artists
– Phaidon, 2019

A History of Pictures: From the Cave to the Computer Screen
– David Hockney & Martin Gayford, Thames & Hudson, 2016

How to Be an Artist
– Jerry Saltz, Ilex, 2020

How to See: Looking, Talking, and Thinking about Art
– David Salle, W. W. W. Norton & Company, 2016

Lucky Kunst: The Story of YBA
– Gregor Muir, Aurum Press, 2009

Masculinities: Liberation through Photography
– Alona Pardo, Prestel, 2020

The Mirror and the Palette: Rebellion, Revolution and Resilience, 500 Years of Women's Self-Portraits
– Jennifer Higgie, Weidenfeld & Nicolson, 2021

On Being an Artist
– Michael Craig-Martin, Art/Books, 2015

Owning Art: The Contemporary Art Collector's Handbook
– Louisa Buck & Judith Greer, Cultureshock Media, 2006

Painting Now: Five Contemporary Artists
– Andrew Wilson, Tate Publishing, 2013

A Poor Collector's Guide to Buying Great Art
– Erling Kagge, Die Gestalten Verlag, 2015

Seven Days in the Art World
– Sarah Thornton, Granta, 2008

Strangeland
– Tracey Emin, Hodder & Stoughton, 2013

Tracey Emin
– Carl Freedman & Honey Luard, Rizzoli, 2006

The Whole Picture: The colonial story of the art in our museums & why we need to talk about it
– Alice Procter, Ilex, 2020

Why Your Five Year Old Could Not Have Done That: Modern Art Explained
– Susie Hodge, Thames & Hudson, 2012

The $12 Million Stuffed Shark: The Curious Economics of Contemporary Art
– Don Thompson, Aurum Press, 2012

100 Contemporary Artists A–Z
– Hans Werner Holzwarth, Taschen, 2009

INDEX

Artwork titles and illustration page nos. are in *italics*

talk ART

PICTURE CREDITS

Renato César, *Talking Elton*, 2020, digital drawing,
21 × 21cm (8¼ × 8¼in). Brazilian artist Renato has been
a supportive listener of the *Talk Art* podcast since its
inception in Autumn 2018, commemorating numerous
episodes with a unique artwork. Out of more than fifty
Talk Art-inspired artworks shared on his Instagram account
@Tatto_Olive, this is one of our favourites, depicting music
royalty Elton John alongside Russell and Robert (and
Russell's dog Rocky) from their lockdown discussion
for the QuarARTine series in April 2020.

ACKNOWLEDGEMENTS

We would like to thank all of the artists and galleries who generously allowed us to publish their artworks in this book, every guest who has shared their insights and experiences on our podcast and every single one of you for reading and listening.

Special thanks to Jerry Saltz for his inspiring foreword, Tracey Emin for her timeless, handwritten Talk Art drawing and for first introducing us to each other. To Katherine Bernhardt, Yinka Ilori, Teresa Farrell & Alvaro Barrington, Lenz Geerk, Katherine Bradford, Jon Key, Salman Toor, Shawanda Corbett, Ana Benaroya and KAWS for creating awesome unique artworks for the beginning of each chapter; to Rebecca Warren, Toyin Ojih Odutola and Carl Freedman for their continuous support and encouragement; to Tom Lardner at Plus Agency for designing our podcast sleeve, logo and photos.

Thanks also to Antony, Chris and Gareth at Spiritland Productions; Louise, Grace, Zach, Rosie and Paul at Independent Talent; Ella, Ben, Jen and the entire team at Octopus Publishing.

Finally to our Mums, families, collaborators, friends, Steve, Archie, Cooper and Rocky for listening to every episode and for encouraging us to create the podcast in the first place. We love you!

First published in the United States of America in 2021 by Chronicle Books LLC.

Originally published in Great Britain in 2021 by Ilex, an imprint of Octopus Publishing Group Ltd Carmelite House 50 Victoria Embankment London EC4Y 0DZ www.octopusbooks.co.uk

Library of Congress Cataloging-in-Publication data available.

ISBN 978-1-7972-1424-5

Manufactured in Singapore.

Cover design by Allison Weiner.

10 9 8 7 6 5 4 3 2 1

Chronicle books and gifts are available at special quantity discounts to corporations, professional associations, literacy programs, and other organizations. For details and discount information, please contact our premiums department at corporatesales@ chroniclebooks.com or at 1-800-759-0190.

Chronicle Books LLC 680 Second Street San Francisco, California 94107 www.chroniclebooks.com

Case and page 1: Tracey Emin, *talk ART*, 2020, pen on paper